P9-DGD-443

CCLD
3100 N. CENTRAL SCHOOL RD.
CLIFTON, IL 60927
1-815-694-2800

741.6 Craig, James 4704
Cra Working with Graphic Designer

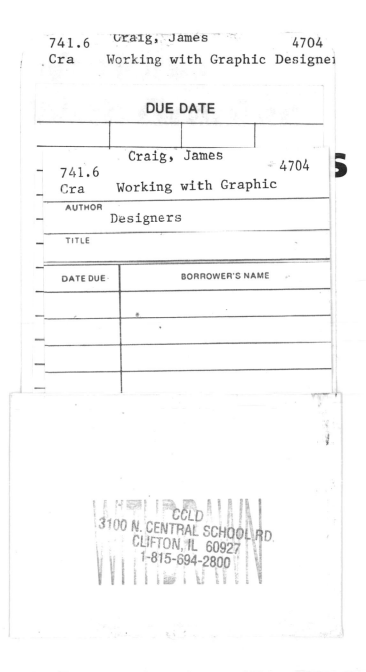

DUE DATE			

Craig, James 4704
741.6
Cra Working with Graphic

AUTHOR Designers

TITLE

DATE DUE	BORROWER'S NAME

WITHDRAWN

CCLD
3100 N. CENTRAL SCHOOL RD.
CLIFTON, IL 60927
1-815-694-2800

CCLD
3100 N. CENTRAL SCHOOL RD.
LIFTON, IL 60927
1-815-694-2800

Other books by James Craig

Designing with Type

Production for the Graphic Designer

Phototypesetting: A Design Manual

Graphic Design Career Guide

Thirty Centuries of Graphic Design

James Craig
William Bevington

Working
With Graphic
Designers

CCLD
3100 N. CENTRAL SCHOOL RD.
CLIFTON, IL 60927
1-815-694-2800

Watson-Guptill Publications
New York

CCLD
Accession No. 4704
Date 12/2/97
Source Donated
Price $22.50

CCLD
3100 N. CENTRAL SCHOOL RD.
CLIFTON, IL 60927
1-815-694-2800

Copyright © 1989 by James Craig and William Bevington

First published in 1989 in New York by Watson-Guptill
Publications, a division of Billboard Publications, Inc.,
1515 Broadway, New York, N.Y. 10036

Library of Congress Cataloging-in-Publication Data
Craig, James, 1930-
 Working with graphic designers: a handbook for
editors, copywriters, art buyers, architects, promotion
directors, production managers & advertising agency
personnel / James Craig and William Bevington.
 p. cm.
 Bibliography: p.
 Includes index.
 ISBN 0-8230-5867-0 : $22.50
 1. Commercial art—Technique. 2. Commercial
art—Handbooks, manuals, etc. I. Bevington, William.
II. Title.
NC1000.C74 1989 88-32526
741.6—dc19 CIP

Distributed in the United Kingdom by Phaidon Press Ltd.,
Littlegate House, St. Ebbe's St., Oxford

All rights reserved. No part of this publication may be
reproduced or used in any form or by any means—graphic,
electronic, or mechanical, including photocopying,
recording, taping, or information storage and retrieval
systems—without written permission of the publisher.

Manufactured in U.S.A.

First printing, 1989

1 2 3 4 5 6 7 8 9 10/93 92 91 90 89

*Dedicated to every client who inspires,
supports, and encourages the graphic
designer. . .and pays on time.*

Contents

Acknowledgments

Little is accomplished without working together; this book is a case in point. If not for the efforts and patience of the following individuals, this book wouldn't exist.

We would like to thank the dedicated employees of Wm. Bevington Design, Inc. for their efforts in helping to assemble the book from illustrations through mechanicals: Kathleen Coe, Brixton Doyle, Chris Gallego, Isabel Guerra, and Eugene Smith, Jr. In addition, we thank Hadass Attia, Elizabeth Blades, and Ann Marie Sweeney for the use of their student projects on page 71.

A special thanks to the following two individuals whose knowledge of typography and attention to detail was critical in meeting the difficult deadlines which this book imposed. To Kathleen Bevington, whose tireless dedication to getting things right has enhanced many a designer's reputation. Thanks for your patience in generating the many excellent typographic illustrations. And to Michael Weinglass for struggling with some very difficult disk conversions in producing a large portion of the text.

We also wish to acknowledge the contributions of our editors, Lanie Lee and Sue Heinemann. We regret that we could not always follow our own advice so readily given in this book when working with them. Additional thanks to our production manager, Ellen Greene, for doing everything within her power to make the book of the highest possible quality. And to Andrew Hoffer, who rearranged his schedules to accommodate our schedules.

Reading a raw manuscript, unedited and without illustrations, is not an easy task. The following people willingly undertook it and for this we are deeply appreciative: Larry Arfield, Jane Eldershaw, Michael Josefowicz, and Jennifer Place.

We are especially grateful to the many professionals who took the time to share their experiences with the reader: Bruce Blackburn, John Mack Carter, Dick Gibbs, Ed Gold, Paula Green, Michael Josefowicz, George Lois, Julia Moore, Alice O'Leary, Nancy Rice, Tony Romeo, Ron Rosenfeld, George Sadek, Norman Sanders, Arnold Saks, and Karl Steinbrenner. Thank you, all.

From William Bevington, the final and greatest thanks must go to his wife, Elaine, for tolerating his ridiculous schedule while working on this book.

Working with an art director is a lot like living with a cat. They tend to set themselves above details such as schedules, house rules, and obedience to commands . . . they come and go as they please . . .

John Mack Carter
Editor, *Good Housekeeping*

While John Mack Carter's comment is witty, it does not exactly project the kind of image a graphic designer would choose. It does, however, express a common perception that creative people can be tempermental, difficult to work with, and unresponsive to the client's needs.

For their part, graphic designers would probably respond by saying that clients often don't know what they want, and furthermore they don't know a good design when they see one. Neither attitude is a recipe for success.

So how does one work effectively with a graphic designer? The first priority is to understand as much as possible about the creative process, from defining the project through reviewing the final piece. This includes an understanding of the fundamentals of typography and production, along with such new technologies as desktop publishing.

Once you become familiar with the basics, you will find that many conflicts can be moved out of the realm of personal likes and dislikes and can be addressed as technical questions. Problems can then be resolved without frustration or anger.

To give you a first hand insight into what contributes to a successful working relationship, we have asked a selected group of editors, copywriters, art directors, printers, and designers to relate their own experiences in the field. We also follow three actual projects from beginning to end and show how the job develops and how specific problems are resolved.

Everything in *Working with Graphic Designers* is designed to help you achieve great results. And great results is what this field is all about.

Who knows, after reading this book and putting its many suggestions into practice, you may find that working with an art director is even easier than living with a cat . . .

The Design Process

To achieve optimum results, it is important to be familiar with the design process from beginning to end, from preparation through production.

A typical job begins with a meeting of key people. The project is discussed, the copy is written, and a designer is chosen. The designer makes a visual presentation, a concept is approved, type is set, and artwork is prepared for production. The job is then printed and distributed.

The success or failure of a job is determined to a great extent by how carefully the project is planned. Many jobs are destined to fail or fall short of expectations because the importance of thorough planning was not appreciated and practical production methods were not understood. Good design combines many skills—creativity is just one of them.

The first step in selling a product, promoting a service, or simply communicating a message is to define the problem. To achieve this you must develop a concise idea of what you wish to accomplish. The list of questions on this page will help you organize and clarify some key points that should be considered in the early planning stages (1).

This planning process usually begins before the designer is engaged, and it involves every individual concerned with the project. When all parties participate at the outset, a common goal is established.

Defining the problem is not unlike describing your ideal home to an architect. In such a case you would be expected to provide certain basic facts; for example, the number and type of rooms, the style you prefer, and how much you're willing to spend. The final building will be determined by how well you communicate this information (2).

Similarly, when you begin working with a graphic designer, you will be asked to supply a general idea of the format, content, intended audience, and budget. By asking these questions, the designer is *not* suggesting *you* design the piece, but is merely trying to determine the image you wish to project, the cost involved, and the most appropriate production methods.

2

WHO IS THE INTENDED AUDIENCE?

WHAT IS THE OBJECTIVE?

WHAT ELEMENTS ARE REQUIRED TO PRODUCE THE PROJECT, AND WHO WILL PROVIDE THEM?

HAS COST BEEN CONSIDERED?

WHAT WILL BE THE GENERAL FORMAT?

HOW MANY PIECES ARE TO BE PRODUCED?

WHEN IS THE PROJECT DUE?

ARE ALL CONCERNED PARTIES INVOLVED IN THE PROJECT?

WHO IS RESPONSIBLE FOR THE FINAL APPROVAL?

HOW WILL THE JOB BE STORED AND DISTRIBUTED?

1

1 Knowing which questions to ask is the first step toward defining the problem. Although each project elicits specific questions, this list will help you get started.

2 One wouldn't dream of building their ideal home without first defining their needs. Design projects require the same approach.

Having familiarized yourself with the project, you are now ready to call in the graphic designer. Assuming you do not have a design staff, you will have to hire a freelance designer. Anyone who has gone through this process is probably aware that the challenge is not simply finding a designer, but finding the *right* designer—one with whom you can work effectively.

Perhaps the ideal way of locating a designer is through a trusted friend or business acquaintance, who can recommend one or more designers qualified to handle your type of project. This approach permits you to determine in advance the candidate's qualifications and whether their rates are within your budget.

You may also consider contacting professional organizations that cater to art directors, graphic designers, illustrators, and related disciplines. Many of these organizations produce annuals that illustrate the work of their members (1). Most major cities have local chapters which can be located through the regional telephone directory.

Another approach would be collecting pieces that are similar or related to your project. If you do find an appropriate example, call the company or organization that produced it and make the necessary inquiries. If the piece was done by a freelance designer or studio, their services may be available.

You might also consider calling the job placement office at the local art school and asking them to recommend one or more students. Although student experience will be limited, this is partially offset by their great enthusiasm and reasonable rates. Sometimes you might be able to hire a member of the faculty, many of whom are practicing professionals.

Artists' agents are another source of talent. Many designers, especially illustrators and photographers, are represented by agents whose business is to show the work of their clients. One advantage of working through an agent is convenience; it is possible to review a variety of candidates through a single contact.

In addition to all the above, there is the *Yellow Pages,* which lists designers and studios under such categories as *graphic designers, artists, art studios, advertising agencies,* and *video productions.* There are also several source books available that show samples of artists' work; perhaps the most popular is the *Black Book,* available in major bookstores.

After selecting a prospective candidate, phone the designer in order to determine such things as experience and availability. It may also be possible to obtain a general idea of the designer's fee. If all goes well, you should be able to come up with at least two designers worth contacting for a portfolio review—a necessary process before making a final selection.

1 Annuals published by major design and advertising organizations are excellent references and may help you find candidates for your particular job.

1

Reviewing Portfolios

The designer's portfolio will help you determine the best candidate for your particular needs. The portfolio should not only portray artistic originality but also demonstrate skills in both organization and problem solving. In addition to relating to your needs, the work should reflect the designer's expertise and ability to carry a project through to completion.

Judging a portfolio is highly subjective. When examining specific pieces ask yourself: Are the design elements well integrated? Can the type be easily read? Does the design solve the problem? Questions such as these will help you evaluate a portfolio (1).

Remember, it is possible for a design to be visually appealing and yet unsuitable for a particular application. Award-winning pieces do not always make the best solutions.

All of the work in the portfolio should be of consistent quality if you are to accurately judge the designer's potential. If it is inconsistent, you have no way of knowing how your project will turn out; it could resemble either the best or worst piece in the portfolio.

If you wish to know more about a particular design, request the name and phone number of the client who commissioned the designer. Call and ask who originated the concept, whether the job was delivered on time and within budget, and whether the client would hire the designer again.

Although you may be impressed by the portfolio, there are other factors to consider. Ask yourself: Can I afford the services of the designer? Can the designer handle all the necessary phases of the project? Will the deadlines be met? In addition, you should be looking for a designer who is not only talented, but enthusiastic, responsible, and reliable. In other words, someone you can feel comfortable working with.

If for any reason you are not satisfied with the designer you have interviewed, start the selection process anew. It may be comforting to know that designers do not charge for showing their portfolios. After the portfolio review process, you can discuss fees, obtain estimates, and go to contract.

DOES THE PORTFOLIO RELATE TO YOUR NEEDS?

DOES THE WORK EXHIBIT CONSISTENT QUALITY?

IS THE MATERIAL WELL ORGANIZED AND NEATLY PRESENTED?

ARE THE PIECES ORIGINAL?

DO THEY SHOW IMAGINATION?

IS THERE ENOUGH WORK TO MAKE AN ACCURATE APPRAISAL?

DO THE DESIGNS SOLVE THE PROBLEMS THEY ADDRESS?

ARE THE PIECES REALISTIC, THAT IS, CAN THEY BE REPRODUCED COMMERCIALLY?

1

1 The best way to evaluate a portfolio is to review the work while asking yourself questions that pertain to your particular needs.

When establishing design fees, it is important to determine just what is meant by a "design fee." For some designers the figure will include everything from concept through mechanicals, while others charge for individual services such as concept, presentation, typesetting, illustration, photography, and mechanicals. Either way, the final fee will be determined by the designer's experience, the nature of the piece, the industry, and the schedule. A good source for current fees is the *Pricing and Ethical Guidelines* by the Graphic Artists Guild (1).

In some cases the design fee is set by the client. This is common with companies that produce similar projects year after year: experience has taught them the approximate cost of the job and the going rates in the marketplace. An example of an established or set fee would be a book jacket for the publishing industry. Of course, established fees will vary from company to company and from industry to industry. For example, advertising agencies generally pay more than publishing houses for similar services.

Most jobs, however, are unique and must be negotiated on a project by project basis. If a job defies an accurate estimation, the designer may suggest a minimum/maximum fee or quote an hourly rate with an estimated total cost. Another possibility is a fixed fee based upon a percentage of the project's total cost.

When the designer takes responsibility for the entire job, payments may have to be made at specific stages in order for the designer to meet financial requirements. Usually, when designers do handle outside services, such as typesetting and printing, it is common practice to add a premium of 15% or 17.5% to the invoice. Whatever the arrangement, it is imperative that the terms be clarified, agreed upon, and submitted in written form.

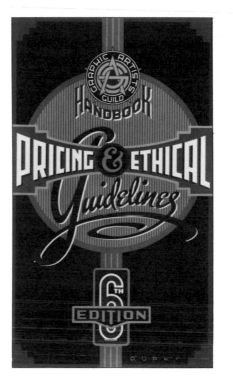

1 Establishing a fair price for design services can be difficult; this handbook produced by the Graphic Artists Guild is a good starting point. By having a general idea of design costs, you will be better prepared for both developing a budget and working with the graphic designer.

1

Developing a Budget

It is essential that you prepare a budget before proceeding with the job. Basically, there are two ways to develop a budget. The first is to arrive at a figure based on estimates obtained from the various suppliers involved. The second is to produce the project within a fixed budget, that is, to produce the job within a given sum. In either case, all the suppliers must be contacted for prices. It is in this area that the designer can be of assistance.

When establishing a budget, you should have a clear idea of what the final product will be and the type of services required to achieve it. For example, a typical brochure will involve the services of a copywriter, a designer, an illustrator or photographer, a typographer, a printer, and a mailing house (1).

Added to this will be an assortment of expenses for materials, photostats, deliveries, and local taxes. You may also be required to furnish credit references or pay for all or part of the job in advance.

When budgeting, you can gain both creatively and economically by taking advantage of the designer's experience. Besides saving time and energy, the designer can supply reliable contacts, suggestions for alternate formats along with cost-effective production methods, printed samples, and, in some cases, credit arrangements. The designer will prepare a budget and submit a written proposal based on your needs (2).

Not only will you benefit from the designer's experience and professional working relationship with the various suppliers, but the designer also takes complete responsibility for the job. Although designers usually charge an additional percentage on outside services, this is generally offset by both industry discounts and the designer's experience in selecting the most economical supplier.

In most cases, designers do not charge for estimating a job, regardless of whether they are ultimately awarded the job or not. On particularly large or complex projects, however, there might be a fee to cover time and out-of-pocket expenses.

If you intend to estimate the job yourself, be realistic about what you want, how much you are willing to spend, and the inherent difficulty of working directly with suppliers. Despite the effort involved in obtaining your own estimates, you stand to increase your knowledge of how a job is produced.

Before investing your time developing a detailed estimate, you may wish to obtain some general price information on similar jobs. By contacting various designers or suppliers, you can determine in advance whether the job can be produced as originally intended and within budget. It will pay to shop around.

When explaining your needs to various suppliers, you may find that communication is a problem. As each industry has its own technical language, you may be confused by the terminology; this is especially true when dealing by phone. In such cases you may prefer to meet face-to-face with a salesperson or company representative. You should also be aware that some suppliers prefer to work only with graphic designers.

When you are required to work with a fixed budget, it is even more important to consult with several suppliers to increase your options. In such cases it is absolutely essential that all parties be given the same specifications; for example, format, number of pages, quality of paper, etc.

Confusing, vague, or misleading specifications will create problems as well as distort the final estimate. For example, a minor change in the dimensions of a brochure could conceivably double the print cost. Should a designer or a supplier suggest a modification in the specifications, all parties should be advised and allowed to rebid.

Even with the most careful planning, changes or alterations are inevitable. It is good practice to allocate extra money in the budget for such situations. The amount can vary significantly and cannot be planned for to the penny; as a rule, the more individuals involved in the approval process, the greater the risk for costly alterations. (See Changes and Corrections, page 31.)

1 When preparing a budget, try to anticipate all the services and expenses required from beginning to end. This list reflects the areas of expense you will encounter when producing a typical print job. Prepare a similar list for each job before obtaining costs.

2 A well-prepared estimate from a designer, or supplier, should be explicit, documenting exactly what is, and is not, covered.

PREPARATION OF COPY.

EDITORIAL EXPENSES.

PRELIMINARY DESIGN/PRESENTATION FEES.

COST OF PHOTOGRAPHS AND ILLUSTRATIONS.

COPYRIGHT OR REPRODUCTION FEES.

FINAL DESIGN/PRESENTATION FEES.

TYPESETTING COSTS.

PHOTOCOPIES AND PHOTOSTATS.

TRAFFIC AND DELIVERY COSTS.

TELEPHONE AND TELEFAX COSTS.

MAJOR TRAVEL EXPENSES.

MECHANICAL PREPARATION FEE.

PAPER, PRINT, AND BINDERY EXPENSES.

DELIVERY AND DISTRIBUTION COSTS.

ALLOWANCES FOR CLIENT ALTERATIONS.

ALLOWANCE FOR AGENCY/STUDIO
COMMISSIONS.

INCIDENTAL EXPENSES.

1

ESTIMATE

PREPARED FOR:
Gads Hill Publishing

DATE:
February 7, 1991

VALID UNTIL:
May 7, 1991

YOUR JOB NO:
1775

LANDPORT DESIGN STUDIO

1812 Portsea Street
New York, New York 10107

Major Identity Project.
Cost estimates and proposals prepared for
Charles Cruncher.

THIS IS PAGE ONE OF THREE PAGES.

Design and concept plus all costs for design
presentation, materials and expenses
and minor revisions (up to 10% AA's) for the
following items:

PHASE ONE
Design and presentation costs for
Logotype, Stationery, and Corporate image
for Gads Hill Publishing.

PHASE TWO
Design and presentation costs for application
of logo to signage and company vehicles.

PHASE THREE
Design and presentation costs for
Graphic standards manual.

This total cost is GUARANTEED unless Gads Hill Publishing
receives in written form a statement detailing possible
cost increases and cause thereof.

A DEPOSIT of $ 4,000.00 is required prior to beginning
PHASE ONE.

A PAYMENT of $ 4,000.00 will be required upon completion
of PHASE ONE.

Additional payments will be required 10 days after
acceptance of final designs for PHASE TWO and PHASE THREE.

We will meet all deadlines as per your October 6 Memorandum.
Printed schedule to be furnished upon go-ahead of project.

2

Developing a Schedule

A great deal of inefficiency and confusion can be avoided if a timetable for each stage of the project is clearly established before the first line is drawn. A precise schedule should be developed based on a realistic amount of time being allotted for each service, including meetings and revisions (1,2).

Schedules are usually developed with the assistance of the designer and worked out in reverse, that is, planned backwards from the deadline. Many projects have fixed deadlines and all services must be geared to that reality.

All parties should follow schedules to the letter. Unfortunately, in the real world delays are likely to occur and adjustments have to be made. As the final deadline is inviolable, this may involve extra effort and overtime.

You may wish to establish a "safety net" by scheduling a "due date" ahead of the actual deadline. Many professionals employ this practice to ensure delivery and to allow for unforeseen problems.

In general, poor scheduling based on wishful thinking and impossible demands creates inconveniences, adds to the cost, and, most importantly, compromises the quality of the job. In addition, it can easily create frustration and bad feelings.

When preparing schedules, be aware that there is a difference between working days and calendar days. If a job requires ten working days, the printer will not include weekends and holidays. Also keep in mind that some services close for extended periods of time during holidays, and for summer vacations.

Date: February 7, 1991

LANDPORT DESIGN STUDIO
1812 Portsea Street
New York, New York 10107

Re: Tentative schedule on your job #917 E

To:
Mr. Charles Cruncher
Gads Hill Publishing
Carter Road
Kent, Connecticut

Dear Mr. Cruncher,

Below is a tentative time frame for the job we discussed. Thank you for considering our studio for your upcoming project.

First Presentation:
One week from go-ahead and initial meeting

Second Presentation:
One week from first presentation

Copy Submission:
One week from final (or approved) presentation

Final art presentation:
Fourth week (all final approvals obtained)

Mechanicals and pre-press production:
Ten working days

Final sign-off with all parties involved:
Four days

Blueprint and corrected blueprint:
Five days

On press:
Fifteen working days

Binding and delivery:
Approx. ten working days

An actual time and day schedule will be prepared upon go-ahead. Schedule assumes only minor changes and unless otherwise noted, twenty-four hour approvals.

Estimated by:
Charles Darnay

1

1 This schedule is based on the number of working days required for each stage of the job.

2 Based on calendar dates, this schedule lists specific times when the designer and the client must deliver materials, work, or approvals in order to meet the deadline.

LANDPORT DESIGN STUDIO

Date _____

Job No. _____

Signed by: _____

1812 Portsea Street
New York, New York 10107

First planning meeting	Jan 01
Cost estimates submitted	Jan 03
First copy in from client	Jan 06
First presentation	Jan 21
Illustration / photography presentation	Jan 24
2nd design presentation	Feb 02
2nd illustration / photography presentation	Feb 02
Final copy from client	Feb 02
Copy to typesetter	Feb 04
First galleys	Feb 07
Second galleys	Feb 19
Third galleys	Feb 22
Final reproduction in	Feb 25
Final art / illustration / photography in	Mar 02
Begin mechanicals	Mar 03
Complete mechanicals	Mar 18
First client review	Mar 19
Final revisions and review	Mar 20
Job to printer	Mar 24
Blueprints and final corrections	Mar 27
Project on press	Apr 02
Delivery	Apr 15

Drawing up the Contract

A contract is the ideal business document; it is a binding agreement that clearly states the conditions and commitments of both parties and is legally enforceable. Ideally, a contract should cover the pertinent factors involved in the project, such as design fees and production costs (if designer's responsibility), scheduling, ownership and usage rights (copyright), payment schedules, and cancellation terms (kill fee).

Design fees and production costs should cover all the specifications. For example, a printed piece should specify size, number of pages, colors, type of paper, illustrations, and quantity.

Scheduling will establish a timetable for the delivery of everything from the initial concept to the final job. The schedule will include all the dates when the designer expects to receive materials or approvals from the client. Allowances should also be made in the contract for delays brought on by alterations, which may have a significant effect on both schedule and expenditure.

Ownership and usage rights should be resolved at the outset. Having work copyrighted is a common practice with illustrators, photographers, and filmmakers. Some designers only agree to a one-time use of their art, after which all materials and copyright privileges revert to the artist. At the other extreme, there are some designers who place no restrictions on their work, thus permitting unlimited use.

Payment schedules are an essential part of the contract since some designers require funds as various stages of the job are complete, such as design, typesetting, mechanicals, and so forth. Other designers prefer a percentage in advance and the balance upon completion; while still others allow the standard thirty days for payment.

Cancellation terms are necessary because not all jobs may go through to completion; this may be due to cancellation of the project or rejection of repeated design proposals. For this reason all contracts should provide a "kill fee," which usually includes a percentage of the design fee and out-of-pocket expenses to date.

While contracts and purchase orders are the ideal documents, they may not always be practical for small or rush jobs (1, 2). In these cases, a signed estimate or letter of agreement on the client's stationery will suffice (3).

It is well worth the time to carefully draw up a contract, letter of agreement, or purchase order. By doing so you help alleviate misunderstandings, thereby improving your working relationship with the designer.

This is a two page document, please sign the second page and return to: LANDPORT DESIGN STUDIO

LANDPORT DESIGN STUDIO

1812 Portsea Street
New York, New York 10107

A. This contract when signed by you with a copy returned to us, will constitute a working agreement between our firms/institutions/corporations. All projects or services which Landport Design Studios produces for your firms/institutions/corporations will be subject to the general provisions outlined in this agreement. Any further agreements entered into between our firms after this time must also be confirmed in writing.

B. Specific projects and/or services will be detailed on our bid or estimate agreement. We will not begin a project until letters or purchase orders are submitted, or oral go-aheads are advised. Approvals constitute an agreement between us in accordance with the terms specified herein, or on our bid or estimate agreement. Unless otherwise specified, all our "Letters of Agreement" or purchase orders will be based on reasonable time schedules. In those cases when work is to be done on a RUSH basis, as not laid out by our estimate or agreement, any additional costs incurred due to such circumstances will be reflected in our billings.

C. The specific fees and billing arrangements for each project or service will be described in the previously mentioned bid or estimate agreement. We reserve the right to refuse to begin, complete or deliver any work until the appropriate fees agreed upon are paid according to billing arrangement specified.
Since it is impossible to predict with absolute accuracy either final fees or, in the case of printed material, final total quantities, a 10% contigency should be allowed for in these cases. Should any of our invoices not be paid within 60 days we reserve the right to charge reasonable interest rates by law. Should we be forced to retain attorneys to collect our invoiced such fees and court costs that may be reasonable and necessary, as well as any interest charges incurred, will be paid by you. Unless otherwise specified in our bid or estimate agreement our fees do not include such items as

color separations, copywriting, illustrations or other such contracted artwork, long distance telephone calls, messenger services, paper, photographs, photo prints, photostats, postage, printing, prints, retouching and shipping. These items will be regarded as out-of-pocket expenses and will be billed in addition to our quoted fee.

D. All work is subject to sales tax unless (1) you are a nonprofit or government organization: (2) the contracted work is for resale and you have furnished us with valid resale number: or, (3) your offices are not located in the state of New York, New Jersey, or Connecticut. Rate specified on our bid or estimate agreement.

E. Rate specified on our bid or estimate agreement. Any work requested by you and performed by us after a bid or estimate agreement has been approved, and which was not included in such documents will be considered to be "new work" and will be billed in addition to the original bid or estimate agreement. If the scope or nature of the job changes to such an extent that the original bid or estimate agreement is no longer applicable, a new bid or estimate agreement will be submitted and must be agreed to by both parties before any further work can proceed.

F. We will not be party to any project which, in our judgment, would be illegal, fraudulent, or in some other way harmful to the best interests of our firm. We will not be responsible for any claims made by you or for any legal clearance incumbent upon you to receive. However, should you request it, we will, at your expense take all necessary steps to secure such legal clearances.

G. We will do everything we can to protect any property or materials you entrust to us and to guard against any loss to you. However, in the absence of gross negligence on our part,. we are not responsible for the loss, damage, destruction or unauthorized use by others of such property nor are we responsible for the failure of other suppliers or

GADS HILL PUBLISHING

200 Two Cities Boulevard, Westminster, Connecticut

PURCHASE AGREEMENT 7084
ACTING AS AGENT FOR NAMED CLIENT

TO:
Landport Design Studio
1812 Portsea Street
New York, New York 10107

DATE: 2/2/89

| CLIENT: Dover Industries | JOB NO: DOV - 001 - 94 |
| PRODUCT: Four-Color Ad Program | |

NOTICE: OUR PURCHASE AGREEMENT NUMBER AND JOB NUMBER MUST APPEAR ON ALL INVOICES IF
AN ESTIMATED PRICE IS INDICATED HERE AND THE SELLER CANNOT PREPARE THE MATERIAL RE-
QUESTED AS ESTIMATED. PURCHASER WILL IN NO EVENT BE LIABLE FOR MORE THAN THAT AMOUNT
UNLESS THE EXCESS HAS BEEN AGREED TO BY PURCHASER BEFORE THE WORK IS COMMENCED

DATE DUE
02/02/99

IMPORTANT NOTICE: UNLESS SPECIFIED BELOW, ALL MATERIALS FURNISHED BY THE SELLER ARE DONE SO AS WORK-
FOR-HIRE A COMPLETE BUY OUT OF ALL RIGHTS, INCLUDING COPYRIGHT AND POSSESSION OF
ORIGINAL ARTWORK/CHROMES, WITH NO LIMITATIONS WHATSOEVER ANY STIPULATIONS IN SELLER'S
BILL WILL NOT BE ACCEPTABLE IF DIFFERENT FROM THIS AGREEMENT

DESCRIPTION:

To Cover Cost of Presentation Comps

IMPORTANT NOTICE: THIS AGREEMENT IS GOVERNED BY ALL OF THE TERMS
ON THE REVERSE SIDE WHICH ARE INCORPORATED HEREIN BY REFERENCE.

SUPPLIER

2

1 A contract can be drawn up by either the designer or the client. In either case, it should outline a general working arrangement and/or define the specific obligations of both parties.

2 Purchase orders are a common way of specifying the cost, terms of the job, and method of payment. They also give the designer authorization to proceed.

3 If a contract or purchase order is not practical, the parties involved should at least sign the estimate or prepare a letter of agreement.

August 23, 1991

LANDPORT DESIGN STUDIO

Jarvis Lorry
Royal George Hotel
Dover

1812 Portsea Street
New York, New York 10107

Dear Mr. Lorry,

This letter will confirm your request that our studio design and produce the logo for your new product line. As we discussed the initial presentation will be composed of at least two variations for your approval.

Because of our tight time schedule this letter signed by you will serve as confirmation to proceed at the agreed upon price of $ 2,000.00.

We look forward to the opportunity of working with you!

Yours most sincerely,

James J. Lamport, President

_____ _____
Client Approval Date

Date

3

Now that you have laid the groundwork, it is time to prepare all the necessary elements in order to proceed with the project. Nothing contributes more to job efficiency than good "copy" preparation. In the graphic design industry, *copy* not only refers to typewritten copy, but all the visual materials required to produce a job—illustrations, photographs, tables, charts, graphs, etc.

Before you begin, it is a good idea to consult with the designer about the requirements of the job. At this point, you should decide who will prepare the various elements of the project. For instance, in most cases the designer will prepare photographs, illustrations, or other visual materials, and the client will be responsible for the typewritten copy.

The most common way of preparing typewritten copy for the graphic designer is on 8 1/2" x 11" bond paper, double-spaced in a single column about 6 inches wide (1). The manuscript should be prepared in a uniform manner; individual pages typed on different machines create difficulty for the designer in organizing the job and estimating the number of characters. (To submit handwritten copy is definitely not recommended.)

Pages should be numbered to avoid confusion in the event they become separated. It is also a good policy to have the name or job title on every page.

Corrections should be marked neatly or typed above the line; if the corrections are extensive, the copy should be retyped. Poorly typed or overly corrected manuscripts are not only an inconvenience for the designer, but will incur penalty charges from typesetters.

If the job involves tables, charts, and graphs, which are usually created by the designer, it is important that all typewritten copy be neatly presented, well edited, and updated. One "minor" change may involve the redrawing of an entire piece of art.

Today, it is also common for designers to receive the copy digitally, which means by disk or telephone. The advantage of this procedure is that the copy need not be retyped by the typesetter. However, it is critical that all parties have compatible computer equipment and that typewritten copy (hard copy) be available where needed. (For further information, see Desktop Publishing on pages 123–127.)

If you, rather than the designer, are responsible for photographs and illustrations, you should be aware that the quality of the images in the final piece are directly dependent upon the quality of the original artwork. Although substandard art can be enhanced during various stages of the printing process, it is time-consuming and expensive. Nothing takes the place of high-quality original art.

Photographs must be carefully handled: do not write on either side, do not crop or fold, and do not attach notes with paper clips. Ideally, they should be taped to a medium gray board and flapped for protection (2). However, do *not* permanently mount the photographs, as they may need to be removed for electronic scanning procedures. Color transparencies should be handled with extreme caution; each one should be submitted in a clearly marked acetate envelope (3).

Before turning the job over to the designer, take the time to make a final review (4). Be certain there are no elements missing, and make an extra effort to deliver the job in one installment. If a project arrives piecemeal, the chance of error increases quite dramatically. When it is necessary to deliver a job in pieces, be certain to supply a cover sheet, detailing all the elements of the job delivered and yet to come.

1 Well-prepared, typewritten copy is essential; it reduces the chances for error and helps keep costs under control.

2 To protect photographs and original art from damage through handling or loss, it should be suitably mounted, protected with a flap, and carefully identified.

3 Color transparencies can be protected and identified by enclosing them in an acetate sleeve.

4 Most jobs are composed of a myriad of pieces, make a final review before turning the job over to the designer.

It was the best of times, it was the worst
of times, it was the age of wisdom, it was
the age of foolishness, it was the epoch of
belief, it was the epoch of incredulity, it
was the season of Light, it was the season
of Darkness, it was the spring of hope, it
was the winter of despair, we had everything
before us, we had nothing before us, we were
all going direct to Heaven, we were all
going direct the other way - in short, the
period was so far like the present period,
that some of its noisiest authorities
insisted on its being received, for good or
for evil, in the superlative degree of
comparison only.

1

2

Trans.115
Job #13-13
Jarndyce & Jarndyce
(Page 23)

3

WAS THE COPY TYPED ON A STANDARD TYPEWRITER: PICA OR ELITE?
WAS THE COPY PROPERLY EDITED?
HAS THE COPY BEEN APPROVED BY ALL CONCERNED PARTIES?
IS THE TYPEWRITTEN COPY COMPLETE?
HAVE YOU ACCOUNTED FOR ALL THE ARTWORK?
IS THE ARTWORK PROPERLY MOUNTED AND PROTECTED?
DO YOU HAVE EXTRA COPIES OF EVERYTHING IN THE EVENT OF LOSS?
HAVE YOU PREPARED A CHECKLIST COVERING EVERY PIECE OF THE JOB?
DID YOU INCLUDE A CONTRACT OR PURCHASE ORDER WITH THE JOB?
HAVE YOU PREPARED A SCHEDULE?
HAVE ALL THE PRICE ISSUES BEEN RESOLVED?
DO YOU HAVE A LIST OF ALL THE FINAL SPECIFICATIONS?

4

Having organized the project and prepared the copy, you are now ready to turn the job over to the graphic designer. How well you communicate with one another will determine the outcome of the job. Just as the graphic designer must understand your needs, it is equally important that you be familiar with the designer's role.

A good designer is a problem solver. The first step, therefore, is to communicate the goals as you have defined them. Apart from the information you have already obtained during the preparation process, there will be other points that will be of interest to the designer.

For instance, an experienced designer will ask many questions: Are there any corporate guidelines or restrictions? Is there a general "look" that should be adhered to? Are there any strong opinions about a particular color or typeface? Answers to these questions will help the designer visualize the general direction of the project. All this information will determine how the designer defines the problem and begins to formulate a solution. In other words, the more the designer knows about the nature of the piece, your organization, and your expectations, the better the chances of success.

While the designer benefits from your input, there is the risk of overdirection, that is, introducing too many directives. If the designer is asked to interpret numerous and confusing or conflicting demands, this may sacrifice creativity and the final results could suffer.

During the first meeting, the designer may wish to discuss some concepts and/or possible solutions. These ideas may be visually supported by sketches, called *thumbnails* (1), made during the first meeting. Ideally, the designer would like to conclude the meeting knowing there is an agreement on the general direction and ultimate goal.

Having a thorough understanding of the job, the designer can now proceed with the creative process. As work progresses, the designer should keep you informed regarding schedules and the general status of the job. If the designer fails to contact you on a regular basis, call and request a progress report.

After this first working meeting, the designer will deliver, on schedule, one or more visual presentations of the project.

1 At the first meeting, the designer may wish to discuss some possible directions through the use of very rough sketches, or *thumbnails*.

The First Presentation

The first opportunity to see the visual results can, understandably, make you a little anxious. This presentation will determine how effectively you prepared the job as well as the competency of the designer. Be sure you allow ample time to complete the meeting, and try to give the designer your undivided attention.

The designer should present an accurate layout with the type and illustrations in position. This is called a *comprehensive,* or *comp,* and it should indicate size, color, and type selection. A comp may be a single page, a double-page spread, or a complete *dummy* (which shows the layout for all the pages). Either way, the best comps resemble the final project and require little explanation from the designer (2).

Comps vary greatly, from inexpensive pencil or marker sketches (1) to costly silk screen presentations (3). The ideal comp will be determined by budget and the approval process. Generally speaking, the more people involved, the more accurate the comp should be. As you become more familiar with design and production procedures, the simple comps may suffice.

Comps fall into three categories: acceptable, not acceptable, and acceptable with changes. If acceptable, the design is ready to go into production. Designs that are totally unacceptable either have to be reworked or a "kill fee" must be paid and a new designer hired.

In most cases, designs fall into the third category in which the concept is acceptable but alterations are required before approval is granted. These adjustments may involve a change of emphasis, type selection, choice of color, placement of elements, or the addition of new materials. Whatever the criticism, accurate feedback is essential if the designer is to integrate the desired changes effectively.

Revised comps should be prepared to ensure that the corrections can be made without sacrificing the integrity of the design. In addition, revised comps are often more refined than the original presentation in terms of accuracy and completeness.

When making revisions, it is important to have the designer confirm that production costs will remain within budget since any design alteration will increase the expense.

Designers need room to experiment, so they may present alternate solutions, some of which may be totally new concepts. This practice should be encouraged; it not only demonstrates the designer's willingness to put forth extra effort, but you stand to benefit from a broader range of options.

1 A comp produced with color markers is acceptable, providing the client is experienced in reading rough comps.

2 A well-executed comp will require little explanation from the designer. In this illustration, the display type and captions can be read while the text is dummy type.

3 The ultimate comp employs typeset copy, precise illustrations, and accurate colors. Although expensive, tight comps, such as this silkscreen example, leave little room for doubt.

1

3

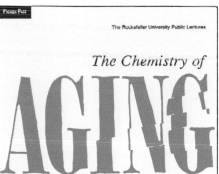

2

One of the most difficult aspects of working with the graphic designer is the act of criticizing work and suggesting changes. Since graphic design is an art and not a science, there is no objective criteria to measure the results.

In order for criticism to be constructive, both the designer and the client have to express their views clearly to avoid any misunderstandings. For instance, when the designer cannot give an explanation for why a particular design works, this creates a problem for the client, who is asked to accept on faith a design which may initially appear to be unsuitable for the job.

On the other hand, frustration also grows when the client is unable to explain why the design is unacceptable in terms that the designer can understand and agree with. When neither can convince the other, both parties usually resort to personal and subjective opinions. This can be an exasperating situation.

It helps to understand that both the designer and the client—and everyone else involved in the approval process—operate on the unstated assumption that they know best what makes a successful design. Who, then, is to determine whether a design is a success or not?

The client's reasoning is, "It's my business and I should know what appeals to my customers." A marketing person could reply, "With my years in the business, I think I understand the needs of the consumer." A salesperson relies on feedback from customers, and the designer stands on expertise in communication skills. Added to these assumptions are the prejudices of the individuals. It's a wonder a consensus is ever reached.

Who is correct and is there a right choice? If the decision is made on the basis of power, then the client certainly has the final say. This is fortuitous if the client has a track record of fine decisions; otherwise, it means overruling potentially better judgments. In some instances, the decision comes down on the side of who is more persuasive. In most cases, a compromise is made. This, however, runs the risk of design by committee, which seldom produces the best results.

In the final analysis, each person must be open to all points of view and be willing to sacrifice their assumptions in the hopes of obtaining a strong and effective design.

Since designers tend to be sensitive to artistic criticism, it is important to realize that they put a great deal of themselves into their work and make decisions reflecting basic design principles and not simply on aesthetic choices. Criticism, therefore, is often taken personally.

Tact is essential; criticism extended in a positive manner will not only motivate the designer, but aid in achieving your goals (1). Begin by stating what you like about the presentation. Focus on the design rather than the designer. For example, instead of saying "*You* made the type too small," try "That type looks a bit small for my reader." This avoids the word *you,* which conveys the idea of personal criticism, making it clear that the work and not the designer is being judged.

It is also common for designers to have their efforts criticized by nondesigners. For this reason expressions such as: "I don't like it"; "It's dull"; "This is uninteresting"; "It doesn't excite me"; and "It's too sophisticated" frustrate the designer, as they offer no clear direction. Be specific about the problem and give precise and logical reasons for suggested alterations.

There will be occasions when the designer rejects a suggestion; in such cases discussions must continue until a consensus is reached. When decisions are left vague, the job usually suffers.

If the presentation is not exactly what you expected, it is possible the information was incomplete when you turned the job over to the designer. In a situation like this, be generous in accepting part of the blame. Remember, the purpose of criticism is to reach a better solution.

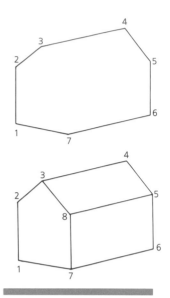

1 At times an excellent suggestion given in the right spirit can save a questionable design.

Most designers prefer to show—and, if necessary, defend—their own work. However, there may be occasions when this is not practical, and you will be required to make the presentation. In such cases, it is your responsibility to understand the designer's intent and to communicate the concept to all concerned parties (1). If you are enthusiastic about what the designer has given you, this should present little difficulty.

If someone appears ambivalent and feels that the design is lacking something, find out why. First, be certain the concept is clearly understood and then determine exactly what upsets the viewer. If possible, pinpoint the problems and elicit alternatives.

Everyone involved recognizes and appreciates suggestions that improve a given project, because everyone wants the job to look its best. Generally speaking, most designs are not total failures and should not be dismissed out-of-hand. In fact, many can be quite successful with only minor modifications.

What can be frustrating from the designer's point of view are the type of changes that are made for political or egotistical reasons rather than with the intent of improving the design. These changes are expensive and seldom make the piece more effective. They should be discouraged.

Realize that changes take time; while it only takes seconds for a suggestion, the "thought is not the deed," and it may take hours or days to translate the idea into a visual presentation. Suggestions may result in a great deal of extra work for questionable results.

After you have made the presentation and assessed all the comments and criticism, you must then communicate the information to the designer. Be specific and suggest possible alternatives for a design you wish to alter (2).

1

1 How you present the designer's work can have a great affect on how it is received.

2 Avoid design by committee, you may end up with something no one likes.

2

The Approval Process

Approvals are required to ensure that each stage of the job proceeds as scheduled. Approvals, however, are not always easy to obtain, thus delaying jobs unnecessarily. There are many reasons for this dilemma.

Sometimes key people are not accessible, or are reluctant to make decisions, which means the job sits on their desk. Others, with the best of intentions, take responsibility and give approvals *without authority.* Finally, there are the procrastinators who simply never get around to approving the job until the critical stage.

Approvals not made on schedule place an increased burden on designers and related services. Work that normally takes days or weeks must be done overnight, which can affect the quality and cost of the job. Although the deadline may be met, the stress created is detrimental to a good working relationship.

In order to streamline the process, deal only with key people and warn them in advance when their approval will be required. State when you need work returned in order to prevent delays. If an approval is late in coming, explain that the deadline is in jeopardy and there is a risk of cost overruns. At times approvals can only be obtained through persistence.

Once the final comp is approved, the designer must prepare art for production, at which time another round of approvals will be necessary. Some studios and agencies have rubber stamps prepared to ensure that all important approvals are obtained (1).

1 To make the approval process more efficient, some agencies use rubber stamps to ensure that all parties sign off on a given job.

1

A typical print job involves setting type, creating images, and assembling a mechanical for the printer. After the type is set, you will receive a *proof (photocopy* or *galley)* to be proofread for errors, both yours and the typesetter's. Once corrected, a final reproduction proof, or *repro,* will be supplied and used to prepare mechanicals.

Because of all these steps, few jobs proceed smoothly from beginning to end without involving some changes. Legitimate corrections have to be made, but how do these alterations affect cost and quality?

A simple rule of thumb is: the later the corrections are made, the more expensive they become. For example, corrections made in typewritten copy cost nothing, while the same changes made at the printing stage would involve typesetting, revising mechanicals, creating new film and printing plates, and losing time on press.

Apart from cost considerations, quality could also suffer: corrections may be obvious in the final piece. For example, a type patch added at a later date may appear darker or lighter than its surrounding text.

When changes do occur, they are usually costly and someone has to pay for them. Corrections can be classified by two simple terms: *Author's Alterations* and *Printer's Errors,* more commonly referred to as *AA's* and *PE's* (1).

AA's involve any changes made by the client in the manuscript or in the job after it has been submitted. This also includes errors made by the typesetter or printer that you approved and later found to be incorrect. For this reason, time spent in careful preparation, proofreading, and supervision will reduce or eliminate costly corrections.

PE's refer to those errors made by the designer (or the typesetter, printer, or supplier) not in compliance with the client's copy or explicit instructions. These errors, although not the responsibility of the client, must be immediately brought to the designer's attention. The earlier an error is recognized, the more quickly it can be rectified in a cost-effective manner.

Any alterations that affect the cost of the job should be negotiated as soon as they arise. The outcome should then be confirmed in writing. In this way disagreements or cost issues will not delay a project or spoil a working relationship.

POSITION		PUNCTUATION	
⌐	MOVE RIGHT	⊙	INSERT PERIOD
⌐	MOVE LEFT	⌃	INSERT COMMA
‖	ALIGN VERTICALLY	:	INSERT COLON
=	ALIGN HORIZONTALLY	;	INSERT SEMICOLON
⊐⊏	CENTER	?	INSERT QUESTION MARK
fl.l.	FLUSH LEFT	!	INSERT EXCLAMATION MARK
fl.r.	FLUSH RIGHT	=/	INSERT HYPHEN
tr.	TRANSPOSE (USED IN MARGIN)	⌄	INSERT APOSTROPHE
∼	TRANSPOSE (USED IN TEXT)	⌄⌄	INSERT QUOTATION MARKS
		⊥N	INSERT 1-EN DASH
STYLE OF TYPE		⊥M	INSERT 1-EM DASH
ital.	ITALIC (USED IN MARGIN)	(/)	PARENTHESES
—	ITALIC (USED IN TEXT)	[/]	BRACKETS
b.f.	BOLDFACE (USED IN MARGIN)		
∼	BOLDFACE (USED IN TEXT)	**PARAGRAPHING**	
sc.	SMALL CAPS (USED IN MARGIN)	⊓	INDENT 1 EM
=	SMALL CAPS (USED IN TEXT)	¶	PARAGRAPH
rom.	ROMAN TYPE	no ¶	NO PARAGRAPH
caps.	CAPS (USED IN MARGIN)		RUN OVER TO NEXT LINE
≡	CAPS (USED IN TEXT)	*runover*	(USED IN MARGIN)
c.+sc.	CAPS AND SMALL CAPS (USED IN MARGIN)	⟶	RUN OVER TO NEXT LINE (USED IN TEXT)
≡	CAPS AND SMALL CAPS (USED IN TEXT)	*run back*	CARRY BACK TO PRECEDING LINE (USED IN MARGIN)
lc.	LOWER CASE (USED IN MARGIN)	⟵	CARRY BACK TO PRECEDING LINE (USED IN TEXT)
lc	LOWER CASE (USED IN TEXT)		
		DELETE AND INSERT	
MISCELLANEOUS		*l*	DELETE
⊗	DIRTY OR BROKEN LETTER	⟲	CLOSE UP AND DELETE
copyout	SOMETHING OMITTED — SEE COPY	*stet.*	LET IT STAND (USED IN MARGIN)
Au.? ⑦	QUESTION TO AUTHOR	LET IT STAND (USED IN TEXT)
sp	SPELL OUT		
A.A.	AUTHOR'S ALTERATIONS	**SPACING**	
P.E.	PRINTER'S ERRORS	#	INSERT SPACE
		⌣	CLOSE UP
		eq #	EQUALIZE SPACE

1

1 Proofreaders' marks are a standard set of symbols used by copywriters, proofreaders, editors, and designers to convey information to the typesetter in a clear and precise manner.

Checking Mechanicals

After the design is approved, mechanicals must be prepared by the designer. When the mechanicals are completed, you must carefully inspect them, as any errors, inaccuracies, or omissions will be reflected in the final piece.

The designer will have you initial or "sign-off" all the mechanicals and artwork. This will give you the opportunity to inspect and approve all the artwork and mechanicals before they are submitted for printing. Once approved, however, the designer is technically not at fault for typos and other mistakes that may be uncovered at a later date. No better reason can be given to inspect the mechanical boards carefully!

This is a "last chance" to be absolutely sure that every element of the job is included and in the proper sequence. Be certain that captions, credits, charts, folios, and other details have not been omitted. Check also that nothing is transposed—which may occur all too easily when everything is in pieces on the designer's drafting table!

Mechanicals are made up of a combination of two kinds of black-and-white elements: copy that is *camera-ready* and copy that first requires special handling. (See Photographing Copy, page 105.) For copy that requires special handling, a *photostat,* or *photocopy,* is pasted in position on the mechanical and indicated "For Position Only" or "FPO." Copy requiring special handling should never be mounted directly on the mechanical.

All art and photographs accompanying the mechanical should be carefully mounted and organized, clearly noting what page they belong to and what position they occupy (1). If images are to be scanned (check with printer), they should be easy to remove from their protective cover but safe from unnecessary handling.

Now examine each mechanical to see if everything is placed squarely on the board, with heads and other graphic elements in proper alignment (2). Although the designer should have been extra thorough in this inspection, it pays to check again, especially if the job comes in just under the wire.

Each board will have a tissue overlay with instructions to the printer concerning color breaks and other specifications. Since mechanicals are prepared in black-and-white, it's easy to miss an improper color indication. Check this carefully.

In short—take time. It is common for mechanicals, being the last item on a long list of procedures, to be cheated of the review they deserve. Time is usually tight, the printer is waiting, and everybody is tired. The industry is fond of saying that there is never enough time to do the job right, but always enough to do it over. A little extra effort can avoid disappointment and unpleasantness.

Once the mechanicals are completed and approved, they must be sent to the printer. If not already determined, you should decide who is going to manage the project. Either you or the designer can serve as the "general contractor" and undertake the responsibility of working with the printer.

Be aware that handling the production phase of a project can be fascinating and rewarding, but it is also time-consuming and demanding. Until you gain experience dealing with printers, it is advisable to let the designer take the responsibility.

1 Original art, such as photographs, should never be mounted directly on the mechanical. Instead, a correctly sized photostat or photocopy is made and positioned on the mechanical. This is then marked "For Position Only" or "FPO."

2 The completed mechanical should be thoroughly inspected by both the designer and client before it is sent to the printer.

winter of despair, we had everything before us, we had nothing before us, we were all going direct t Heaven, we were all going direct the other way - in short, the period was so far like the present period, that some of its noisiest authorities insisted on its being received, for good or for evil, in the superlative degree of comparison only.

of England; there were a king with a large jaw and a queen with a fair face, on the throne of France, In both countries it was clearer than crystal to the lords of the State preserves of loaves and fishes, that things in general were settled for ever.

1

Sydney Carton

"*It is a far, far better thing that I do, than I have ever done; it is a far, far better rest that I go to than I have ever known.*"

It was the best of of times, it was the worst of times, it was the age of wisdom, it was the age of foolishness, it was the epoch of belief, it was the epoch of incredulity, it was the season of Light, it was the season of Darkness, it was the spring of hope, it was the winter of despair, we had everything before us, we had nothing before us,we were all going direct to Heaven, we were all going direct the other way – in short, the period was so far like the present period, that some of its noisiest authorities insisted on its being received, for good or for evil, in the superlative degree of comparison only

There were a king with a large jaw and a queen with a plain face on the throne of England; there were a king with a

Lucy Manatte

"*It may be too late, I don't know, but let it not be a minute later*"

large jaw and a queen with a fair face, on the throne of France. In both countries it was clearer than crystal to the lords of the State preserves of loaves and fishes, that things in general were settled for ever.

12

13

2

CHECK COLOR BREAKS, IF ANY

IMAGES SHOULD BE PROPERLY CROPPED AND IN CORRECT POSITION

CHECK ALIGNMENT OF ALL TYPE AND IMAGES

CHECK DISTANCE BETWEEN CROP MARKS TO CONFIRM PAGE SIZE

CHECK FOLIOS

BE SURE TO INCLUDE ALL PHOTOGRAPHS AND NECESSARY ART WITH MECHANICALS

INSPECT TYPE TO BE CERTAIN ALL CORRECTIONS WERE MADE

Once the approved mechanicals are delivered to the printer, they will then be photographed onto film, and an inexpensive paper proof, called a *blueprint,* will be made from this film (1).

The term blueprint is derived from the overall color of the proof—which ranges in value from light blue, representing white, to deep blue, representing black. If the job involves full-color images, color proofs will be supplied along with, or instead of, blueprints. (See Color Proofing, page 115.) Once again, approvals will be required.

When inspecting a blueprint you should be diligent, as this is the final review before the job goes to press (2). Clearly mark every correction or flaw and then sign the proof. This will authorize the printer to proceed with the job, send it to the binder, and arrange delivery.

As mentioned earlier, corrections at this late stage are costly and should be kept to an absolute minimum. Late changes will involve setting type or altering images so that the mechanical can be repaired by shooting new films and remaking the blueprints.

1

THIS IS THE LAST CHECK FOR ERRORS IN THE COPY.

INDICATE ANY BROKEN LETTERS.

MAKE CERTAIN TRIM SIZE IS CORRECT.

CHECK PAGE SEQUENCE AND NUMBERS.

BE CERTAIN ALL IMAGES ARE CORRECTLY POSITIONED.

CHECK IMAGES FOR PROPER CROPPING.

CHECK TYPE AND IMAGES FOR ALIGNMENT.

BE CERTAIN THAT IMAGES ARE NEITHER FLOPPED NOR UPSIDE DOWN.

CHECK HALFTONES FOR STRAIGHT, CLEAN EDGES.

INSPECT FOR PROPER COLOR BREAKS.

CIRCLE ALL IMPERFECTIONS, SUCH AS DUST, SCRATCHES, AND SPECS.

2

1 After the mechanical has been photographed by the printer, you will receive a paper proof, called a *blueprint.* Once inspected and signed, the blueprint serves as a contract permitting the printer to proceed.

2 Using this list, review the blueprint carefully as any errors or imperfections will appear in the printed piece.

Good design can never be an off-the-shelf product, and therefore problems are bound to arise, albeit through ignorance, negligence, or incompetence. Typographical errors, equipment failure, a poor fold in a brochure, a mislabeled package, or a late delivery can all cause unforeseen hardship. When one considers the number of people involved in the average job and the chances for error, it's surprising how many jobs are trouble-free.

To avoid disasters you should be in regular contact with the designer through all phases of a project; in addition, try to be as accessible as possible since quick decisions can often avert potential problems. Be ready to alter course and make adjustments.

What actions should be taken when things go wrong? First, don't waste time assigning blame; concentrate on solving the problem. Ask the designer what should be done to rectify the situation while maintaining the delivery date. If possible, come up with alternate plans yourself. Be sure to determine if there will be any cost increases and resolve how they will be handled.

When the job is back under control, ask the designer for further details as to what caused the project to falter and how this can be prevented in the future. At times it may be advisable to pay a kill fee and hire a new designer, rather than produce unacceptable results.

Because the world of communications is man-made, every failing is the result of human error, for example, neglecting to measure the dimensions on a mechanical, or failing to check the correct spelling of someone's name. As each problem is realized and resolved, it becomes a valuable learning experience. Although mishaps may seem insurmountable when they first loom before you, dealing with them makes the next hurdle that much easier.

1 A job is like a giant puzzle made up of many pieces if one is incorrect or missing, problems arise.

After the job is completed and delivered, there remains one important task—reviewing the project. By studying the results, you can determine the strengths and weaknesses of the entire design process (1,2). There are two extremes that should be avoided when evaluating the results: being either too accepting or too demanding.

By being too accepting, you risk setting a low standard for your suppliers, which some are only too happy to accommodate. You should reject or be compensated for anything that is not according to specifications, such as wrong colors, paper, or size. Obvious quality flaws such as poor printing or trimming are also grounds for rejection. There is an expression in the industry, "You deserve what you accept." Remember this and demand what you paid for.

Being too demanding, on the other hand, can be unrealistic. While both designer and client want the absolute best, there are technical limitations which may affect the look of the final piece. For example, a designer's comp may promise more than can be delivered, such as tiny white letters dropped out of a full-color image; a printed image that has the brilliance of an illuminated transparency; or glossy blacks that have the density of a photograph. Be demanding, but be realistic.

When judging the results, bear in mind that there is a quality range that suppliers refer to as "commercially acceptable." Hopefully, your job will fall at the high end of this range; if not, the supplier should be advised of the shortcomings. In this way, future projects will be improved and you will have established your criteria for quality.

It is impossible to divorce the issue of money from the final results. The well-worn cliché "you get what you pay for" has some relevance in the design and communication field. With an unlimited budget, excellence is easy to obtain; few jobs, however, enjoy this luxury. Most projects are expected to succeed within a modest budget.

If you find the results disappointing, you may have tried to get too much for your money; next time you may have to produce a simpler job in order to maintain quality. For example, a well-printed two-color job on quality paper is far superior to a poorly printed full-color piece on low-grade stock. This is just one illustration of a practical compromise.

If you haven't done so already, this is an excellent time to reflect on the working relationship with the designer. Were you treated fairly and honestly? Were you kept abreast at every stage? How were unforeseen difficulties handled? Was the final cost as anticipated? And perhaps most significant, would you work with this designer again?

WHAT IS YOUR OVERALL IMPRESSION?

WAS THE DESIGN SUCCESSFUL?

HOW DOES THE PIECE FEEL; WHAT IS THE TACTILE QUALITY?

WAS THE PRINT QUALITY SATISFACTORY?

ARE YOU SATISFIED WITH THE COLOR?

WHAT ARE THE PIECE'S STRONGEST AND WEAKEST QUALITIES?

DID ANY TYPOGRAPHICAL ERRORS SLIP THROUGH?

HOW DID THE ILLUSTRATIONS AND PHOTOGRAPHS REPRODUCE?

1

1, 2 After the job has been printed, take time to evaluate the results. A great deal of information can be gained, which will serve you well on future jobs.

willing to take our outstretched hand and accept a place in a residential program or return to the care of relatives. **W**ithin its first year of operation, VOA's outreach teams assisted approximately 5,000 individuals to leave the terminals. **A**nd because of VOA's excellent reputation, the communities in which we work often seek us out to respond to a need that they have identified. In this way we were asked, and have agreed, to provide a comprehensive service to runaway and homeless youth in Westchester County and to develop the first parole resource center for ex-offenders. In 1988 we will begin development of our first community residence for ambulatory AIDS patients. **A**t Volunteers of America, rehabilitation means assisting the individual to successfully reintegrate into the community in a productive and meaningful role. Whether the person is a homeless alcoholic or a young man or woman from within the correctional system, VOA's supportive services assist each individual in learning and using the necessary tools for living independently. **T**he Men's Rehabilitation Center is VOA's oldest service program, dating back to 1896 when founders Maude and Ballington Booth set up their first mission on the lower east side. Originally custodial in nature, providing food, shelter, clothing and spiritual guidance, today's program is contemporary and dynamic. VOA's rehabilitation programs promote activity on the part of the clients, actively drawing them into their own recovery process. **T**ake for example the case of John, just one of our residents. **J**ohn's drinking problem began when he was only 15 years old. Idolizing the older youths in his neighborhood, John drank to be like them. Having always felt inadequate, John drank and felt accepted. And if a little was good, well, a lot was better. **F**or the next 22 years, John's drinking was a destructive influence on his life. He received reprimands in the Marines, he fought with his wife and family, and he was unable to hold down a job. At 25, John had far more responsibility than he thought he could handle. **J**ohn tried to control his drinking, but found he couldn't. His wife, who had been supportive, lost patience and asked him to leave. Without a home and without a family he felt abandoned and angry. John attempted to "bottom out," to reach the lowest point from which he could only move up, but found that his bottoms only got lower. He experienced blackouts and began to abuse drugs. **L**ike alcohol, the rehabilitation programs he sought became an addiction. John was looking for someone to take care of him. In 1987, after several suicide attempts and a drug overdose, John met a man who referred him to VOA's Men's Rehabilitation Center. **A**fter leaving yet another sobering up station, John decided to give it a try. He spoke with the director of the program and the alcohol counselor and was accepted into the program. **A**t the Men's Rehabilitation Center John became involved with Alcoholics Anonymous in meetings both inside and outside the center. He met people who were working together, reaching out and people who cared. John discovered the will to survive and stay sober. **S**heltered work programs, alcohol counseling, literacy training and housing and employment counseling support the resident in his attempt to reintegrate into the community. **R**esidents in the program work in the thrift stores, they man the trucks picking up donated clothing and furniture, they work in the kitchens and they maintain the facility. The atmosphere is supportive and each man has

At VOA's Men's Rehabilitation Center John discovered the will to survive and stay sober.

DO ALL ELEMENTS ALIGN PROPERLY?

ARE DETAILS, COLOR, AND VALUES SATISFACTORY?

IS SECOND COLOR PROPERLY ALIGNED?

IF REPRODUCTION IS MORE THAN ONE COLOR, IS IMAGE IN PROPER REGISTRATION?

IS TYPE PRINTED WITH CONSISTENT INKING THROUGHOUT?

Working Together

Respected professionals consider the ability to work together a key factor in achieving outstanding results. In this section, fourteen renown editors, copywriters, art directors, and others involved in communication design, relate insightful, first-hand accounts of their working experience in the field. While individual styles may vary, certain qualities such as trust, dedication, and mutual respect arise time and again.

Partners

I've always thought that the best designer/ client relationship is a partnership between the two. Stated in practical terms, if I have a good understanding of and access to the background and context of a problem, and if my client participates freely in the process that leads us to an answer or recommendation, chances are that, between us, we'll end up with an appropriate and effective result.

Most designers spend large portions of their careers searching for clients with whom they can share an open-ended trust relationship. Why is it so difficult to find this kind of situation? I suppose the reasons would fill volumes, but most of it seems to come down to the way two individuals get along together, the chemistry that occurs between them, and the trust and confidence that naturally develops in a positive working relationship.

I've been very lucky in my career to have had a number of excellent relationships with clients. Most of these have followed similar patterns: they have been long-term in nature; they have all produced work about which everyone involved could be proud; and they have all produced friendships that have endured beyond shared business interests.

In the end, it seems to me, it is mutual trust, openness, easy access, positive attitudes, and unselfishly shared responsibility and recognition that lead to the best kind of designer/client relationship. It is important, also, to remember that someone must make a first move to set the tone for a new relationship. To discover who that should be, take a look in the nearest mirror.

Bruce Blackburn
President
Blackburn & Associates, Inc.

1

2

1 Logo developed for de Laire, a marketer of fragrances used by major cosmetic companies.

2 The familiar NASA logo, created as part of a major governmental program.

How to Keep Art Directors in Their Place

I ought to know better than to write about art directors today because now it seems so many of them can read. But I will anyway, since most of them will be content with the headline and blurb and a glance at the illustration.

Given the fact that I have been the chief editor of more major magazines over the last quarter century than any other editor — and survived to tell about it — one might suspect that I've had the benefit of working with a number of talented art directors. One would be right. Currently, that lineup includes Herb Bleiweiss, art director, and Bruce Danbrot, design director, of *Good Housekeeping;* Julio Vega, art director of *Country Living;* and Bryan McCay, art director of *Victoria.*

A funny thing happened to me on the way to the National Magazines Awards this year — I was asked to chair the screening for the 105 entries submitted in the category of design. I was impressed by the fact that, of the five finalists in this category, two were quite new magazines: *European Travel & Life* and *New York Woman.*

My conclusion was that art direction is not just an important factor in the success of these contemporary magazines, but that it may well be the *most important* single factor.

Almost unheralded, the age of the art director has returned to magazines. Nothing else so readily conveys the purpose and concept of the magazine as its design. In the mix of elements that go into the making of a magazine, no other factor is judged so importantly by the casual reader, the dedicated subscriber, and the advertiser alike.

How can the editor get the best work from an art director? The trouble with the really talented art directors is that they go around most of the time thinking that they are the editor. It's even worse when they *don't* think so, though, because then they must be challenged to educate and inspire the rest of the editorial staff to their way of thinking and imagining. To do this, I give them awards. I give them at least half the money they want, and occasionally — at least once a year — I use one of their titles.

Living with an art director is a lot like living with a cat. They have their own agendas. They tend to set themselves above details such as schedules, house rules, and obedience to commands. With the understanding that it is their responsibility to set the standards for elegance and grace, they come and go as they please. And — if you are a very, very good editor — they will accept you as an equal and treat your judgment with a degree of respect.

John Mack Carter

John Mack Carter
Editor-in-Chief
Good Housekeeping

1 Cover for *Good Housekeeping* magazine, a publication that has served the homemaker for decades.

How to Get What You Want from Your Graphic Designer

The practice of public relations ranges over several communications disciplines. Thus, the public relations practitioner, usually functioning as a journalist, needs graphic designers to play key roles in implementing a variety of projects: annual reports, feature articles, advertorials, newsletters, corporate magazines, or literature.

Whether we labor in the field of corporate, association, or agency PR, we search continually for the "right" artists and how to get the best out of them. When we sit down with a chosen designer, it's easy to say too much or too little. How do we tell this specialist, whose mind sees images as ours sees words, exactly what we want (or think we want)? We must cover project specifications, but still give the artist creative freedom to come up with that inspired design we wordsmiths might not have imagined. Graphically speaking, that's a tall order.

No wonder, then, that most PR people search out those designers that have a track record in whatever job is at hand. Others put their full faith and trust in just one art studio, because they have learned to communicate with the studio representative, who may be more of a salesperson than an artist.

When we do a job we prefer to talk directly to the designer, and here's what we've found works best to get what we want:

• Select a designer who can show work representing a cross section of business experience. Since our clients are usually business people, our PR job is to help them achieve specific business objectives. We like designers who understand this.

• If possible, show the designer good and bad examples of previous work done for that client. See if you can get on the same wave length as to what works and what doesn't.

• Describe the target audience and objective(s).

• Cite a design budget range.

• Encourage creativity and a variety of rough sketches to show the client (if we think it's advisable).

• Keep communicating with the designer before, during, and after the project is completed. This makes good things happen, and continuity of contact keeps things on schedule. Try to avoid time crunches — the curse of the communications business.

We enjoy working with graphic designers. Writers and artists have much in common. Our philosophy in approaching business relationships with graphic designers is to be professional, courteous, informative, demanding, and above all, fair in our dealings throughout an assignment. That's how we work as a team to satisfy clients *and* our creative selves.

Dick Gibbs
CEO
Gibbs & Soell, Inc.
Public Relations

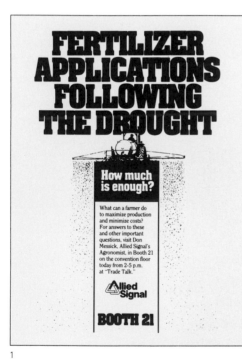

1

1 Public relations announcement for Allied Signal, created by Gibbs & Soell, Inc.

Revolution to Resolution

Young designers are attracted to the profession because they are obsessed with the desire to remake the world's artifacts into objects that look and work better. In order for this to happen, they accept the fact that they will have to work hard to sharpen their creative skills.

Creativity, at its very essence, is a confluence of isolated ideas which, of and by themselves, do not appear to belong together. When combined, they make for something no one has ever quite seen before.

To identify these disparate elements at all requires that designers spend hours learning to be keen observers and great readers. They learn how to focus on one subject to the exclusion of all others. At the same time, they learn to pay attention to all the details in the world around them that most people simply overlook.

Ideas which remain forever locked in one's head might as well never have existed at all. To get an idea down on paper with any degree of precision, designers are also forced to learn to be analytical, organized, and disciplined.

Furthermore, since meeting deadlines is the lifeblood of our craft, designers also must learn to be decisive, to make final and binding choices, good or bad.

All these qualities — being observant, organized, efficient, goal-oriented, decisive, and finally, creative and innovative — make for pretty damn good business people. When I finally realized the incredible truth that, in spite of the fact that I was "just a graphic designer," I was probably more qualified to understand and advise my clients on their business and marketing problems than most of their own staff, I began to have more success with them.

Looking back on it, I would have to say that the best work I have ever done was created for clients who I approached as a partner, a peer who treated me the same way.

Once a client realizes that the most important contribution I can make to their business is not to help them make things look better, but to help them achieve distinction, things start to click.

Distinction, by its very definition, means standing apart from those around you. Therefore it carries with it not only the burden of being ready and willing to go against the mainstream, but also the added problem of not being absolutely certain that things will work, since they have never been done before.

Achieving distinction requires a determination by a client not only to allow designers the freedom to go where no man has gone before (to coin a phrase), but actually encourages them to do so, in spite of the fact that doing so can sometimes be very uncomfortable.

Designers who aren't giving their clients some sleepless nights or an occasional burning sensation in the pit of their stomachs probably aren't helping their clients much.

The fact of the matter is that a successful designer/client relationship is not so much a result of trying to produce excellent design work, as it *is* the result of working hard together to create the conditions that allow the two to consistently produce excellent design work. And these conditions usually resemble the Russian Revolution a lot more than they do the Reagan years.

Ed Gold
Executive Art Director
Barton-Gillet

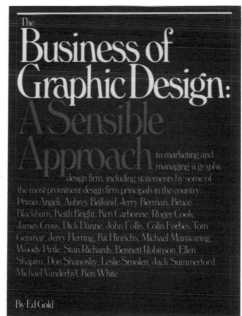

1 *The Business of Graphic Design,* Ed Gold's guide for graphic designers who wish to establish and promote their own business.

1

Odd Couples

Collaboration is a many-splendored art. It is full of surprises. Things you didn't know you knew suddenly emerge. Thoughts that whirled endlessly like a gerbil on a treadmill coalesce and plant themselves upright in your mind. And, thrill of thrills, you just never know who you're going to be. To explain.

To bring forth more than a mouse means, in a collaborative effort, exerting your ego, sometimes; submerging it, sometimes. It means argument with one partner, diplomacy with another, forcefulness with a third, givingness with a fourth.

I worked with all the great art directors who gave shape to Doyle Dane Bernbach in its glory days. Each one brought me to a new sense of myself, enlarged my vision, brought out something different in me. And each one was incredibly different to work with. There was the intense, soul-searching, squeezing-down-to-the-essence, peeling-an-idea-away-like-an-onion that was working with Helmut Krone. No pain, no gain. But when you got to this idea-nub, it was irrefutable. Nothing you could change. Ever.

With a Bill Taubin, it was Paris in the Spring. Getting there was half the fun. Ideas running out of your fingertips. If I was a Valkyrie with Helmut, I was a whimsical elegant creature with Bill. And there was nothing like the sheer delight of joining a fine mind at joyous play.

Bert Steinhauser and I combined passion and good common sense in exactly the right proportions. We built on each other's half-spoken ideas, marched many times to the same drummer. Passed copywriter and art director roles back and forth like a basketball. Together we brought Mickey Mouse to heel for Heinz and batted out more Acrilan trade ads than I care to count.

Bob Gage, now there was a mind. Warm. And Olympian. You'd spout; he'd sit. Quiet. Unmoved. A Bull Halsey waiting to unleash his incredible power. When it happened, there was a visual you'd never expect and it'd knock your socks off (or have you up all night writing to character-count!). He made you push yourself and you did. Who'd want to disappoint this magician? This master?

Run, ideas, run. Do a scribble, a thumbnail, on to the next idea and the next.

With the spontaneity of Sid Meyers, the strength of Les Feldman, the explosiveness of Rick Levine — who have I forgotten? — all wonderful sharers, doers-together.

And when I opened my own shop and went art-director hunting, I lucked into the fanatic perfectionist and ebullience that was Chuck Bua. Nobody could've done more to continue growing me. And giving our work our own look. Not DDB anymore. But the new Paula Green thing.

This work has been good to me. I've had Bernie Eckstein with his delicious humor and gorgeous graphics to carry me forward (talk about an unexpected head!). And Joe Goldberg, profound and intuitive, cutting away everything that doesn't matter. And Bill Crossan with his crisp, artful professionalism.

And did any writer ever tell you how it is to work writer-to-writer? Well, let me. It's something else. To match wits with Peggy Courtney, explore beauty and wisdom with Rita Grisman. Words flowing. Ideas clambering over each other.

And I'll tell you something else. If I had had a collaborator on this piece, it would've gotten done a lot faster! Right, Jim?

Paula Green

Paula Green
President, Creative Director
Paula Green Inc. Advertising

1 Paula Green's full-color magazine ad promoting Goya foods.

There's Nothing Better than Printing

Designers, as a group, are very much like any group of professionals. They exhibit varying levels of skill, intelligence, sensitivity, and creativity. The thing that separates them from "normal" people is that they tend to be concerned with things that most people might see but don't really think about. For example, the spacing between two letters; the way a particular paper feels; the rhythm of a book or a brochure; the quality of a coating of ink on a piece of paper — in short, they care very much about the elements of a printed piece. They have a sensitivity to the vocabulary of print. And they usually can feel the thrill of printing.

No matter how many times I've been on press, there is still something exciting about seeing ink on paper. Something satisfying about holding a finished piece, noting a good score, folding it over, and feeling that the piece "works."

Recently, we tried an unusual technique for reproducing duotones. After much discussion with the designer, and after the scans, the matchprints, the stripping, and the blueprints, I stood next to the press with the pressman and the designer/photographer. As the first sheets came down, it was immediately obvious that the technique was going to work smashingly. The crisp clean paper, the brilliant saturation of ink, the smell, and the reflection of light were all part of the experience of reproducing and hopefully adding something to the original art. I can usually share that excitement and satisfaction with my designer/client.

Of course, relatively few pieces generate that kind of excitement. But I have found that every project has an "idea." Sometimes it's a good one, sometimes not so good. But usually if a designer worked on it, there is at least one and sometimes two or three things implicit in the arrangement of elements that are critical to a design. It could be as straightforward as three lines of Bodoni italic centered on one panel; a solid red panel that has to "sing" to work; a newsletter with crisp halftones and clean black type; or a stationery project with a soft line drawing that doesn't want to get heavy.

With any project, the job of sensitive print production is first to identify and understand the critical ideas. Then to write a production plan that maximizes the chances for them to work. Because of the constraints of time and money, compromises almost always have to be made. The art of this business is to know which compromises can be made and which can't. If you're working with professionals, who understand the vocabulary of print, negotiating this journey can be exciting and very satisfying.

Michael Josefowicz

Michael Josefowicz
President
Red Ink Productions, Inc.

1 Sample page and cover from the series *The Avant-Garde in Print*, comprised of historical samples of fine printing and typography. The job demanded special colors and printing techniques in order to capture the spirit of the original art.

CCLD
3100 N. CENTRAL SCHOOL RD.
CLIFTON, IL 60927
1-815-694-2800

Poison Gas

I have always said
(arrogantly, to be sure)
that I do great work with great copywriters
(usually arrogant types),
great work with fair copywriters,
and great work with lousy copywriters.

To me, the commitment to create a piece of
work is a sworn oath that I will carry my
solution to its most *extreme* possibility.
A designer's job is to go *beyond* the request
of those who make the request.

I believe advertising can create miracles.
I believe, in fact, that advertising is poison gas.
(Lay it out there, and it should attack the ears,
nose, throat, and nervous system.)

The result that you should crave in creating
any work, any ad campaign, any promotion
piece, any package design, any corporate
symbol, any invitation to a party . . . should
be *the* emphasis in uncovering the solution.
Once that criterion is understood,
the designer must *not* accept an answer
until his instincts tell him that
what he has put on paper will result
in an explosion of communicating . . . of *selling*.

Any less ambitious thinking is simply lazy,
untalented, unacceptable.

George Lois
Chairman and Creative Director
Lois Pitts Gershon Pon GGK

1

2

1 This one-page ad splashed
Pauline Trigère's name on the
pages of major magazines and
newspapers all over America.

2 An ad designed to sell
commercial space on Manhattan's
west side. The "western" theme
was carried throughout the
campaign.

What I Have Learned from Graphic Designers: Reflections of a Book Editor

Editors are often accused — quite justifiably — of having narrow editorial bias, of believing that it is the editorial content that makes or breaks a book and that a book's design is merely the incremental embellishment of its content.

Publishing experience tells otherwise. The way a book *looks* is most often what determines whether the book buyer notices it in the first place; its content is, for all practical purposes, invisible until that book is opened. The selling seduction is so often in the design that the graphic designer is, in fact, a crucial member of the bookmaking team.

It is the editor's responsibility to have a clear idea of what the book needs to be, which is much more than knowing what the manuscript contains and how many and what kind of illustrations it will have. And knowing what the book is to become depends on a thorough knowledge of its audience's expectations, the nuances of its market. (Is its primary market a visually sophisticated one, such as design professionals? Or will the readers be older people who need large type, or younger and affluent book buyers whose reading is mostly upscale magazines, or two-year college students raised on Sesame Street?)

If it is the editor's responsibility to know these things, it is his or her duty to communicate them to the designer — as completely and clearly as possible, and, ideally, as early as possible. The designer's input can, and often does, shape the editorial content. Long before an editor transmits a project with a detailed design memo that outlines a book's parts, levels of heads and subheads, illustration program, and all exceptional design elements, the designer deserves a look at the project and a chance to know about its objectives in the marketplace.

What I have learned from working with graphic designers is that given good information, they do their work very well. They design books much better than editors can. Designers are pros at what they do, and they merit the respect that professionals are due. The respectful thing for an editor to do is to communicate a vision for a book and then walk away and let the designer carry on.

Julia Moore
Senior Editor
Harry N. Abrams, Inc.

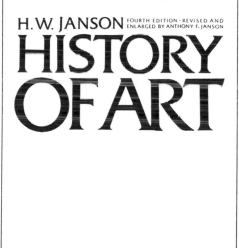

1

1 Book editors, such as Julia Moore, sometimes have the good fortune to work on classic texts; in this case, the fourth edition of Janson's *History of Art*.

How a First-Time Advertiser and an Agency Can Work Together

I share ownership of an agency with my creative partner, Walter Kaprielian. Being relatively small, we often receive inquiries from first-time advertisers. Some we can handle, some not. Their budgets usually start out anywhere between $500,000 and $1,000,000. (That's small by today's standards.)

Working with a first-time advertiser can be a great experience. Many prospects who decide they need an advertising program come with no preconceived ideas about the advertising process. This gives the agency an opportunity to do great work. Such was the case for Federal Express, when it landed its business at Ally & Gargano years ago. Or Perdue, when it checked in at the newly formed Scali, McCabe, Sloves. The campaigns created for those new advertisers went on to become "classics" and made advertising history.

We've developed some simple rules that our agency follows when starting out with new clients. When we don't follow our own advice, good intentions can end up as broken relationships.

Rule 1. Get the client to agree on a budget.
Nothing is more important than this. Not having a budget agreed upon can ruin your new relationship before you even have the chance to do any creative work. If a client cannot give you an advertising budget, beware. They are either starting off the relationship playing games or are so unknowledgeable that you won't get to first base no matter how wonderful your creative ideas are.

Explain why the costs for great photography, illustrations, or commercials are as much as they are. Also tell your client why his cousin who happens to own a Nikon will not achieve the same results as a Skrebneski, Hiro, or Ridley Scott. Go over the costs of media. Most clients are absolutely shocked when they find out what space or time costs are. Try to get your client to view the advertising budget as an investment in the future, not a cost that has to be measured week by week.

Rule 2. Let the creative person create.
This is critical to keeping your future relationship in tact. Don't cave in and let your new client write headlines or create storyboards; they won't respect you, if you

do. Many entrepreneurs love to think they can do everything. Patience is a key word, but also be firm. Yes, his input is valuable, but he must let the creative people translate that into advertising.

Rule 3. Keep your relationship with the top person.
As you help your new client's business grow, there will, undoubtedly, be new people coming on board at the client organization. It is critical to maintain contact with the top person during this phase because that new director of marketing without a question of a doubt, wants to etch his or her reputation in stone as quickly as possible. New ideas are welcome, but first examine why the "old" ones are failing, *if* they are failing. Take the new senior vice president through the history, strategies, and objectives. The smart ones will know how to work with the agency. But you must continue your tie with the top so strategies and objectives don't get lost in the translation.

There are a dozen or more pointers that I can think of that apply to the relationship. I believe the three I've just cited are the most important, but there is just one more rule that I'd like to mention and this one is for the client: If you find an agency you like, don't treat them as suppliers. Respect them as your partner. If you do, they'll make your sales take off. If they don't, call me!

Alice O'Leary
President/CEO
Kaprielian O'Leary Advertising

1

1 Ad created for the exclusive Madison Avenue shop, Davidoff.

2 By combining the bull and the bear, this full-color ad captures the attention of the would-be investor.

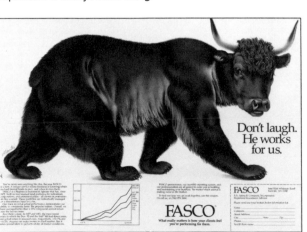

Advertising: Perception. Reality.

I've spent the last nineteen years working in a business that's ranked barely one notch above that of used car salesmen by the American public. And I've loved nearly every minute of it.

When asked to isolate an attitude that's enabled me to be successful or, as I prefer it, to be a survivor in this business, it would be this:

I've always followed my head, my conscience, and my heart (but not always in that order).

I don't sell snake oil, and I don't work for or with snakes. I don't bullshit clients, and I don't bullshit consumers. I don't ever want to not be able to look either of my thirteen-year-old daughters in the eye and not feel good about the goods or services I'm trying to sell to their best friend's parents.

Life is too short; my family time is too precious. And there's too much of my energy and soul in my work to ever abandon those principles.

It's possible to do *all* those things and still come out on top and in one piece in advertising. It's possible to be a woman, have a family, build a business, have a top-notch, well-paid staff, attract a blue-chip list of clients, do advertising that works, win top awards, and still sleep at night.

Nancy Rice
Partner
Rice & Rice, Advertising, Inc.

1

2

1 Four-color trade ad created for *Rolling Stone* magazine.

2 Black-and-white consumer newspaper ad developed for the Episcopal Ad Project.

What Do You Think?

"What do you think?" is important to the creation of any piece of communication. A piece of graphic art goes through stages of development like a living organism, and does not reach the final state of being until it is on press or running on television. However, while a piece of communication is taking form and is being created, it should always be put to the "What do you think?" test.

Since a job could call for a graphic designer, photographer, typographer, filmmaker, video designer, retoucher, or any other talented person, the thing I always keep in mind is that each of these people have a talent that I do not. A way of looking at things, the way I do not. A sense of design which differs from mine. A background of experiences which is rich with solving problems that I have never been a part of.

With this in mind, after selecting the appropriate artist for a job, I always explain my needs to the artist and interpret the feelings and needs of my client. After going over my ideas about the project, I say with absolute sincerity, "What do you think?" This question is the key to working with any creative person.

Why hire someone and then decide what you want them to do. I must clarify here that not all ideas given by the artist are acceptable. However, in the mix of responses to the question "What do you think?" there are exciting possibilities, which generate fresh looks at work that may start out one way, and end altogether differently. The result, a great-looking piece of communication, a happy client, a happy artist, and a happy art director — me.

I began my career at Scali, McCabe, Sloves. They were the people who made Perdue chickens famous. While I was there, I learned the art of "What do you think?" from people like Sam Scali, Robert Ritzfeld, and other art directors. They would put a layout in front of me, or a piece of type, and ask "What do you think?"

I also worked at a wonderful company called Doyle Dane Bernbach. I used to love to walk into the studio when the mechanicals were being prepared. Everytime I would give someone in the studio a piece of work to do, I would ask "What do you think?" They loved the involvement, and I loved the help they gave me in deciding what to do. In medical terms, this is called a second opinion.

To me, every person that handles a piece of communication, from the client who orders it to the art director who directs it, from the artists that give it life to the people in the studio who help it become a finished piece, should be asked the most magnificent words in the graphic arts, "What do you think?"

I might add in closing that it is vitally important for the graphic designer to understand the needs of the client. Believe it or not, we can learn from clients. After all, they are paying the bills, and it would be useful to ask them "What do you think?" when you are about to proceed on a job. Most clients are more than eager to let you know what they think. I like to ask this question before, during, and after the job is completed.

Now I will take a moment and call my good friend William Bevington, who asked me to write this piece, and inquire, "What do you think?"

Tony Romeo
Vice President, Associate Creative Director
Lord Einstein O'Neal & Partners

1

1 Advertising campaign utilizing bold image and clean typography to stress practicality and performance of Saab automobiles.

Don't Be a Contra

The premise of this book, "How to work with graphic designers," answers its own implied question.

To work with them you work *with* them.

Advertising art directors are generally a fussy lot, graphically speaking.

They care about little things like windows and gutters and indents and word spacing and letterspacing. Little things that many writers may not think about very often.

So if you're going to work with them, you'll spend a lot of time cutting two letters out of this line and adding a three letter word to that line and so forth.

Helmut Krone, one of the most innovative designers in the world, would spend weeks worrying over the typography of an ad. It was maddening for the writer. But usually more than worth the aggravation.

I've been very lucky. I've worked with some of the finest art directors in the business.

My partner and friend, Len Sirowitz, is naturally the first to come to mind. Then, in alphabetical order so as not to put any noses out of joint, Alan Beautikant, Kenny Duskin, Bob Gage, George Lois (briefly, but interestingly), Sid Meyers, Hal Nankin, and Bert Steinhauser.

One thing you have to remember about working with art directors in that league — the great ones, they all want to play writer. They may not admit it, but it's there.

And that's all right with me — *if they let me play art director.*

The truth is, you have to forget the labels when you work with great art directors. You must come at problems as two "idea guys" — not words and pictures.

Be loose and nonpossessive of your craft — that's the way to work.

Ron Rosenfeld
Co-Chairman
Rosenfeld, Sirowitz & Humphrey, Inc.

1, 2 Two ads from a campaign that promotes the Yugo as an alternative to expensive automobiles.

1

2

Pro Bono Work

The Cooper Union is a full scholarship, tuition-free institution of higher education. It is composed of three schools, these being art, architecture, and engineering. Within the art school is The Center for Design and Typography. This Design Center was established in 1979 to provide *pro bono* (minimal or no cost) design services to not-for-profit organizations.

Senior students work with a professional staff on projects for a wide variety of clients — from well-known institutions to storefront beginnings. I am the Director of the Design Center and the past years recall many achievements, a well as some hard-learned lessons.

The achievements have been exhibited and recognized by professional societies; the hard-learned lessons deserve to be shared in these pages.

The first lesson is that pro bono work is very hard to "sell" to a client. After all, if it is "free" it cannot be very good. This is coupled with the fact that a "free" job is in some ways similar to having an unlimited budget — clients quickly lose track of all the little changes and "extras."

The inexperienced client is usually harder to please than an organization known for its good design. In fact, some organizations in desperate need of design work are almost impossible to work for because there is no reasonable design precedent in their experience.

While the designer's responsibilities include education on behalf of good design, some cases of visual illiteracy are beyond help. Of course, "good design" is in the eyes of the beholder; hence, lack of it flourishes nicely, thank you, and includes about 90% of visual materials printed.

It is important for the designer to put a stop to round table critiques after the first or second comment. How? By explaining in detail, why any visual decision has been made. In short, the solutions have not been arbitrary; they were good, well-considered reasons by the designer for any choice of color, placement, and so forth.

Therefore, designers should not accept arbitrary suggestions based on personal dislikes or uniformed prejudices. On the other hand, legitimate comments deserve attention and corrective action. Good design direction, however, is seldom achieved by combining the suggestions of a large group — a committee has yet to design anything well.

George Sadek
Creative Director
The Center for Design and Typography
The Cooper Union

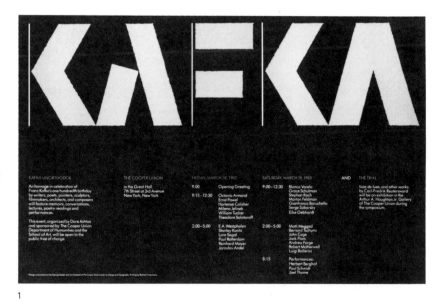

1

1 Poster/announcement for a conference on Franz Kafka given at The Cooper Union.

Personality Quiz

This quiz gives you an unqualified WYPRTOY (What your printer really thinks of you) Rating. It may provide insight into why your printing bills are so high, and may dispel the fact that printers are all out to get you.

Circle: A for Always
 S for Sometimes
 N for Never, I swear

A S N Do you ask for estimates in four quantities, in two design formats, and in 4, 5, and 6 colors?

A S N Do you send your printer swatches (for critical ink-color matches) made of cloth, wood, or dirt?

A S N Do you mark every job RUSH!, to be sure you receive the priority treatment you deserve?

A S N Have you ever folded an 8″ x 10″ chrome in half and mailed it to your printer in a 6″ x 9″ envelope without a stiffener?

A S N Have you ever asked your printer to pick up art and mechanicals at 8:00 P.M., and then called at 8:00 A.M. the next morning to ask where the proofs are?

A S N Do you ignore a printer's warning about ghosting, because you don't want to redesign the damned thing?

A S N Do you write the helpful comment "Match Art" on color proofs?

A S N Do you really believe a Scitex can fix anything?

A S N Do you send your assistant to the printer for color OKs, and then become a big-shot critic about what he or she has approved?

A S N Have you ever said to your printer: "I'm glad I reached you before you went home." "Good idea. Figure it that way, too." "I thought you included the overtime in your estimate."

A S N Do you pay your bills only at the change of seasons?

A S N Do you call your printer and ask for the photograph you used in a piece three years ago, before looking through that pile of crap in your own office?

Scoring System:
Each Yes answer earns 5 points.
Each Sometimes answer earns 3 points.
Each No answer earns 0 points.

Rating System:
Less than 20 points.
You are the salt of the earth. Printers love you. They weep at the thought of losing you.

More than 20 but less than 35 points.
Nobody's perfect. The job isn't easy and God knows, you try. Take this mediocre rating with a grain of aspirin.

35 points or more.
Look here, you sunuvabitch . . .

Norman Sanders

Norman Sanders
President of Sanders' Division
Laurel Printing, Inc.

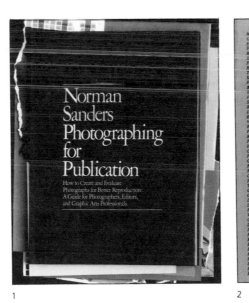

1 2

1, 2 Two excellent books on production by Norman Sanders with the goal of achieving finer results in printing.

Working with Clients

Over the years I have discovered that there are really no dependable guidelines in working with clients. They come as varied as the range of individuals in our society. Many are simply wonderful, many are terribly difficult, and most fall in-between.

The best people to work for are those who are the actual decision makers, or who are a short step away from the final decision makers. The strongest (or the weakest) link in a client relationship is the person you are working with directly.

In my experiences, I have found that corporations and public companies are somewhat easier to work with than single proprietors or businesses that are controlled by an entrepreneur.

I try to prepare each project very carefully and leave little to chance. By prejudging the reactions of a client to a given series of solutions, I can anticipate those reactions and be ready with answers if there are any problems.

There is a certain loyalty and pay back loyalty that I thrive on, with all sorts of extras that are not billable — such as offering advice and counsel on far-ranging subjects. Some of my relationships with clients go back to the beginning of my career. I have been able to follow good clients from business to business as their careers change. I have also been able to survive within corporations, even as people come and go.

Besides the obvious requirement of creating and producing the best possible work for any assignment, big or small, the second most important element in a designer-client relationship is honesty about what you produce and how you go about it. Being quietly honest may burn you occasionally, but in the long term you are the winner.

Arnold Saks
President
Arnold Saks Associates

1

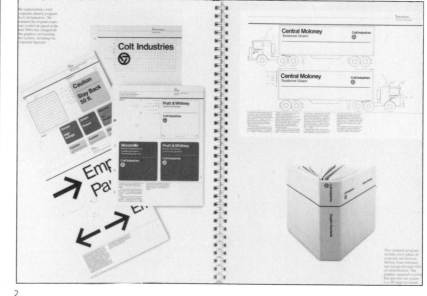

2

1 Cover for the well-known Swiss annual collection of international graphics.

2 Sample pages from the design manual created for Colt Industries.

How to Do Great Work and Like the Client in the Bargain

You've heard it before — advertising would be a great business if only it weren't for clients. Often we believe that we know better than they do . . .that if they'd only leave us alone we'd do some great work for them. Well, sometimes that's the case, but, more often than not, great advertising and communication design is done for clients who understand advertising and the creative process, and they encourage and demand the very best.

It all starts with the client's product, the intended consumer for the product, and the client's opinion of himself and his customers. As they say in the world of computers, "garbage in, garbage out." All it takes is a keen look around the contemporary world of advertising to pick out the great work and the great clients.

Of course, everything's relative. Take any product category — mass consumer products or narrow specialty products — and you will see a quality pecking order from the least expensive and lowest quality to the most expensive and highest quality. The advertising and promotion of a product will reflect three things: 1. the quality of the product; 2. the socio-economic and psychographic profile of the intended consumer, and; 3. the opinion of the client, including a fair indication of his attitude toward his intended consumer. Oh yes, the media in which it will be advertised will tell you a lot, too. Guaranteed. Try it yourself. It's a fascinating and educational analysis.

What's all this got to do with creating great advertising? Everything. Assuming you've got the talent, the smarts, and a real understanding of the product and its intended user, you'll never do great work — or even good work — for a client who doesn't appreciate it, or doesn't know what good is. In other words, you'll be only as good as your client allows you to be. Every year, as part of the awards presentation for the Art Directors Club in New York, we honor a company or person at such a company who has consistently supported — nay, demanded — first-rate advertising and communication design over the years. Those are the people and companies you'll want to work for if you want to do great work.

Water seeks its own level, they say. And so will talent. So if you want to do great work, do it for a great client — or teach him to be one. Consider Somerset Maugham's point of view — when you refuse to accept anything but the best, you very often get it.

Karl Steinbrenner

Karl Steinbrenner
President
Steinbrenner Associates Communications

1

1 By combining a hand grenade with a sprig of holly, an effective image was created to announce an NBC special program entitled, "Christmas In Vietnam."

Basic Typography

One of the fundamental tools of graphic design is typography, the art of designing with type. Virtually all visual communication involves some use of the printed word. Despite this fact, type is often mishandled because the importance of good typography is overlooked or simply misunderstood, resulting in poor communication and unread messages.

Although a designer may spend a lifetime mastering the art of typography, it is not difficult to understand the basics. A familiarity with the rules of typography, type terminology, and typefaces will give you confidence when dealing with graphic designers and greater control over the finished piece.

Typefaces

A typeface refers to a specific design of an alphabet. Every typeface has a name. In many cases the typeface is named after its designer, for example: *Garamond, Caslon, Baskerville, Bodoni,* and *Frutiger.* Other typefaces are named for countries, *Helvetica* and *Caledonia;* magazines or newspapers, *Century* and *Times New Roman;* or simply a name that appealed to the designer, *Futura, Broadway,* and *Souvenir* (1).

To most people all typefaces look pretty much the same. Differences can be subtle; often, it is no more than a slight variation in the design of a single stroke. However, by learning what to look for, you will find that typefaces vary a great deal.

At first you will only be able to identify typefaces by their more obvious individual characteristics such as the shape of a particular letter (2). As your eye becomes better trained, you will recognize typefaces by the texture they create on the printed page. For example, Garamond is "quiet" and elegant while Bodoni tends to sparkle.

Despite the wide variety of typefaces available, you will find that most designers prefer to work with only a dozen or so. (See pages 77–101 for specimens of some well-designed, popular typefaces.)

Garamond

Caslon

Baskerville

Bodoni

Frutiger

Helvetica

Caledonia

Century

Times Roman

Futura

Broadway

Souvenir

1

g	g	g
GARAMOND	CASLON	BASKERVILLE
g	g	g
BODONI	FRUTIGER	HELVETICA
g	g	g
CALEDONIA	CENTURY	TIMES ROMAN
g	g	g
FUTURA	BROADWAY	SOUVENIR

1 Typefaces acquire their names from many sources: some are named after the designer, others for a country or place, while still others are simply names that appealed to the designer.

2 Differences in type design can be subtle or obvious; by comparing single letters, you will begin to understand what makes each typeface unique.

Although we are surrounded by the printed word, we are seldom aware of the subtleties of typography. When reading we take little notice of the typeface and type arrangement—this is as it should be since type is merely a vehicle to communicate a printed message.

However, if you wish to have an active role in how your message is seen and read, an understanding of typography is essential. The following are some terms used by graphic designers when working with type (1).

Roman. The upright letterforms derived from roman characters. The type you are now reading is roman. Roman is the easiest and most comfortable type style to read.

Italic. Letterforms that slant to the right; they are used mainly for emphasis, as a companion to the roman. *These words are in italic.*

Characters. The name given to individual letters, figures, and punctuation.

Uppercase. The capital letters which are indicated *U.C.,* also referred to as *Caps* or simply *C*. The term derives from the early days of handset type when capital letters were stored in the upper portion of the typecase. The small letters were kept in the lower portion and called *lowercase.*

Lowercase. The small letters which are indicated *lc.* When combined with uppercase, they are indicated *U/lc* or *C/lc.*

Baseline. An imaginary line on which all the characters of a given line stand.

Meanline. An imaginary line that marks the top of most lowercase letters, such as *a, c, e, i,* and especially *x.*

Ascender. The part of a lowercase letter, such as the strokes on the letters *b, d,* or *h,* that rise above the meanline.

Descender. The part of a lowercase letter, such as the strokes on the letters *p, y,* or *g,* that fall below the baseline.

Counter. The enclosed spaces within a letterform, such as the bowl of the letters *b, d,* or *p.*

x-Height. The height of the body, or main element, of the lowercase letterform, which falls between the meanline and baseline. It is the height of a lowercase *x.*

Serif. The short stroke that projects from the end of the main stroke.

Serif typefaces. Traditionally referring to those typefaces having classical serifs (2).

Sans serif typefaces. Not all typefaces have serifs; typefaces without serifs are called sans serifs (3).

Slab serif typefaces. Typefaces with heavy serifs and little contrast between thick and thin strokes. Designed to attract attention, slab serifs are widely used in advertising. Also called *Egyptian* (4).

Script typefaces. Typefaces resembling handwritten forms. They can vary from formal scripts to free flowing brushstroke styles (5).

1 Before beginning to work with type, you should be familiar with the basic terminology.

2, 3, 4, 5, 6 Although there are thousands of typefaces, most can be categorized as being either serif, sans serif, slab serif, script, or decorative.

ROMAN ITALIC COUNTER ASCENDER MEANLINE
60 POINTS SERIF DESCENDER BASELINE
UPPERCASE LOWERCASE

1

Decorative typefaces. A general term that describes a wide range of display typefaces that are primarily ornamental or unorthodox in style (6).

Font. Traditionally, all the characters of one size and of one typeface. Today, the term is used loosely, for it can also refer to all the sizes of one specific typeface.

Ligatures. Two or more characters joined as a single letterform, such as *fi, ffi,* or *ffl.* Ligatures are a refinement, common with traditional typography; today, they are the exception rather than the rule.

Modern figures. Also called *lining figures.* Numerals the same height as capitals: 1, 2, 3, 4, 5, 6, 7, 8, 9, 0. Since they are designed to align in tabulation, Modern figures are most often used for annual reports, charts, and tables.

Old Style figures. Also called *nonlining figures.* Numerals that vary in height, some having ascenders or descenders: 1, 2, 3, 4, 5, 6, 7, 8, 9, 0. Old Style figures are primarily used when less obtrusive numerals are required, such as within a text. Only a small percentage of typefaces possess Old Style figures.

Small caps. A complete alphabet of capitals that are the same size as the x-height of the typeface. Abbreviated as *sc,* small caps are often used in place of all-capital words or abbreviations which tend to overpower the surrounding text. Most typefaces do not offer small caps.

Serif
2

Sans serif
3

Slab serif
4

Script
5

Decorative
6

X-HEIGHT SMALL CAPS LIGATURE MODERN FIGURES OLD STYLE FIGURES

Many typefaces are available in a wide range of styles, designed to accommodate the diverse needs of the graphic designer; this is especially true concerning display type. Most are based on varying the weight (1) or width (2) of the letterforms or a combination of both (3). Although some typefaces are available in a variety of styles, the majority are limited to roman, italic, and bold.

When all styles and sizes of a given typeface are combined, the result is a *family of type.* Using typefaces from within the same family gives the printed piece a unified appearance, as all share the same characteristics.

Regular. The standard weight of a typeface; also referred to as *normal.*

Light. A lighter, or thinner, version of the regular weight. An extremely light version is often referred to as *thin.*

Bold. A heavy version of the regular weight. Among the various bold designations are *semibold, heavy, black, extrabold,* and *ultra.*

Condensed. A narrow version of the regular typeface; also referred to as *compressed* or *compact.*

Extended. An expanded version of the regular typeface.

1, 2, 3 Typefaces are often available in varying weights, widths, or combinations of both. This offers the designer flexibility in the creative process.

Thin
Light
Regular
Semibold
Bold
Extrabold
1

Condensed
Extended
2

Light Condensed
Semibold Condensed
Bold Extended
3

With hundreds of typefaces available, selecting the right typeface can be difficult. To simplify the matter, the following historical classifications for serif typefaces will be helpful: *Old Style, Transitional,* and *Modern.*

The major characteristics that distinguish one serif typeface from another are variations in stress, serifs, and the contrast between thick and thin strokes. These characteristics can be understood by examining three popular serif typefaces: *Garamond, Baskerville,* and *Bodoni* (1).

Garamond, which was designed around 1615, is a typical Old Style typeface. Garamond has heavily bracketed serifs, an oblique stress, and very little contrast between the thick and thin strokes.

Baskerville, designed in 1757, is an excellent example of a Transitional typeface, so-called because it forms a bridge between the Old Style and Modern typefaces. Compared to the Old Style, Baskerville shows greater contrast between the thick and thin strokes, the serifs are less heavily bracketed, and the stress is almost vertical.

Bodoni, designed in the late eighteenth century, is called a Modern typeface. Bodoni has an extreme contrast between the thick and thin strokes, virtually unbracketed serifs, and a strong vertical stress.

In addition to the characteristics noted above, you will also find that the x-height varies among the three examples, despite the fact that they are set in the same size.

Old Style
Transitional
Modern

1

1 Understanding the characteristics of historical typefaces and how type design evolved will give you a basis upon which to judge all typefaces, as well as assist you in selecting the most appropriate typeface for a particular job.

There are two important terms designers use when specifying type: *points* and *picas*. Points are used to measure the type size, while picas are used to measure the line length. The line length is also referred to as the *measure*. There are 12 points to a pica and 6 picas to an inch (1).

The system of type measurement goes back hundreds of years and is based on metal type (2). However, for our purpose it is sufficient to think of the point size as the measurement from the top of the ascender to the bottom of the descender, plus a small amount of space above and below to prevent the characters from touching when set (3). The type you are now reading is 9 1/2 point *Frutiger 45*.

Type sizes are traditionally divided into two basic categories: *text* and *display*. Text type refers to the smaller sizes up to 14 point, while display type covers all sizes above 14 point (4).

The only sure way to establish the type size of a printed piece is to compare it to a sample from a type specimen book. This is necessary because type size refers to the traditional metal type blocks upon which the characters are cast, and not the size of the printed letter. For this reason, measuring a printed letter will not give you the point size of the type in question.

It should also be noted that while points are used to measure and specify type, it is the x-height that conveys the illusion of type size (5). Therefore, typefaces in the same point size may appear larger or smaller because of variations in the x-height.

6	abcdefghijklmnopqrstuvwxyz
7	abcdefghijklmnopqrstuvwxyz
8	abcdefghijklmnopqrstuvwxyz
9	abcdefghijklmnopqrstuvwxyz
10	abcdefghijklmnopqrstuvwxyz
11	abcdefghijklmnopqrstuvwxyz
12	abcdefghijklmnopqrstuvwxyz
14	abcdefghijklmnopqrstuvwxyz
18	abcdefghijklmnopqrstuvwxyz
24	abcdefghijklmnopqrstuvwxyz
30	abcdefghijklmnopqrstuvw
36	abcdefghijklmnopqrst
42	abcdefghijklmnop
48	abcdefghijklmno
60	abcdefghijkl
72	abcdefghij

4

1 The two basic units of measurement in typography are points and picas. Although a single point is quite small, it does make a difference in terms of readability.

2 Type sizes are based on the body size of metal type. Although metal type is rarely used today, the measurement system remains.

3 Type can also be measured baselineto-baseline, providing no additional space has been added between the lines.

4 Although type can be set in virtually any size, this illustration shows the traditional sizes of both text and display type.

5 The three type specimens shown are all 72 point, but the x-height makes them appear to vary in size.

72 POINTS

Bqx Bqx Bqx

5

Picas are used to measure the length of a line of type. The type you are now reading is set on a measure of 14½ picas with an average of forty characters per line.

Line length should be determined by both aesthetics and readability. While newspapers and periodicals may set type in short lines of approximately twenty-five characters (1), the ideal line length for readability is around forty characters (2), with novels running closer to seventy (3).

1 Short lines of approximately twenty-five characters are often used in newspapers and magazines for rapid reading.

2, 3 Longer lines ranging from forty to seventy characters are ideal for lengthy reading. Lines that are longer than this, however, can inhibit comfortable reading.

It was the best of times, it was the worst of times, it was the age of wisdom, it was the age of foolishness, it was the epoch of belief, it was the epoch of incredulity, it was the season of Light, it was the season of Darkness, it was the spring of

1

It was the best of times, it was the worst of times, it was the age of wisdom, it was the age of foolishness, it was the epoch of belief, it was the epoch of incredulity, it was the season of Light, it was the season of Darkness, it was the spring of hope, it was the winter of despair, we had everything before us, we had nothing before us, we were all going direct to Heaven, we were all going direct the other way — in short, the period was so far like the present period, that some of its noisiest authorities insisted on its being received, for good or

2

It was the best of times, it was the worst of times, it was the age of wisdom, it was the age of foolishness, it was the epoch of belief, it was the epoch of incredulity, it was the season of Light, it was the season of Darkness, it was the spring of hope, it was the winter of despair, we had everything before us, we had nothing before us, we were all going direct to Heaven, we were all going direct the other way — in short, the period was so far like the present period, that some of its noisiest authorities insisted on its being received, for good or for evil, in the superlative degree of comparison only. There were a king with a large jaw and a queen with a plain face, on the throne of England; there were a king with a large jaw and a queen with a fair face, on the throne of France. In both countries it was clearer than crystal to the lords of the State preserves of loaves and fishes, that things in general

3

When setting type, it is possible to vary the amount of space between lines; this is referred to as *linespacing* or *leading* and is measured in points and half points. (The term *leading* is derived from metal type terminology when actual lead pieces were inserted between lines of type to space them apart.) When no linespacing is added, the type is said to be set *solid* (1).

With most typefaces, readability is improved with the addition of some linespacing. For example, 9 point Garamond with 2 points of linespacing is referred to as "nine on eleven" and is written 9/11. The first figure represents the type size, and the second figure is the type size *plus* the linespacing (2).

It is also possible to specify minus or negative linespacing, where the baseline-to-baseline measurement is less than the type size, for example, 9/8 Garamond. Minus leading is common with display sizes but is seldom specified for text (3).

1 Type set with no additional space between lines is referred to as *solid*.

2 Most typefaces are more readable when one or more points of linespacing have been added. The sample shown here has been set with one point additional linespacing.

3 Type can also be set with minus linespacing; this reduces the space between the lines, making it denser than type set solid. The drawback with setting type in this manner is that letters may touch and readability may suffer.

It was the best of times, it was the worst of times, it was the age of wisdom, it was the age of foolishness, it was the epoch of belief, it was the epoch of incredulity, it was the season of Light, it was the season of Darkness, it was the spring of hope, it was the winter of despair, we had everything before us, we had nothing before us, we were all going direct to Heaven,
1

It was the best of times, it was the worst of times, it was the age of wisdom, it was the age of foolishness, it was the epoch of belief, it was the epoch of incredulity, it was the season of Light, it was the season of Darkness, it was the spring of hope, it was the winter of despair, we had everything before us, we had nothing before
2

It was the best of times, it was the worst of times, it was the age of wisdom, it was the age of foolishness, it was the epoch of belief, it was the epoch of incredulity, it was the season of Light, it was the season of Darkness, it was the spring of hope, it was the winter of despair, we had everything before us, we had nothing before us, we were all going direct to Heaven,
3

Letterspacing and Word Spacing

As the word implies, letterspacing refers to the space between letters and can be adjusted to accommodate the designer's needs. Letterspacing can be specified with the following general terms: *normal, tight,* or *very tight* (1). If a designer does not specify a preference, the copy will be set normal.

Word spacing refers to the space between the words. As with letterspacing, it is adjustable and specified with the same terms. Generally speaking, letterspacing and word spacing are set compatibly—if the letterspacing is set tight, the word spacing should also be set tight.

The terms used for letterspacing and word spacing are relative and may vary from one system or typesetter to another.

1 Letterspacing and word spacing can drastically effect readability. Before turning a job over to the typesetter, it is good practice to review some type samples set with varying amounts of spacing. Most type is set either normal or tight.

It was the best of times, it was the worst of times, it was the age of wisdom, it was the age of foolishness, it was the epoch of belief, it was the epoch of incredulity, it was the season of Light, it was the season of Darkness, it was the spring of hope, it was the winter of despair, we had everything before us, we had nothing before us, we were all going direct to Heaven, we were all going direct the other way — in short, the period was so far like the present period, that some of its noisiest authorities insisted on its being received, for

NORMAL SPACING

It was the best of times, it was the worst of times, it was the age of wisdom, it was the age of foolishness, it was the epoch of belief, it was the epoch of incredulity, it was the season of Light, it was the season of Darkness, it was the spring of hope, it was the winter of despair, we had everything before us, we had nothing before us, we were all going direct to Heaven, we were all going direct the other way — in short, the period was so far like the present period, that some of its noisiest authorities insisted on its being received, for good or for evil, in the

TIGHT SPACING

It was the best of times, it was the worst of times, it was the age of wisdom, it was the age of foolishness, it was the epoch of belief, it was the epoch of incredulity, it was the season of Light, it was the season of Darkness, it was the spring of hope, it was the winter of despair, we had everything before us, we had nothing before us, we were all going direct to Heaven, we were all going direct the other way — in short, the period was so far like the present period, that some of its noisiest authorities insisted on its being received, for good or for evil, in the superlative degree of comparison only.

VERY TIGHT SPACING

1

With so many typefaces available, one of the most common questions asked by the layman is, "How do you choose a good typeface?" Making a decision goes beyond aesthetics—designers base their choice on many considerations.

Two major factors are *legibility* and *readability.* Legibility is dictated by the design of the individual characters, how well they fit together, and our familiarity with the letterforms (1). Readability is what the designer does with the type to make the copy easy to read, and is affected by choice of type size, line length, letterspacing, word spacing, and linespacing.

Choice of typeface is also dictated by the amount of copy. Lengthy copy, which requires prolonged reader attention, is usually handled conservatively to aid in reading comfort. For this reason most novels are set with traditional typefaces which are designed for extensive reading, such as Baskerville or Garamond, in single, justified columns.

On the other hand, short amounts of copy, such as captions, blurbs, or headlines, offer the designer more flexibility in typeface selection. Because of the brevity of such material, the reader will tolerate more diversity in type style as well as size and arrangement.

The nature of the message may also determine the choice of typeface, especially when used for display purposes. Type is often used to create a mood; for example, the typeface used to advertise lingerie would probably be inappropriate to advertise industrial equipment. Finding an appropriate display face should not present a problem, as there are far more display typefaces than text typefaces.

In addition to the typeface being suitable for the product, it should be appropriate for the audience. Readers of classical literature are more comfortable with serif typefaces than sans serif. If the reader is either very young or very old, you should choose a simple, well-designed typeface in a large text size, such as Century Expanded.

When working with type, it is recommended that you utilize as few typefaces as possible. Mixing too many typefaces or styles, is distracting and has a negative impact on readability (2). As you become more familiar with type, you can experiment while still maintaining readability.

Selecting an appropriate typeface does not guarantee the desired outcome. Although the right typeface is critical, good design is equally important to maintain readability.

1 Good design begins with a well-designed typeface; in order to be legible, the letterforms must work together and be familiar to the reader. The samples shown here are all well-designed, however they vary in familiarity.

2 By trying to emphasize too many words, even a well-designed typeface can be difficult to read

1

It was the **best of times,** it was the WORST OF TIMES, it was the *age of wisdom*, it was the **age of foolishness,** it was the EPOCH OF BELIEF, it was the **epoch of incredulity,** it was the *season of Light*, it was the **season of Darkness,** it was the SPRING OF HOPE, it was the **winter of despair,** we had EVERYTHING BEFORE US, we had NOTHING BEFORE US, we were all going direct to **Heaven,** we were all going direct **the other way**

2

Type Arrangements

There are five basic ways of arranging lines of type on a page. The first method is to set all the lines the same length so that they align both on the left and on the right. This is referred to as *justified* type and is the most common method of setting type (1). It is ideal for lengthy reading as the even lines create a quiet shape on the page, which is conducive to reading comfort.

The other common method of setting type is *flush left, ragged right;* the style you are now reading (2). Among the advantages of this method are even word spacing and visual interest. Type can also be set *flush right, ragged left* (3). This arrangement is generally considered more difficult to read and should be restricted to short amounts of copy, such as captions.

Another way to arrange type is *centered,* in this case both the left and the right sides are equally ragged (4). While this gives the page a sense of dignity, readability suffers due to the difficulty of finding the beginning of each new line. Centered type arrangements are popular for invitations.

Perhaps the most dramatic type arrangement is the *random* or *asymmetric* format. In such an arrangement, the type shows no predictable pattern in line length or placement (5). Random type arrangements are most conducive to short amounts of copy, such as titles, blurbs, or advertisements.

1 Justified type is the most widely used type arrangement. As all the lines are the same length, the margins are even and the page assumes a quiet look.

2, 3 Type set with lines of varying length, and even wordspacing, is referred to as unjustified type. Flush left, ragged right is commonly used and easy to read. Flush right, ragged left, on the other hand, is far more difficult to read and used primarily for captions.

4 Centered type is used primarily for short amounts of copy, such as display heads, invitations, and blurbs.

5 Random type arrangements have no predictable pattern in length or placement, but offer wide design possibilities for short amounts of copy.

It was the best of times, it was the worst of times, it was the age of wisdom, it was the age of foolishness, it was the epoch of belief, it was the epoch of incredulity, it was the season of Light, it was the season of Darkness, it was the spring of hope, it was the winter of despair, we had everything before us, we had nothing before us, we were all going direct to Heaven, we were all

1

It was the best of times, it was the worst of times, it was the age of wisdom, it was the age of foolishness, it was the epoch of belief, it was the epoch of incredulity, it was the season of Light, it was the season of Darkness, it was the spring of hope, it was the winter of despair, we had everything before us, we had nothing before us, we were all going

2

It was the best of times, it was the worst of times, it was the age of wisdom, it was the age of foolishness, it was the epoch of belief, it was the epoch of incredulity, it was the season of Light, it was the season of Darkness, it was the spring of hope, it was the winter of despair, we had everything before us, we had nothing before us, we were all going

3

It was the best of times, it was the worst of times, it was the age of wisdom, it was the age of foolishness, it was the epoch of belief, it was the epoch of incredulity, it was the season of Light, it was the season of Darkness, it was the spring of hope, it was the winter of despair,

4

It was the best of times, it was the worst of times, it was the age of wisdom, it was the age of foolishness, it was the epoch of belief, it was the epoch of incredulity, it was the season of Light, it was the season of Darkness, it was the spring

5

A well-designed piece not only maintains a fine balance between type and images, but also demonstrates concern for the "white space" that surrounds these elements. This space has been compared to the silence between notes in a musical score; without which the music would simply become noise.

Unfortunately, there is no formula to determine the ideal amount of white space. One design may succeed with little white space, while another may be more effective with a single word or image surrounded by an expanse of white space (1).

Designers and their clients often perceive white space from different points of view. Designers see this space as critical to the integrity of the design, a necessary ingredient which allows the design to breathe. Clients, on the other hand, often see white space as an unused area and the perfect opportunity to add copy or increase the size of an image.

Should there be a conflict with the designer concerning the use of white space, it is not a bad idea to defer to the artist's judgment—providing all your other criteria have been met. By compromising on white space, you run the risk of sacrificing the quality of the design.

1 The ideal use of white space can create controversy between the designer and the client. Shown here are three examples in which designers used varying amounts of white space to solve a design problem. It is interesting to note that all three designs employ about the same amount of copy.

omega at one time was the last letter of the Greek alphabet. The semetic form of the letter may be derived from an earlier form representing an eye. The Greeks of Miletus in adapting the semetic alphabet used the letter to express the long O sound. The symbol omega is related to omicron, which represents the modern day O. Omicron stands for the little o (micro), while omega stands for the big O (mega). Omega may be the last letter of the Greek alphabet, but it definitely is not the least. Translated it means the $Great$ O. Figuratively, it is the end or last of anything. The omega point refers to a point which is the divine end, or God, towards which evolution is moving. Omega at one time was the last letter of the Greek alphabet. The semetic form of the letter may be derived from an earlier form representing an eye. The Greeks of Miletus in adapting the semetic alphabet used the letter to express the

1

If you study a well-designed page, you will probably be impressed by its simplicity and how tastefully the type, images, and white space relate to one another. To achieve this the designer frequently uses a grid.

A grid is a series of horizontal and vertical guidelines which assists the designer in arranging type and illustrations so they can be presented to the reader in an organized and aesthetic manner. Grids are most useful for designing projects of more than one page, such as books, magazines, catalogs, and annual reports.

The design of the grid is determined by factors such as size, amount of type, number and nature of illustrations, and the desired look of the piece.

To create a grid the page is divided into columns. While any number of columns may be utilized, one-, two-, or three-column grids are the most common (1). The one-column grid is a simple format often utilized for novels, while two- and three-column grids are commonly used for advertisements and magazines.

Readability is a major consideration when developing a grid. The number of characters per line will have a profound effect on reading comfort. Although a three-column format may look appealing, readability may dictate a one- or two-column layout.

Images, unlike type, are usually more adaptable to the grid. In most cases they can be enlarged, reduced, or cropped to fit one or more columns. Images can also *bleed*, that is, run off the page.

Having determined the number and position of the vertical columns, the designer must also establish horizontal guidelines to accommodate heads, subheads, folios, and other graphic elements that require special treatment.

Grids can become quite complex; they can have columns that vary in width as well as number, and even overlap. The more complex a grid, the more variety is possible and the more demands are placed on the designer. The grid for this book combines three and four columns (2, 3).

It should be noted that the grid is simply a means of organizing copy. The same grid in the hands of different designers will produce quite diverse results, as each person brings an aesthetic to bear.

1

2

3

1 The grid is a useful tool used by designers to organize type and illustrations on a page. The most common grids are one-, two-, and three-column.

2 The grid for this book combines both three and four columns. Multiple grid formats offer greater design possibilities.

3 This illustration shows how the grid was used to layout pages 58 and 59 of this book.

Copyfitting

Copyfitting is the process of establishing the amount of space typewritten copy will occupy when converted into typeset copy. Although the designer is responsible for this procedure, an understanding of the copyfitting process will help you develop a sense of how much space typewritten copy requires.

Copyfitting is simplified when the manuscript is typed (or output) on one of two basic typewriter formats: *pica* or *elite*. The pica sets ten characters per inch while the elite sets twelve characters. (There is no correlation between the *pica* typewriter format and the *pica* measure in typography.) Some typewriters offer what is called *proportional spacing;* this should be avoided since it makes copyfitting more difficult. The individual letters occupy varying amounts of space and are, therefore, difficult to count (1).

The first step in copyfitting is to calculate the total number of characters in the typewritten manuscript. This procedure, called *character counting,* is achieved by determining the number of characters in an average line and multiplying this by the total number of lines per page and then by the number of pages in the manuscript. Most word processing programs will indicate an exact character count on the screen.

To illustrate this process, copy has been produced on a pica typewriter, at ten characters per inch (2). An average line has approximately 43 characters and there are 14 lines: therefore the copy contains approximately 602 characters. If a more accurate count is desired, add the characters that exceed the line and subtract those that fall short. In this case the exact count is 599 characters.

Having calculated the total number of characters, the designer must now determine whether the copy will fit in the desired space in the chosen typeface and size.

Assume that this copy is to be converted into 11 point Garamond, set on a 20 pica measure. Because every typeface is unique and requires a varying amount of space, one must refer to a table or chart provided by the typographer to see how many characters will fit in a line. According to the type specimen shown on page 79, 11 point Garamond sets 2.7 characters per pica. Multiply this number (2.7 characters per pica) by the length of the line (20 picas) to obtain a total of 54 characters. Therefore, 11 point Garamond sets 54 characters on a 20 pica line.

To determine the number of typeset lines the copy will occupy, divide 599 (the exact number of characters in the copy) by 54 (the number of typeset characters that will set in a line). The result is 11 full lines with 5 characters left over. These remaining characters must also be considered a full line; therefore, the typewritten copy will require 12 lines when typeset (3). It is important to realize that copyfitting is at best an estimate and when actually set, may vary.

To establish the depth of the column, the designer multiplies the number of lines (12) by the point size of the type (11 point). The total column depth is 132 points. For large measures, points are converted into picas, just as inches are converted into feet. By dividing 132 points by 12 (there are 12 points in a pica), the result is 11 picas and 0 points.

The above example assumes that the type is set solid (no linespacing added). If linespacing is used (i.e., 11/13), this will affect the depth. In this case the number of lines (12) must be multiplied by the point size *plus the linespacing* (13). The total depth will now become 156 points, or 13 picas.

If the type runs too long or too short, the designer may make adjustments by adding (or subtracting) linespacing, altering type size, or changing the line measure. In extreme cases the copy may have to be cut or lengthened.

The best of times
PICA

The best of times
ELITE

The best of times
PROPORTIONAL

1

It was the best of times, it was the worst of

—— 43 CHARACTERS ——

times, it was the age of wisdom, it was the

age of foolishness, it was the epoch of belief,

it was the epoch of incredulity, it was the

season of Light, it was the season of Darkness,

it was the spring of hope, it was the winter of

despair, we had everything before us, we had

nothing before us, we were all going direct

to Heaven, we were all going direct the other

way - in short, the period was so far like the

present period, that some of its noisiest

authorities insisted on its being received,

for good or for evil, in the superlative

degree of comparison only.

2

1 To simplify the process of copyfitting, copy should always be prepared with typewriters having either pica or elite formats. Avoid the use of proportional formatted typewriters.

2 For a simple copyfitting exercise, this copy has been prepared on a pica typewriter.

3 When the above copy is set in 11 point Garamond by a 20 pica measure, the copy occupies 12 lines.

It was the best of times, it was the worst of times, it was the age of wisdom, it was the age of foolishness, it was the epoch of belief, it was the epoch of incredulity, it was the season of Light, it was the season of Darkness, it was the spring of hope, it was the winter of despair, we had everything before us, we had nothing before us, we were all going direct to Heaven, we were all going direct the other way — in short, the period was so far like the present period, that some of its noisiest authorities insisted on its being received, for good or for evil, in the superlative degree of comparison only.

3

Typesetting Systems

Typesetting has changed dramatically since the mid-fifteenth century when Johann Gutenberg first introduced metal type. Setting type by hand was the only typesetting method until 1886 when Ottmar Mergenthaler mechanized typesetting by developing the Linotype machine, which was capable of casting lines of type as single, complete units (1).

The next major change in typesetting came during the 1960s when phototypesetting became a practical alternative to linecasting. Phototypesetting machines, with their high-speed, electronically controlled components, set type by firing a beam of high-intensity light through a negative of the individual letters onto photosensitive paper or film (2).

Today, phototypesetting is rapidly being replaced by digital typesetting. Laser systems "generate" characters as a series of small dots (or lines) based on information electronically stored in the memory of a computer (3). Not only can characters be generated at the rate of thousands per second, but the dots can be manipulated so the type can be condensed, expanded, or slanted in either direction (4).

2

3

1

1 This illustration shows Ottmar Mergenthaler demonstrating his typesetting machine, capable of setting single lines of type. This machine mechanized the process of setting type.

2 In the phototypesetting process, a beam of light is flashed through a negative, thus projecting the letter(s) onto photosensitive paper or film.

3 Today, most type is set at very high speeds on digital typesetters. Shown here is the Linotronic 300, which stores typeface information digitally and uses a laser beam to output the characters as a series of dots.

4 With digital typesetting systems, characters can be altered by condensing, expanding, or slanting.

GG
GG

4

The following twenty-four pages introduce a limited selection of well-designed, widely used typefaces. Some of the typefaces have existed for hundreds of years while others are recent designs; collectively they will form an excellent foundation from which you can broaden your typographic knowledge. They are arranged in historical order and span over 350 years of typographic design (1).

Each example is given two pages: on the left is a short history of the typeface along with a showing of 54 point roman display type. The right-hand page shows four settings of text type, both roman and italic, with one point of linespacing.

For copyfitting purposes, the number of characters per pica is indicated below the typeset examples.

To aid in selecting an appropriate text size and style, it is often necessary to isolate the block of type. This can be accomplished by cutting a small window in a sheet of paper and laying this template over the text example (2).

1 A dozen well-designed typefaces; some hundreds of years old, but all popular and widely used today. Each has been set in its respective style.

.**2** A template for viewing text type examples on the following pages.

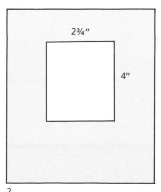

2

Garamond

Caslon

Baskerville

Bodoni

Century Expanded

Memphis

Times Roman

Palatino

Helvetica

Optima

Frutiger

Galliard

1

Claude Garamond, who died in 1561, was originally credited with the design of this elegant French typeface; however, it has recently been discovered that the typeface was redesigned by Jean Jannon around 1615. Many of the present-day versions of this typeface are based on Jannon's design, although they are called *Garamond*.

Garamond is a typical Old Style typeface, having very little contrast between the thick and thin strokes, heavily bracketed serifs, and an oblique stress. The letterforms are open and round, making the face extremely readable. The capital letters are shorter than the ascenders of the lowercase letters.

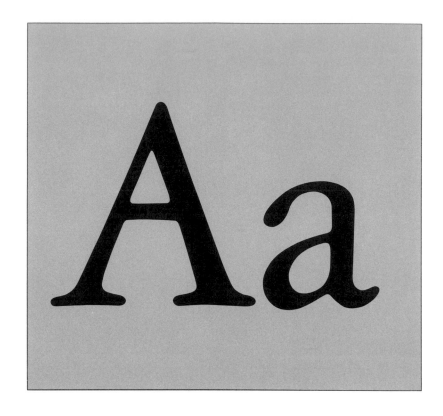

ABCDEFGHIJKLMN
OPQRSTUVWXYZ
abcdefghijklmnop
qrstuvwxyz
1234567890$.,"-:;!?&

54 POINT GARAMOND

It was the best of times, it was the worst of times, it was the age of wisdom, it was the age of foolishness, it was the epoch of belief, it was the epoch of incredulity, it was the season of Light, it was the season of Darkness, it was the spring of hope, it was the winter of despair, we had everything before us, we had nothing before us, we were all going direct to Heaven, we were all going direct the other way — in short, the period was so far like the present period, that some of its noisiest authorities insisted on its being received, for good or for evil, in the superlative degree of comparison only. There were a king with a large jaw and a queen with a plain face, on the throne of England; there were a king with a large jaw and a queen with a fair face, on the throne of France. In both countries it was clearer than crystal to the lords of the State preserves of loaves and fishes, that things in general were settled for ever. It was the year of Our Lord one thousand seven hundred and seventy-five. Spiritual revelations were conceded to England *at that favoured period, as at this. Mrs. South-cott had recently attained her five-and-twentieth blessed birthday, of whom a prophetic private in the Life Guards had heralded the sublime appear-*

9/10 GARAMOND 3.3 CPP

It was the best of times, it was the worst of times, it was the age of wisdom, it was the age of foolishness, it was the epoch of belief, it was the epoch of incredulity, it was the season of Light, it was the season of Darkness, it was the spring of hope, it was the winter of despair, we had everything before us, we had nothing before us, we were all going direct to Heaven, we were all going direct the other way — in short, the period was so far like the present period, that some of its noisiest authorities insisted on its being received, for good or for evil, in the superlative degree of comparison only. There were a king with a large jaw and a queen with a plain face, on the throne of England; there were a king with a large jaw and a queen with a fair face, on the throne of France. In both countries it was clearer than crystal to the lords of the State preserves of *loaves and fishes, that things in general were settled for ever. It was the year of Our Lord one thousand seven hundred and seventy-five. Spiritual revelations were conceded to England*

10/11 GARAMOND 3.0 CPP

Garamond set justified on a 14½ pica measure with the number of characters per pica (CPP) indicated.

It was the best of times, it was the worst of times, it was the age of wisdom, it was the age of foolishness, it was the epoch of belief, it was the epoch of incredulity, it was the season of Light, it was the season of Darkness, it was the spring of hope, it was the winter of despair, we had everything before us, we had nothing before us, we were all going direct to Heaven, we were all going direct the other way — in short, the period was so far like the present period, that some of its noisiest authorities insisted on its being received, for good or for evil, in the superlative degree of comparison only.

There were a king with a large jaw and a queen with a plain face, on the throne of England; there were a king *with a large jaw and a queen with a fair face, on the throne of France. In both countries it was clearer than crystal to the lords of the State preserves of loaves and*

11/12 GARAMOND 2.7 CPP

It was the best of times, it was the worst of times, it was the age of wisdom, it was the age of foolishness, it was the epoch of belief, it was the epoch of incredulity, it was the season of Light, it was the season of Darkness, it was the spring of hope, it was the winter of despair, we had everything before us, we had nothing before us, we were all going direct to Heaven, we were all going direct the other way — in short, the period was so far like the present period, that some of its noisiest authorities insisted on its being received, for good or for evil, in the superlative degree *of comparison only. There were a king with a large jaw and a queen with a plain face, on the throne of England; there were a king with a large jaw and a queen*

12/13 GARAMOND 2.5 CPP

William Caslon, an English engraver, set up his type foundry in 1720 and within five years had designed, cut, and cast his first roman and italic typefaces. Although strongly influenced by Dutch design, *Caslon* became the quintessential English typeface and dominated English printing throughout the century. Caslon is considered the last of the major Old Style typefaces.

Caslon was also popular in the American colonies, and the personal favorite of Benjamin Franklin. It is interesting to note that the American Declaration of Independence and the Constitution were set in *Caslon*.

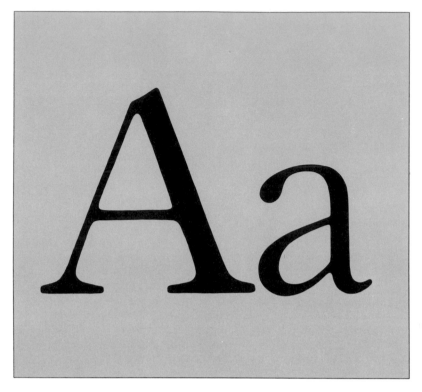

ABCDEFGHIJKLMN
OPQRSTUVWXYZ
abcdefghijklmnop
qrstuvwxyz
1234567890$.,"-:;!?&

54 POINT CASLON

It was the best of times, it was the worst of times, it was the age of wisdom, it was the age of foolishness, it was the epoch of belief, it was the epoch of incredulity, it was the season of Light, it was the season of Darkness, it was the spring of hope, it was the winter of despair, we had everything before us, we had nothing before us, we were all going direct to Heaven, we were all going direct the other way — in short, the period was so far like the present period, that some of its noisiest authorities insisted on its being received, for good or for evil, in the superlative degree of comparison only. There were a king with a large jaw and a queen with a plain face, on the throne of England; there were a king with a large jaw and a queen with a fair face, on the throne of France. In both countries it was clearer than crystal to the lords of the State preserves of loaves and fishes, that things in general were settled for ever. It was the year of Our Lord one thousand seven hundred and seventy-five. Spiritual revelations were conceded to England at that favoured *period, as at this. Mrs. Southcott had recently attained her five-and-twentieth blessed birthday, of whom a prophetic private in the Life Guards had heralded the sublime appearance by announcing that*

9/10 CASLON 3.3 CPP

It was the best of times, it was the worst of times, it was the age of wisdom, it was the age of foolishness, it was the epoch of belief, it was the epoch of incredulity, it was the season of Light, it was the season of Darkness, it was the spring of hope, it was the winter of despair, we had everything before us, we had nothing before us, we were all going direct to Heaven, we were all going direct the other way — in short, the period was so far like the present period, that some of its noisiest authorities insisted on its being received, for good or for evil, in the superlative degree of comparison only. There were a king with a large jaw and a queen with a plain face, on the throne of England; there were a king with a large jaw and a queen with a fair face, on the throne of France. In both countries it was clearer than crystal to the lords of the State preserves of loaves and *fishes, that things in general were settled for ever.*

It was the year of Our Lord one thousand seven hundred and seventy-five. Spiritual revelations were conceded to England at that

10/11 CASLON 3.0 CPP

Caslon set justified on a 14½ pica measure with the number of characters per pica (CPP) indicated.

It was the best of times, it was the worst of times, it was the age of wisdom, it was the age of foolishness, it was the epoch of belief, it was the epoch of incredulity, it was the season of Light, it was the season of Darkness, it was the spring of hope, it was the winter of despair, we had everything before us, we had nothing before us, we were all going direct to Heaven, we were all going direct the other way — in short, the period was so far like the present period, that some of its noisiest authorities insisted on its being received, for good or for evil, in the superlative degree of comparison only. There were a king with a large jaw and a queen with a plain face, on the throne of England; there were a king with a large jaw and a queen with a *fair face, on the throne of France. In both countries it was clearer than crystal to the lords of the State preserves of loaves and fishes, that things in general were settled*

11/12 CASLON 2.7 CPP

It was the best of times, it was the worst of times, it was the age of wisdom, it was the age of foolishness, it was the epoch of belief, it was the epoch of incredulity, it was the season of Light, it was the season of Darkness, it was the spring of hope, it was the winter of despair, we had everything before us, we had nothing before us, we were all going direct to Heaven, we were all going direct the other way — in short, the period was so far like the present period, that some of its noisiest authorities insisted on its being received, for good or for evil, in the superlative degree of comparison *only. There were a king with a large jaw and a queen with a plain face, on the throne of England; there were a king with a large jaw and a queen with a*

12/13 CASLON 2.4 CPP

Baskerville, designed by the Englishman John Baskerville in 1757, is an excellent example of a Transitional typeface. Transitional typefaces are so called because they form a bridge between the Old Style and Modern typefaces.

Compared to Old Style, Baskerville shows greater contrast between the thick and thin strokes, the serifs are less heavily bracketed, and the stress is almost vertical. The letters are very wide for their x-height, are closely fitted, and are of excellent proportions—making Baskerville one of the most pleasant and readable typefaces.

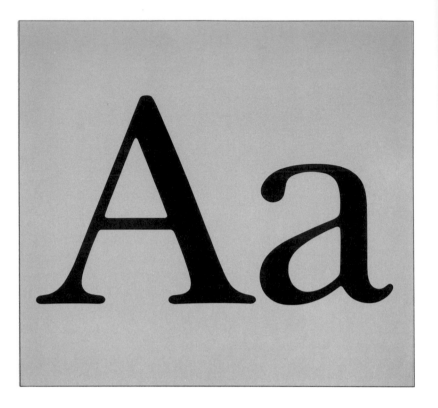

ABCDEFGHIJKLMN
OPQRSTUVWXYZ
abcdefghijklmnop
qrstuvwxyz
1234567890$.,"-:;!?&

54 POINT BASKERVILLE

It was the best of times, it was the worst of times, it was the age of wisdom, it was the age of foolishness, it was the epoch of belief, it was the epoch of incredulity, it was the season of Light, it was the season of Darkness, it was the spring of hope, it was the winter of despair, we had everything before us, we had nothing before us, we were all going direct to Heaven, we were all going direct the other way — in short, the period was so far like the present period, that some of its noisiest authorities insisted on its being received, for good or for evil, in the superlative degree of comparison only. There were a king with a large jaw and a queen with a plain face, on the throne of England; there were a king with a large jaw and a queen with a fair face, on the throne of France. In both countries it was clearer than crystal to the lords of the State preserves of loaves and fishes, that things in general were settled for ever. It was the year of Our Lord one thousand seven hundred and seventy-five. Spiritual revelations were conceded to England at that favoured period, as at this. Mrs. Southcott had recently attained her five-and-twentieth blessed birthday, of whom a *prophetic private in the Life Guards had heralded the sublime appearance by announcing that arrangements were made for the swallowing up of London and Westminster. Even the Cock-lane ghost had been*

8/9 BASKERVILLE 3.2 CPP

It was the best of times, it was the worst of times, it was the age of wisdom, it was the age of foolishness, it was the epoch of belief, it was the epoch of incredulity, it was the season of Light, it was the season of Darkness, it was the spring of hope, it was the winter of despair, we had everything before us, we had nothing before us, we were all going direct to Heaven, we were all going direct the other way — in short, the period was so far like the present period, that some of its noisiest authorities insisted on its being received, for good or for evil, in the superlative degree of comparison only. There were a king with a large jaw and a queen with a plain face, on the throne of England; there were a king with a large jaw and a queen with a fair face, on the throne of France. In both countries it was clearer than crystal to the lords of the State preserves of loaves and fishes, that things in general were settled for ever. It *was the year of Our Lord one thousand seven hundred and seventy-five. Spiritual revelations were conceded to England at that favoured period, as at this. Mrs. Southcott had recently*

9/10 BASKERVILLE 2.8 CPP

Baskerville set justified on a 14½ pica measure with the number of characters per pica (CPP) indicated.

It was the best of times, it was the worst of times, it was the age of wisdom, it was the age of foolishness, it was the epoch of belief, it was the epoch of incredulity, it was the season of Light, it was the season of Darkness, it was the spring of hope, it was the winter of despair, we had everything before us, we had nothing before us, we were all going direct to Heaven, we were all going direct the other way — in short, the period was so far like the present period, that some of its noisiest authorities insisted on its being received, for good or for evil, in the superlative degree of comparison only. There were a king with a large jaw and a queen with a plain face, on the throne of England; there were a king with a large jaw and a queen with a fair face, *on the throne of France. In both countries it was clearer than crystal to the lords of the State preserves of loaves and fishes, that things in general were settled for ever.*

10/11 BASKERVILLE 2.6 CPP

It was the best of times, it was the worst of times, it was the age of wisdom, it was the age of foolishness, it was the epoch of belief, it was the epoch of incredulity, it was the season of Light, it was the season of Darkness, it was the spring of hope, it was the winter of despair, we had everything before us, we had nothing before us, we were all going direct to Heaven, we were all going direct the other way — in short, the period was so far like the present period, that some of its noisiest authorities insisted on its being received, for good or for evil, in the superlative degree of comparison only. There were a king with a *large jaw and a queen with a plain face, on the throne of England; there were a king with a large jaw and a queen with a fair face, on the throne of France. In*

11/12 BASKERVILLE 2.3 CPP

Bodoni is a Modern typeface, designed in the late 1700s by the Italian typographer Giambattista Bodoni.

At the end of the eighteenth century, a fashion grew for typefaces with a stronger contrast between the thick and thin strokes, unbracketed serifs, and a strong vertical stress. These were called Modern typefaces. All of the older typefaces became known as Old Style, while the more recent typefaces— just prior to the change—were referred to as Transitional.

Although Bodoni has a small x-height, it appears very wide and black. Because of the strong vertical stress, accentuated by its heavy thick strokes and hairline thin strokes, the horizontal flow necessary for comfortable reading is impaired. Bodoni, therefore, requires generous linespacing.

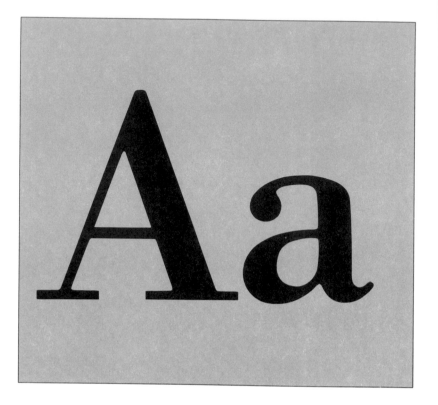

ABCDEFGHIJKLMN
OPQRSTUVWXYZ
abcdefghijklmnop
qrstuvwxyz
1234567890$.,"'-:;!?&

54 POINT BODONI

It was the best of times, it was the worst of times, it was the age of wisdom, it was the age of foolishness, it was the epoch of belief, it was the epoch of incredulity, it was the season of Light, it was the season of Darkness, it was the spring of hope, it was the winter of despair, we had everything before us, we had nothing before us, we were all going direct to Heaven, we were all going direct the other way — in short, the period was so far like the present period, that some of its noisiest authorities insisted on its being received, for good or for evil, in the superlative degree of comparison only. There were a king with a large jaw and a queen with a plain face, on the throne of England; there were a king with a large jaw and a queen with a fair face, on the throne of France. In both countries it was clearer than crystal to the lords of the State preserves of loaves and fishes, that things in general were settled for ever. It was the year of Our Lord one thousand seven hundred and seventy-five. Spiritual revelations were conceded to England at that favoured period, as at this. Mrs. Southcott had recently attained her five-and-twentieth blessed birthday, of whom a prophetic private in the Life Guards had heralded the sublime appear*ance by announcing that arrangements were made* *for the swallowing up of London and Westminster.* *Even the Cock-lane ghost had been laid only a* *round dozen of years, after rapping out its mes-*

8/9 BODONI 3.4 CPP

It was the best of times, it was the worst of times, it was the age of wisdom, it was the age of foolishness, it was the epoch of belief, it was the epoch of incredulity, it was the season of Light, it was the season of Darkness, it was the spring of hope, it was the winter of despair, we had everything before us, we had nothing before us, we were all going direct to Heaven, we were all going direct the other way — in short, the period was so far like the present period, that some of its noisiest authorities insisted on its being received, for good or for evil, in the superlative degree of comparison only. There were a king with a large jaw and a queen with a plain face, on the throne of England; there were a king with a large jaw and a queen with a fair face, on the throne of France. In both countries it was clearer than crystal to the lords of the State preserves of loaves and fishes, that things in general were settled for ever. It was the year of Our Lord one thousand seven hundred and *seventy-five. Spiritual revelations were con* *ceded to England at that favoured period, as* *at this. Mrs. Southcott had recently attained* *her five-and-twentieth blessed birthday, of*

9/10 BODONI 3.0 CPP

Bodoni set justified on a 14½ pica measure with the number of characters per pica (CPP) indicated.

It was the best of times, it was the worst of times, it was the age of wisdom, it was the age of foolishness, it was the epoch of belief, it was the epoch of incredulity, it was the season of Light, it was the season of Darkness, it was the spring of hope, it was the winter of despair, we had everything before us, we had nothing before us, we were all going direct to Heaven, we were all going direct the other way — in short, the period was so far like the present period, that some of its noisiest authorities insisted on its being received, for good or for evil, in the superlative degree of comparison only. There were a king with a large jaw and a queen with a plain face, on the throne of England; there were a king with a large jaw and a queen with a fair face, on the throne of France. In both countries it was clearer than crystal to the *lords of the State preserves of loaves and* *fishes, that things in general were settled* *for ever. It was the year of Our Lord one* *thousand seven hundred and seventy-five.*

10/11 BODONI 2.7 CPP

It was the best of times, it was the worst of times, it was the age of wisdom, it was the age of foolishness, it was the epoch of belief, it was the epoch of incredulity, it was the season of Light, it was the season of Darkness, it was the spring of hope, it was the winter of despair, we had everything before us, we had nothing before us, we were all going direct to Heaven, we were all going direct the other way — in short, the period was so far like the present period, that some of its noisiest authorities insisted on its being received, for good or for evil, in the superlative degree of comparison only. There were a king with a large jaw and a queen with a plain face, on *the throne of England; there were a* *king with a large jaw and a queen with* *a fair face, on the throne of France. In* *both countries it was clearer than crys-*

11/12 BODONI 2.5 CPP

After the introduction of Modern typefaces, type designers began to search for new forms of typographic expression. In England, around 1815, a type style appeared that was characterized by thick slab serifs and main strokes with little contrast between the thick and thin strokes. This style was called *Egyptian*.

An excellent example of a refined Egyptian typeface is *Century Expanded*. It is based on a type called *Century*, which was commissioned by Theodore Lowe De Vinne and designed by Linn Boyd Benton in 1895, for *The Century Magazine*.

Century Expanded's large x-height and simple letterforms combine to make it very legible and especially popular for children's books. Like most members of the Egyptian family of typefaces, Century Expanded makes a good display type because of its boldness.

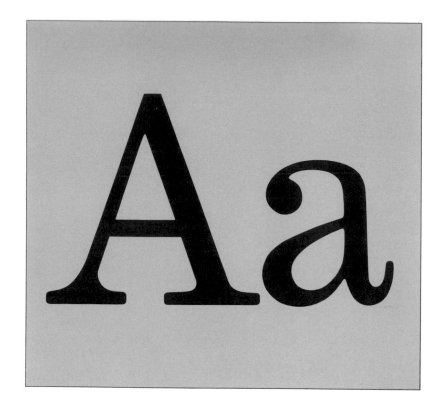

ABCDEFGHIJKLM
NOPQRSTUVWXYZ
abcdefghijklmnop
qrstuvwxyz
1234567890$.,"-:;!?&

54 POINT CENTURY EXPANDED

It was the best of times, it was the worst of times, it was the age of wisdom, it was the age of foolishness, it was the epoch of belief, it was the epoch of incredulity, it was the season of Light, it was the season of Darkness, it was the spring of hope, it was the winter of despair, we had everything before us, we had nothing before us, we were all going direct to Heaven, we were all going direct the other way — in short, the period was so far like the present period, that some of its noisiest authorities insisted on its being received, for good or for evil, in the superlative degree of comparison only. There were a king with a large jaw and a queen with a plain face, on the throne of England; there were a king with a large jaw and a queen with a fair face, on the throne of France. In both countries it was clearer than crystal to the lords of the State preserves of loaves and fishes, that things in general were settled for ever. It was the year of Our Lord one thousand seven hundred and seventy-five. Spiritual revelations were conceded to England at that favoured period, as at this. Mrs. South-cott had recently attained her five-and-twentieth blessed birthday, of whom a prophetic private in *the Life Guards had heralded the sublime appearance by announcing that arrangements were made for the swallowing up of London and Westminster. Even the Cock-lane ghost*

8/9 CENTURY EXPANDED 3.2 CPP

It was the best of times, it was the worst of times, it was the age of wisdom, it was the age of foolishness, it was the epoch of belief, it was the epoch of incredulity, it was the season of Light, it was the season of Darkness, it was the spring of hope, it was the winter of despair, we had everything before us, we had nothing before us, we were all going direct to Heaven, we were all going direct the other way — in short, the period was so far like the present period, that some of its noisiest authorities insisted on its being received, for good or for evil, in the superlative degree of comparison only. There were a king with a large jaw and a queen with a plain face, on the throne of England; there were a king with a large jaw and a queen with a fair face, on the throne of France. In both countries it was clearer than crystal to the lords of the State preserves of loaves and fishes, that things in general were settled for ever. It was the year of Our Lord one *thousand seven hundred and seventy-five. Spiritual revelations were conceded to England at that favoured period, as at this. Mrs. Southcott had recently attained her five-and-*

9/10 CENTURY EXPANDED 2.9 CPP

Century Expanded set justified on a 14½ pica measure with the number of characters per pica (CPP) indicated.

It was the best of times, it was the worst of times, it was the age of wisdom, it was the age of foolishness, it was the epoch of belief, it was the epoch of incredulity, it was the season of Light, it was the season of Darkness, it was the spring of hope, it was the winter of despair, we had everything before us, we had nothing before us, we were all going direct to Heaven, we were all going direct the other way — in short, the period was so far like the present period, that some of its noisiest authorities insisted on its being received, for good or for evil, in the superlative degree of comparison only. There were a king with a large jaw and a queen with a plain face, on the throne of England; there were a king with a large jaw and a queen with a fair face, on the throne of France. In both *countries it was clearer than crystal to the lords of the State preserves of loaves and fishes, that things in general were settled for ever. It was the year of Our*

10/11 CENTURY EXPANDED 2.6 CPP

It was the best of times, it was the worst of times, it was the age of wisdom, it was the age of foolishness, it was the epoch of belief, it was the epoch of incredulity, it was the season of Light, it was the season of Darkness, it was the spring of hope, it was the winter of despair, we had everything before us, we had nothing before us, we were all going direct to Heaven, we were all going direct the other way — in short, the period was so far like the present period, that some of its noisiest authorities insisted on its being received, for good or for evil, in the superlative degree of comparison only. There were a king with a *large jaw and a queen with a plain face, on the throne of England; there were a king with a large jaw and a queen with a fair face, on the throne*

11/12 CENTURY EXPANDED 2.3 CPP

Memphis was designed in 1929 for the Stempel Foundry by Emil Rudolf Weiss. Memphis is the earliest modern revival of the Egyptian type style, that is, slab serif.

The first slab serif typeface was cast in 1817 by the Vincent Figgins Foundry in London. It was designed expressly for advertising purposes rather than for book publishing. Although slab serifs, with their heavy strokes and serifs, were designed to attract attention, there are many refined enough for use as text type, which are called ''modified Egyptians.''

Following the success of Memphis, other type manufacturers commissioned similar designs. Some of the more popular and lasting versions include *Stymie, Karnak,* and *City.*

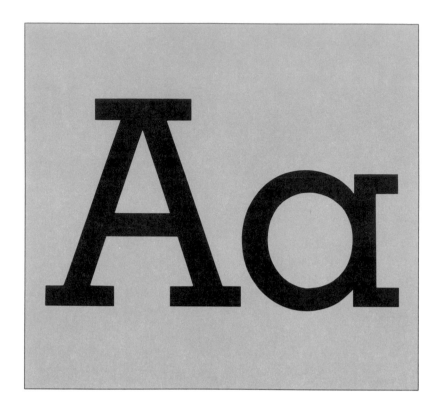

ABCDEFGHIJKLMN
OPQRSTUVWXYZ
abcdefghijklmnop
qrstuvwxyz
1234567890$.,''-:;!?&

It was the best of times, it was the worst of times, it was the age of wisdom, it was the age of foolishness, it was the epoch of belief, it was the epoch of incredulity, it was the season of Light, it was the season of Darkness, it was the spring of hope, it was the winter of despair, we had everything before us, we had nothing before us, we were all going direct to Heaven, we were all going direct the other way — in short, the period was so far like the present period, that some of its noisiest authorities insisted on its being received, for good or for evil, in the superlative degree of comparison only. There were a king with a large jaw and a queen with a plain face, on the throne of England; there were a king with a large jaw and a queen with a fair face, on the throne of France. In both countries it was clearer than crystal to the lords of the State preserves of loaves and fishes, that things in general were settled for ever. It was the year of Our Lord one thousand seven hundred and seventy-five. Spiritual revelations were conceded to England at that favoured period, as at this. Mrs. Southcott had recently attained her five-and-twentieth blessed birthday, of whom a prophetic private in the Life Guards had heralded the sublime appearance by

8/9 MEMPHIS 3.0 CPP

It was the best of times, it was the worst of times, it was the age of wisdom, it was the age of foolishness, it was the epoch of belief, it was the epoch of incredulity, it was the season of Light, it was the season of Darkness, it was the spring of hope, it was the winter of despair, we had everything before us, we had nothing before us, we were all going direct to Heaven, we were all going direct the other way — in short, the period was so far like the present period, that some of its noisiest authorities insisted on its being received, for good or for evil, in the superlative degree of comparison only. There were a king with a large jaw and a queen with a plain face, on the throne of England; there were a king with a large jaw and a queen with a fair face, on the throne of France. In both countries it was clearer than crystal to the lords of the State preserves of loaves and fishes, that things in general were settled for ever. It was the year of Our Lord one thousand seven hundred and seventy-five. Spiritual revelations were

9/10 MEMPHIS 2.7 CPP

Memphis set justified on a 14½ pica measure with the number of characters per pica (CPP) indicated.

It was the best of times, it was the worst of times, it was the age of wisdom, it was the age of foolishness, it was the epoch of belief, it was the epoch of incredulity, it was the season of Light, it was the season of Darkness, it was the spring of hope, it was the winter of despair, we had everything before us, we had nothing before us, we were all going direct to Heaven, we were all going direct the other way — in short, the period was so far like the present period, that some of its noisiest authorities insisted on its being received, for good or for evil, in the superlative degree of comparison only. There were a king with a large jaw and a queen with a plain face, on the throne of England; there were a king with a large jaw and a queen with a fair face, on the throne of France. In both countries it was clearer than crystal to the lords of the

10/11 MEMPHIS 2.4 CPP

It was the best of times, it was the worst of times, it was the age of wisdom, it was the age of foolishness, it was the epoch of belief, it was the epoch of incredulity, it was the season of Light, it was the season of Darkness, it was the spring of hope, it was the winter of despair, we had everything before us, we had nothing before us, we were all going direct to Heaven, we were all going direct the other way — in short, the period was so far like the present period, that some of its noisiest authorities insisted on its being received, for good or for evil, in the superlative degree of comparison only. There were a king with a large jaw and a queen with a plain face, on the throne of England; there were a

11/12 MEMPHIS 2.2 CPP

Times Roman, originally called the *Times New Roman,* is perhaps the most popular serif typeface in use today. It was designed by Stanley Morison and drawn by Victor Lardent in 1931, for the exclusive use of *The Times* of London. It was first cut by the Monotype Corporation and then produced by Linotype.

Times Roman was an immediate success, hailed not only as the perfect newspaper typeface but also as the most important type design of the twentieth century. Since then, designers have found that Times Roman makes an excellent typeface for any job.

Times Roman is compact, attractive, and legible. Because of its rather large x-height, Times Roman sets exceptionally well in the smaller type sizes.

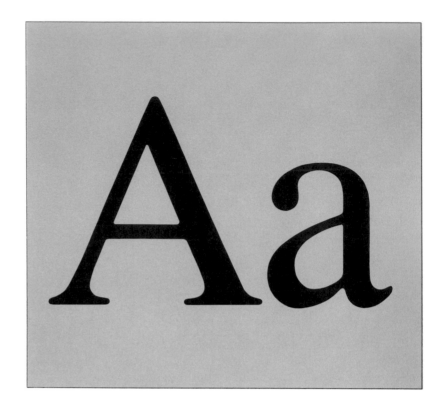

ABCDEFGHIJKLMN
OPQRSTUVWXYZ
abcdefghijklmnop
qrstuvwxyz
1234567890$.,''-:;!?&

54 POINT TIMES ROMAN

It was the best of times, it was the worst of times, it was the age of wisdom, it was the age of foolishness, it was the epoch of belief, it was the epoch of incredulity, it was the season of Light, it was the season of Darkness, it was the spring of hope, it was the winter of despair, we had everything before us, we had nothing before us, we were all going direct to Heaven, we were all going direct the other way — in short, the period was so far like the present period, that some of its noisiest authorities insisted on its being received, for good or for evil, in the superlative degree of comparison only. There were a king with a large jaw and a queen with a plain face, on the throne of England; there were a king with a large jaw and a queen with a fair face, on the throne of France. In both countries it was clearer than crystal to the lords of the State preserves of loaves and fishes, that things in general were settled for ever. It was the year of Our Lord one thousand seven hundred and seventy-five. Spiritual revelations were conceded to England at that favoured period, as at this. Mrs. Southcott had recently attained her five-and-twentieth blessed birthday, of whom a prophetic private in the Life Guards had heralded the sublime appearance by announcing that arrangements were *made for the swallowing up of London and Westminster. Even the Cock-lane ghost had been laid only a round dozen of years, after rapping out its messages, as the spirits of this very year last past (supernaturally*

8/9 TIMES ROMAN 3.3 CPP

It was the best of times, it was the worst of times, it was the age of wisdom, it was the age of foolishness, it was the epoch of belief, it was the epoch of incredulity, it was the season of Light, it was the season of Darkness, it was the spring of hope, it was the winter of despair, we had everything before us, we had nothing before us, we were all going direct to Heaven, we were all going direct the other way — in short, the period was so far like the present period, that some of its noisiest authorities insisted on its being received, for good or for evil, in the superlative degree of comparison only. There were a king with a large jaw and a queen with a plain face, on the throne of England; there were a king with a large jaw and a queen with a fair face, on the throne of France. In both countries it was clearer than crystal to the lords of the State preserves of loaves and fishes, that things in general were settled for ever. It was the year of Our Lord one thousand seven hundred and seventy-five. *Spiritual revelations were conceded to England at that favoured period, as at this. Mrs. Southcott had recently attained her five-and-twentieth blessed birthday, of whom a pro-*

9/10 TIMES ROMAN 3.0 CPP

Times Roman set justified on a 14½ pica measure with the number of characters per pica (CPP) indicated.

It was the best of times, it was the worst of times, it was the age of wisdom, it was the age of foolishness, it was the epoch of belief, it was the epoch of incredulity, it was the season of Light, it was the season of Darkness, it was the spring of hope, it was the winter of despair, we had everything before us, we had nothing before us, we were all going direct to Heaven, we were all going direct the other way — in short, the period was so far like the present period, that some of its noisiest authorities insisted on its being received, for good or for evil, in the superlative degree of comparison only. There were a king with a large jaw and a queen with a plain face, on the throne of England; there were a king with a large jaw and a queen with a fair face, on the throne of France. In both countries it was clearer than crystal to the *lords of the State preserves of loaves and fishes, that things in general were settled for ever. It was the year of Our Lord one thousand seven hundred and seventy-five.*

10/11 TIMES ROMAN 2.7 CPP

It was the best of times, it was the worst of times, it was the age of wisdom, it was the age of foolishness, it was the epoch of belief, it was the epoch of incredulity, it was the season of Light, it was the season of Darkness, it was the spring of hope, it was the winter of despair, we had everything before us, we had nothing before us, we were all going direct to Heaven, we were all going direct the other way — in short, the period was so far like the present period, that some of its noisiest authorities insisted on its being received, for good or for evil, in the superlative degree of comparison only. There were a king with a large jaw and a queen with a plain face, on *the throne of England; there were a king with a large jaw and a queen with a fair face, on the throne of France. In both countries it was clearer than crys-*

11/12 TIMES ROMAN 2.4 CPP

Hermann Zapf was born on November 8, 1918, in Nuremberg, Germany. Inspired by the work of the type designer Rudolf Koch, Zapf decided to become a calligrapher. After serving his apprenticeship, Zapf broadened his knowledge in printing, punch cutting, and other related skills.

In 1950, Zapf created the first of his many universally acclaimed typefaces, *Palatino.* This elegant typeface reflects the classical letterforms of the Renaissance Old Style typefaces. As an excellent typeface for books, Palatino has been adopted by every major typesetting manufacturer in the Western world.

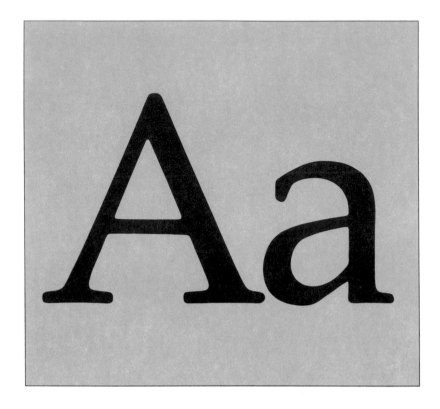

ABCDEFGHIJKLMN
OPQRSTUVWXYZ
abcdefghijklmnop
qrstuvwxyz
1234567890$.,''-:;!?&

54 POINT PALATINO

It was the best of times, it was the worst of times, it was the age of wisdom, it was the age of foolishness, it was the epoch of belief, it was the epoch of incredulity, it was the season of Light, it was the season of Darkness, it was the spring of hope, it was the winter of despair, we had everything before us, we had nothing before us, we were all going direct to Heaven, we were all going direct the other way—in short, the period was so far like the present period, that some of its noisiest authorities insisted on its being received, for good or for evil, in the superlative degree of comparison only. There were a king with a large jaw and a queen with a plain face, on the throne of England; there were a king with a large jaw and a queen with a fair face, on the throne of France. In both countries it was clearer than crystal to the lords of the State preserves of loaves and fishes, that things in general were settled for ever. It was the year of Our Lord one thousand seven hundred and seventy-five. Spiritual revelations were conceded to England at that favoured period, as at this. Mrs. Southcott had recently attained her five-and-twentieth blessed birthday, of whom a prophetic *private in the Life Guards had heralded the sublime appearance by announcing that arrangements were made for the swallowing up of London and Westminster. Even the Cock-lane ghost had been*

8/9 PALATINO 3.1 CPP

It was the best of times, it was the worst of times, it was the age of wisdom, it was the age of foolishness, it was the epoch of belief, it was the epoch of incredulity, it was the season of Light, it was the season of Darkness, it was the spring of hope, it was the winter of despair, we had everything before us, we had nothing before us, we were all going direct to Heaven, we were all going direct the other way — in short, the period was so far like the present period, that some of its noisiest authorities insisted on its being received, for good or for evil, in the superlative degree of comparison only. There were a king with a large jaw and a queen with a plain face, on the throne of England; there were a king with a large jaw and a queen with a fair face, on the throne of France. In both countries it was clearer than crystal to the lords of the State preserves of loaves and fishes, that things in general were settled for ever.

It was the year of Our Lord one thousand seven hundred and seventy-five. Spiritual revelations were conceded to England at that favoured period, as at this. Mrs. Southcott had

9/10 PALATINO 2.8 CPP

Palatino set justified on a 14½ pica measure with the number of characters per pica (CPP) indicated.

It was the best of times, it was the worst of times, it was the age of wisdom, it was the age of foolishness, it was the epoch of belief, it was the epoch of incredulity, it was the season of Light, it was the season of Darkness, it was the spring of hope, it was the winter of despair, we had everything before us, we had nothing before us, we were all going direct to Heaven, we were all going direct the other way — in short, the period was so far like the present period, that some of its noisiest authorities insisted on its being received, for good or for evil, in the superlative degree of comparison only. There were a king with a large jaw and a queen with a plain face, on the throne of England; there were a king with a large jaw and a queen with a fair face, *on the throne of France. In both countries it was clearer than crystal to the lords of the State preserves of loaves and fishes, that things in general were*

10/11 PALATINO 2.5 CPP

It was the best of times, it was the worst of times, it was the age of wisdom, it was the age of foolishness, it was the epoch of belief, it was the epoch of incredulity, it was the season of Light, it was the season of Darkness, it was the spring of hope, it was the winter of despair, we had everything before us, we had nothing before us, we were all going direct to Heaven, we were all going direct the other way — in short, the period was so far like the present period, that some of its noisiest authorities insisted on its being received, for good or for evil, in the superlative degree of comparison only. There were a king *with a large jaw and a queen with a plain face, on the throne of England; there were a king with a large jaw and a queen with a fair*

11/12 PALATINO 2.3 CPP

Although typefaces without serifs were used in the nineteenth century, it was not until the twentieth century that they became widely used. In 1957, Edouard Hoffman took an existing typeface, *Neue Haas Grotesk,* and had it redrawn by Max Miedinger. The result was *Helvetica,* the most widely used sans serif in the world today.

Although Helvetica has a large x-height and narrow letters, its clean design makes it very readable. Because there are no serifs to aid in the horizontal flow, Helvetica should always be leaded.

ABCDEFGHIJKLMN
OPQRSTUVWXYZ
abcdefghijklmnop
qrstuvwxyz
1234567890$.,"-:;!?&

It was the best of times, it was the worst of times, it was the age of wisdom, it was the age of foolishness, it was the epoch of belief, it was the epoch of incredulity, it was the season of Light, it was the season of Darkness, it was the spring of hope, it was the winter of despair, we had everything before us, we had nothing before us, we were all going direct to Heaven, we were all going direct the other way — in short, the period was so far like the present period, that some of its noisiest authorities insisted on its being received, for good or for evil, in the superlative degree of comparison only. There were a king with a large jaw and a queen with a plain face, on the throne of England; there were a king with a large jaw and a queen with a fair face, on the throne of France. In both countries it was clearer than crystal to the lords of the State preserves of loaves and fishes, that things in general were settled for ever. It was the year of Our Lord one thousand seven hundred and seventy-five. Spiritual revelations were conceded to England at that favoured period, as at this. Mrs. Southcott had recently attained her five-and-twentieth blessed birthday, of whom a prophetic private in *the Life Guards had heralded the sublime appearance by announcing that arrangements were made for the swallowing up of London and Westminster. Even the Cock-lane ghost had*

8/9 HELVETICA 3.3 CPP

It was the best of times, it was the worst of times, it was the age of wisdom, it was the age of foolishness, it was the epoch of belief, it was the epoch of incredulity, it was the season of Light, it was the season of Darkness, it was the spring of hope, it was the winter of despair, we had everything before us, we had nothing before us, we were all going direct to Heaven, we were all going direct the other way — in short, the period was so far like the present period, that some of its noisiest authorities insisted on its being received, for good or for evil, in the superlative degree of comparison only.

There were a king with a large jaw and a queen with a plain face, on the throne of England; there were a king with a large jaw and a queen with a fair face, on the throne of France. In both countries it was clearer than crystal to the lords of the State preserves of loaves and fishes, that things in general were settled for ever. It was the year of Our *Lord one thousand seven hundred and seventy-five. Spiritual revelations were conceded to England at that favoured period, as at this. Mrs. Southcott had re-*

9/10 HELVETICA 3.0 CPP

Helvetica set justified on a 14½ pica measure with the number of characters per pica (CPP) indicated.

It was the best of times, it was the worst of times, it was the age of wisdom, it was the age of foolishness, it was the epoch of belief, it was the epoch of incredulity, It was the season of Light, it was the season of Darkness, it was the spring of hope, it was the winter of despair, we had everything before us, we had nothing before us, we were all going direct to Heaven, we were all going direct the other way — in short, the period was so far like the present period, that some of its noisiest authorities insisted on its being received, for good or for evil, in the superlative degree of comparison only. There were a king with a large jaw and a queen with a plain face, on the throne of England; there were a king with a large jaw and a queen with a fair face, on the *throne of France. In both countries it was clearer than crystal to the lords of the State preserves of loaves and fishes, that things in general were set-*

10/11 HELVETICA 2.7 CPP

It was the best of times, it was the worst of times, it was the age of wisdom, it was the age of foolishness, it was the epoch of belief, it was the epoch of Incredulity, it was the season of Light, it was the season of Darkness, it was the spring of hope, it was the winter of despair, we had everything before us, we had nothing before us, we were all going direct to Heaven, we were all going direct the other way — in short, the period was so far like the present period, that some of its noisiest authorities insisted on its being received, for good or for evil, in the superlative degree of comparison only. There were a king with a *large jaw and a queen with a plain face, on the throne of England; there were a king with a large jaw and a queen with a fair face, on the throne*

11/12 HELVETICA 2.4 CPP

It was during the late 1950s that Hermann Zapf created what was possibly his most original typeface, *Optima*—a design that is neither serif nor sans serif.

This "serifless roman" is based on the round proportions of the Transitional typefaces, such as Baskerville. Instead of serifs, however, there is the gentle flairing at the extremities of the strokes.

Although not originally conceived as a book typeface, Optima has proved to be more than suitable for continuous reading. It is both elegant and highly readable.

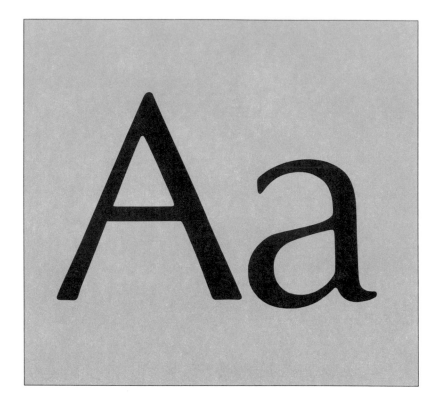

ABCDEFGHIJKLMN
OPQRSTUVWXYZ
abcdefghijklmnop
qrstuvwxyz
1234567890$.,''-:;!?&

It was the best of times, it was the worst of times, it was the age of wisdom, it was the age of foolishness, it was the epoch of belief, it was the epoch of incredulity, it was the season of Light, it was the season of Darkness, it was the spring of hope, it was the winter of despair, we had everything before us, we had nothing before us, we were all going direct to Heaven, we were all going direct the other way — in short, the period was so far like the present period, that some of its noisiest authorities insisted on its being received, for good or for evil, in the superlative degree of comparison only. There were a king with a large jaw and a queen with a plain face, on the throne of England; there were a king with a large jaw and a queen with a fair face, on the throne of France. In both countries it was clearer than crystal to the lords of the State preserves of loaves and fishes, that things in general were settled for ever. It was the year of Our Lord one thousand seven hundred and seventy-five. Spiritual revelations were conceded to England at that favoured period, as at this. Mrs. Southcott had recently attained her five-and-twentieth blessed birthday, of whom a prophetic private in the Life Guards had heralded the sublime *appearance by announcing that arrangements were made for the swallowing up of London and Westminster. Even the Cock-lane ghost had been laid only a round dozen of years, after rapping out*

8/9 OPTIMA 3.0 CPP

It was the best of times, it was the worst of times, it was the age of wisdom, it was the age of foolishness, it was the epoch of belief, it was the epoch of incredulity, it was the season of Light, it was the season of Darkness, it was the spring of hope, it was the winter of despair, we had everything before us, we had nothing before us, we were all going direct to Heaven, we were all going direct the other way — in short, the period was so far like the present period, that some of its noisiest authorities insisted on its being received, for good or for evil, in the superlative degree of comparison only. There were a king with a large jaw and a queen with a plain face, on the throne of England; there were a king with a large jaw and a queen with a fair face, on the throne of France. In both countries it was clearer than crystal to the lords of the State preserves of loaves and fishes, that things in general were settled for ever. It was the year of Our Lord one thousand seven hundred and *seventy-five. Spiritual revelations were conceded to England at that favoured period, as at this. Mrs. Southcott had recently attained her five-and-twentieth blessed birthday, of whom*

9/10 OPTIMA 2.7 CPP

Optima set justified on a 14½ pica measure with the number of characters per pica (CPP) indicated.

It was the best of times, it was the worst of times, it was the age of wisdom, it was the age of foolishness, it was the epoch of belief, it was the epoch of incredulity, it was the season of Light, it was the season of Darkness, it was the spring of hope, it was the winter of despair, we had everything before us, we had nothing before us, we were all going direct to Heaven, we were all going direct the other way — in short, the period was so far like the present period, that some of its noisiest authorities insisted on its being received, for good or for evil, in the superlative degree of comparison only. There were a king with a large jaw and a queen with a plain face, on the throne of England; there were a king with a large jaw and a queen with a fair face, on the throne of France. In both countries it was clearer *than crystal to the lords of the State preserves of loaves and fishes, that things in general were settled for ever. It was the year of Our Lord one thousand seven hun-*

10/11 OPTIMA 2.5 CPP

It was the best of times, it was the worst of times, it was the age of wisdom, it was the age of foolishness, it was the epoch of belief, it was the epoch of incredulity, it was the season of Light, it was the season of Darkness, it was the spring of hope, it was the winter of despair, we had everything before us, we had nothing before us, we were all going direct to Heaven, we were all going direct the other way — in short, the period was so far like the present period, that some of its noisiest authorities insisted on its being received, for good or for evil, in the superlative degree of comparison only. There were a king with a large jaw and a queen with a plain *face, on the throne of England; there were a king with a large jaw and a queen with a fair face, on the throne of France. In both countries it was*

11/12 OPTIMA 2.2 CPP

Adrien Frutiger was born on March 28, 1928, in Unterseen, Switzerland. His earliest success was the design of *Univers* in 1954. This sans serif family, consisting of twenty-one styles, is considered by many to be the most basic and rational of the postwar sans serifs.

A more recent success is *Frutiger.* This sans serif was originally designed in 1976 for directional signs at the Charles de Gaulle Airport in Paris and later adapted by Linotype as a typeface. Frutiger, unlike Univers and Helvetica, is softer and more rounded, combining type design with the craft of lettering to create a timeless, legible typeface.

ABCDEFGHIJKLMN
OPQRSTUVWXYZ
abcdefghijklmnop
qrstuvwxyz
1234567890$.,"-:;!?&

54 POINT FRUTIGER 55

It was the best of times, it was the worst of times, it was the age of wisdom, it was the age of foolishness, it was the epoch of belief, it was the epoch of incredulity, it was the season of Light, it was the season of Darkness, it was the spring of hope, it was the winter of despair, we had everything before us, we had nothing before us, we were all going direct to Heaven, we were all going direct the other way — in short, the period was so far like the present period, that some of its noisiest authorities insisted on its being received, for good or for evil, in the superlative degree of comparison only. There were a king with a large jaw and a queen with a plain face, on the throne of England; there were a king with a large jaw and a queen with a fair face, on the throne of France. In both countries it was clearer than crystal to the lords of the State preserves of loaves and fishes, that things in general were settled for ever. It was the year of Our Lord one thousand seven hundred and seventy-five. Spiritual revelations were conceded to England at that favoured period, as at this. Mrs. Southcott had recently attained her five-and twentieth blessed birthday, of whom a prophetic private in the Life Guards had heralded the sublime appearance by announcing that arrangements were made for the

8/9 FRUTIGER 3.1 CPP

It was the best of times, it was the worst of times, it was the age of wisdom, it was the age of foolishness, it was the epoch of belief, it was the epoch of incredulity, it was the season of Light, it was the season of Darkness, it was the spring of hope, it was the winter of despair, we had everything before us, we had nothing before us, we were all going direct to Heaven, we were all going direct the other way — in short, the period was so far like the present period, that some of its noisiest authorities insisted on its being received, for good or for evil, in the superlative degree of comparison only. There were a king with a large jaw and a queen with a plain face, on the throne of England; there were a king with a large jaw and a queen with a fair face, on the throne of France. In both countries it was clearer than crystal to the lords of the State preserves of loaves and fishes, that things *in general were settled for ever. It was the year of Our Lord one thousand seven hundred and seventy-five. Spiritual revelations were conceded to England at that*

9/10 FRUTIGER 2.7 CPP

Frutiger set justified on a 14½ pica measure with the number of characters per pica (CPP) indicated.

It was the best of times, it was the worst of times, it was the age of wisdom, it was the age of foolishness, it was the epoch of belief, it was the epoch of incredulity, it was the season of Light, it was the season of Darkness, it was the spring of hope, it was the winter of despair, we had everything before us, we had nothing before us, we were all going direct to Heaven, we were all going direct the other way — in short, the period was so far like the present period, that some of its noisiest authorities insisted on its being received, for good or for evil, in the superlative degree of comparison only. There were a king with a large jaw and a queen with a plain face, on the throne of England; there were a king with a large jaw and a queen *with a fair face, on the throne of France. In both countries it was clearer than crystal to the lords of the State preserves of loaves and fishes,*

10/11 FRUTIGER 2.5 CPP

It was the best of times, it was the worst of times, it was the age of wisdom, it was the age of foolishness, it was the epoch of belief, it was the epoch of incredulity, it was the season of Light, it was the season of Darkness, it was the spring of hope, it was the winter of despair, we had everything before us, we had nothing before us, we were all going direct to Heaven, we were all going direct the other way — in short, the period was so far like the present period, that some of its noisiest authorities insisted on its being received, for good or for evil, in the superlative degree of comparison only.

There were a king with a large jaw and a queen with a plain face, on the throne of England; there were a king with a large jaw and a

11/12 FRUTIGER 2.3 CPP

Galliard, a contemporary adaptation of one of Robert Granjon's sixteenth-century typefaces, was designed between 1978 and 1981 by Matthew Carter, the renowned English typeface designer. Galliard is one of the new breed of typefaces in which the designer was aided by a computer to achieve his goal.

This Old Style typeface with its slightly squared serifs and large lowercase letterforms is one of the most readable and elegant of the contemporary typefaces. Galliard is available in eight variations; it is equally at home in books, annual reports, and newsletters.

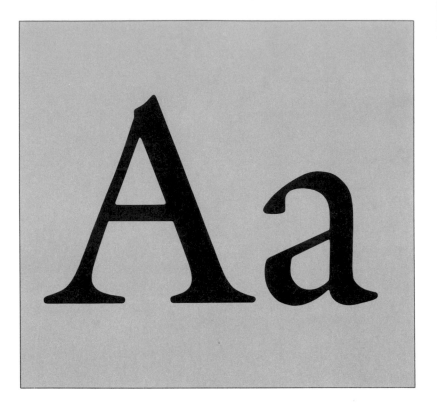

ABCDEFGHIJKLMN
OPQRSTUVWXYZ
abcdefghijklmnop
qrstuvwxyz
1234567890$.,"-:;!?&

54 POINT GALLIARD

It was the best of times, it was the worst of times, it was the age of wisdom, it was the age of foolishness, it was the epoch of belief, it was the epoch of incredulity, it was the season of Light, it was the season of Darkness, it was the spring of hope, it was the winter of despair, we had everything before us, we had nothing before us, we were all going direct to Heaven, we were all going direct the other way — in short, the period was so far like the present period, that some of its noisiest authorities insisted on its being received, for good or for evil, in the superlative degree of comparison only. There were a king with a large jaw and a queen with a plain face, on the throne of England; there were a king with a large jaw and a queen with a fair face, on the throne of France. In both countries it was clearer than crystal to the lords of the State preserves of loaves and fishes, that things in general were settled for ever. It was the year of Our Lord one thousand seven hundred and seventy-five. Spiritual revelations were conceded to England at that favoured period, as at this. Mrs. Southcott had recently attained her five-and-twentieth blessed birthday, of whom a prophetic private in the Life Guards had heralded the sublime appearance by announcing that *arrangements were made for the swallowing up of London and Westminster. Even the Cock-lane ghost had been laid only a round dozen of years, after rapping out its messages, as the spirits of this*

8/9 GALLIARD 3.4 CPP

It was the best of times, it was the worst of times, it was the age of wisdom, it was the age of foolishness, it was the epoch of belief, it was the epoch of incredulity, it was the season of Light, it was the season of Darkness, it was the spring of hope, it was the winter of despair, we had everything before us, we had nothing before us, we were all going direct to Heaven, we were all going direct the other way — in short, the period was so far like the present period, that some of its noisiest authorities insisted on its being received, for good or for evil, in the superlative degree of comparison only. There were a king with a large jaw and a queen with a plain face, on the throne of England; there were a king with a large jaw and a queen with a fair face, on the throne of France. In both countries it was clearer than crystal to the lords of the State preserves of loaves and fishes, that things in general were settled for ever.

It was the year of Our Lord one thousand seven hundred and seventy-five. Spiritual *revelations were conceded to England at that favoured period, as at this. Mrs. Southcott had recently attained her five-and-twentieth blessed birthday, of whom a prophetic private in the Life*

9/10 GALLIARD 3.0 CPP

Galliard set justified on a 14½ pica measure with the number of characters per pica (CPP) indicated.

It was the best of times, it was the worst of times, it was the age of wisdom, it was the age of foolishness, it was the epoch of belief, it was the epoch of incredulity, it was the season of Light, it was the season of Darkness, it was the spring of hope, it was the winter of despair, we had everything before us, we had nothing before us, we were all going direct to Heaven, we were all going direct the other way — in short, the period was so far like the present period, that some of its noisiest authorities insisted on its being received, for good or for evil, in the superlative degree of comparison only. There were a king with a large jaw and a queen with a plain face, on the throne of England; there were a king with a large jaw and a queen with a fair face, on the throne of France. In both countries it was clearer than crys-*tal to the lords of the State preserves of loaves and fishes, that things in general were that things in general were settled for ever. It was the year of Our Lord one*

10/11 GALLIARD 2.7 CPP

It was the best of times, it was the worst of times, it was the age of wisdom, it was the age of foolishness, it was the epoch of belief, it was the epoch of incredulity, it was the season of Light, it was the season of Darkness, it was the spring of hope, it was the winter of despair, we had everything before us, we had nothing before us, we were all going direct to Heaven, we were all going direct the other way — in short, the period was so far like the present period, that some of its noisiest authorities insisted on its being received, for good or for evil, in the superlative degree of comparison only. There were a king with a large jaw and a queen with *a plain face, on the throne of England; there were a king with a large jaw and a queen with a fair face, on the throne of France. In both coun-*

11/12 GALLIARD 2.5 CPP

Printing

By what process does a design become a printed page? While this question may be of little concern to the average reader, to the designer it is critical.

The printing process has a major impact on design and determines to a large extent the designer's choice of type, illustrations, and paper. The more the designer—and you—know about printing, the better you will be able to control the quality and cost of a job.

The following section offers a brief overview of the printing process, focusing on the most popular method used today; offset lithography.

Perhaps the best way to understand the printing process is to begin with black-and-white printing. (For color printing, see page 114.) This procedure starts when all mechanicals and related art are approved and then submitted to the printer. In printing terminology this material will fall into two categories: *line copy* and *continuous-tone copy*. Each has unique characteristics and must be handled differently in order to prepare it for reproduction.

Line copy is any image that is made up of solid blacks having no gradation of tone: lines, dots, rules, solid masses, etc. (1). Line copy is also the simplest and least costly to reproduce. The type you are now reading is line copy.

Continuous-tone copy is any image that has a full range of tones from white to black. Examples of continuous-tone copy are original photographs, charcoal drawings, and pencil sketches. If you look closely at a black-and-white photograph, you will notice that the tones vary and seem to blend into one another, resulting in a range of gray values. The printer must reproduce these gray tones exactly as you see them with only black ink.

Because a printing press can only print solid tones, continuous-tone copy must first be converted into line copy before it can be reproduced. This is done by photographing the art through a screen. Therefore, if you look closely at a reproduction of a photograph in a book or magazine, you will notice that the image is composed of tiny dots (2).

1

1 This caricature of Charles Dickens along with his signature are both examples of line art.

2 Continuous-tone copy, such as a photograph, must first be converted into line copy before it can be reproduced. This illustration shows an enlarged detail of a photograph after being converted into line copy.

The first step in the printing process is to photograph the line and continuous-tone copy using a special camera, called a *process* or *copy camera*.

Line copy is exposed to a high-contrast film that reduces everything to either black or white. This film is then developed, producing a *line negative* (1).

Continuous-tone copy, on the other hand, is shot through a fine screen positioned in direct contact with the unexposed film (2). The screen reduces the continuous-tone copy into thousands of tiny solid dots varying in size, shape, and number. When printed, these dots give the illusion of the original tones.

Screens come in a variety of styles (elliptical, square, and chain) and are usually chosen by the printer. Selecting the most appropriate screen is determined by the type of image to be reproduced and factors such as availability and printing technique.

All screens are measured by the number of lines per inch. Although the most common are 55, 65, 85, 110, 120, 133, and 150, some screens can go as high as 300. The more lines per inch, the finer the dot pattern, and the higher the quality of the reproduction. For example, a 55-line screen has 3,025 dots per inch while a 150-line screen has 22,500. The more dots the printed image, or *halftone*, contains, the more it will resemble the original (3).

The correct screen for a given job is determined by the printing press, the printing ink, and to a great extent, the paper. Newspapers, with their rough surface and high-speed presses, require a coarse 85-line screen. If a finer screen were used, the space between the dots would fill in and the details would suffer.

Publications printed on smooth, coated paper accept much finer screens, thus producing high-quality halftones containing more dots and excellent detail. Magazines, therefore, can utilize screens of around 150 lines, while fine books can use screens of 200 lines or higher.

1

2

3

1 After the line copy has been photographed, a line negative is produced.

2 Continuous-tone copy is converted into line copy by shooting through a screen which breaks the image into solid dots. Shown here is an enlarged detail of a screen.

3 By shooting the same image through four different screens, one can see that the finer the screen, the greater the detail.

Halftones, Veloxes, and Line Conversions

The conventional halftone is usually referred to as a *square halftone*, which means that all the corners are at right angles (1). There are a number of options available to the designer, which can create dramatic effects when used with imagination and good judgment. While some can be produced with handwork or computers, others require special screens.

One of the most common variations is the *silhouette halftone,* in which the important area is highlighted by removing the background. This can be done either photographically or by hand (2).

Another possibility is the *dropout halftone*, where specified areas have been highlighted by eliminating the screened dots (3). By removing the dots, the treated areas appear brighter. This technique is often used in advertising to highlight a product.

A *vignette halftone* is used to make the image fade softly into the white of the page, imparting an old-fashioned appearance (4). Vignettes, as with other custom halftones, are usually done by hand and are, therefore, time-consuming and expensive. Although some custom halftones can be produced more quickly, utilizing emerging computer technologies, this may incur even greater expense.

A useful technique is to combine line copy with continuous-tone copy to produce a *combination line and halftone* (5). In this method the line copy is not screened and maintains the strength of its solid blacks.

Halftones are usually created by the printer. An exception to this is the *velox*, which is a screened print on paper that can be pasted directly onto the mechanical and shot with other line copy (6). Veloxes are often used by the designer on small jobs to save on the cost of stripping. The savings may be dubious, as the quality of a velox is generally inferior to that of a halftone.

Special screens can be used to create a wide range of custom effects, such as *mezzotint* (7), *vertical straightline* (8), or steel etch (9). These are usually referred to as *line conversions* and are relatively inexpensive compared to special halftones.

Line conversions are generally handled by the printer. However, they can be obtained by the designer as paper prints and pasted directly onto the mechanical and shot as line copy.

1 Square halftone is the most common method of converting a continuous-tone photograph.

2 In a silhouette halftone, the background is eliminated to highlight a particular area or subject.

3 Dropout halftones highlight areas by dropping out the dots and having the paper show through.

4 Vignette halftones can be used to create a soft shape on the page.

5 A combination line and halftone technique is used to maintain the strength of the line art.

6 Veloxes are paper halftones which can be pasted directly onto the mechanical.

7, 8, 9 Line conversions can add interest to otherwise uninspiring halftones. *Mezzotints, vertical straight lines,* and *steel etches* are just three such examples.

1

2

3

4

5

6

7

8

9

After the printer has photographed all the mechanicals and art, the film negatives must be assembled or "stripped" in their final position to produce a *flat* (1). This operation is referred to as *stripping*. A flat is required in order to produce a *printing plate*. From this flat, a paper proof, called a *blueprint,* is made and submitted for approval (2).

Any corrections or changes should be clearly indicated on the blueprint as a guide for both the designer and printer. The mechanicals must then be corrected. The printer will then reshoot the mechanical(s) and strip the corrected negatives into the flat. In some cases, simple changes, such as deleting an isolated line or word, can be accomplished by "opaquing" or blacking out the element from the film. This is a change that incurs little effort or expense.

If mistakes or additions are extensive, a new blueprint should be prepared and approved by the client. When all parties are fully satisfied with the blueprints, the corrected flat is ready for platemaking. It should be noted that a signed blueprint is a legal contract permitting the printer to proceed with the job.

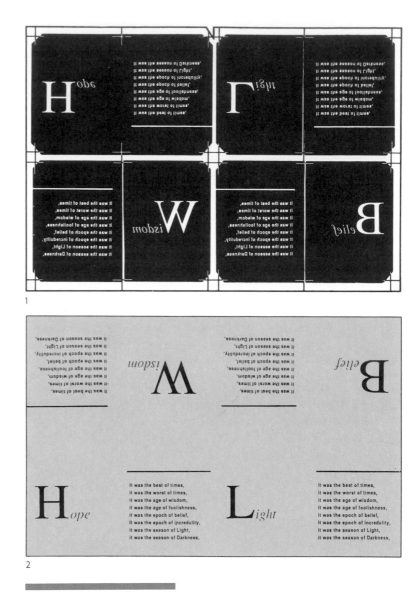

1

2

1 After the copy is shot, the various negatives are assembled into pages as dictated by the layout and imposition of the printed piece. These assemblages are called *flats.*

2 A paper proof, called a *blueprint,* is made from the flat. Once approved by the client, the printer can proceed to platemaking.

A printing plate is made by exposing the flat onto a thin light-sensitive metal plate, and then processing this plate through a chemical bath. All printing plates have one thing in common: the area to be printed must stand apart from the nonprinting area.

There are three major printing processes that are used to separate the printing and nonprinting areas: in *letterpress* the printing area is raised (1); in *gravure* the printing area is lowered (2); and in *offset lithography* both areas are on the same level and the plate is chemically treated so that the printing area accepts ink and the nonprinting area rejects it (3). Today, offset lithography is by far the most widely utilized method of printing.

Other methods of graphic reproduction include *screen printing*, *flexography*, *collotype*, and *thermography*. These are usually used for specialized tasks. (See glossary for description of these processes.)

1 There are three major printing processes. Letterpress, which is printing from a raised surface, is the oldest.

2 Gravure, also referred to as intaglio or engraving, is a process in which the image area is etched below the surface of the printing plate. The image is transferred to the paper by means of pressure.

3 Offset lithography is a chemical or planographic printing process based on the principle that water and grease (printing ink) do not mix.

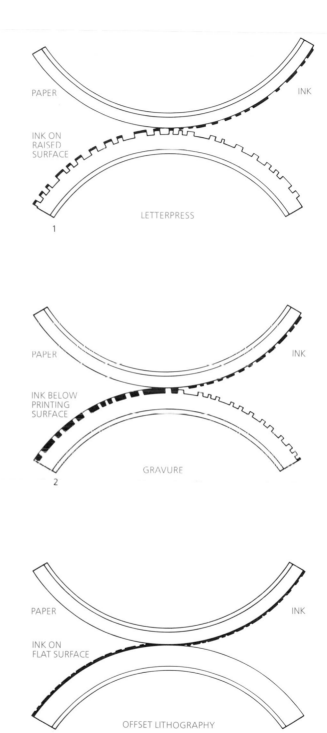

PAPER INK

INK ON RAISED SURFACE

LETTERPRESS

1

PAPER INK

INK BELOW PRINTING SURFACE

GRAVURE

2

PAPER INK

INK ON FLAT SURFACE

OFFSET LITHOGRAPHY

3

Offset lithography

Offset lithography owes its popularity to a number of factors. It is economical, versatile, and capable of printing high-quality images on a wide range of varied surfaces.

From the designer's point of view, offset lithography offers great flexibility—practically any two-dimensional art can be printed by offset lithography.

The lithographic process was invented in 1796 by a Bavarian named Aloy Senefelder. Lithography, which means "stone writing," was based on the simple principle that water and grease do not mix.

In the process of lithography the image to be printed is drawn directly on a smooth slab of limestone with a grease crayon. The stone is then sponged with a solution of water, gum arabic, and acid. The greasy image area rejects the solution and the nonimage area accepts the solution.

The opposite occurs when the ink is applied to the stone; the image area accepts the ink and the nonimage area rejects the ink (1). The image is then transferred with a press from the stone to the paper.

Although this lithographic process is still practiced by many fine artists (2), it is "offset" lithography which dominates commercial printing. In offset lithography the flat stone has been replaced by three cylinders, which are referred to as *plate*, *blanket*, and *impression*.

In operation, the printing plate is dampened with a water solution which the image rejects and the nonimage area accepts. Next, the plate is inked and the opposite occurs; the image area accepts the ink. The inked image is then transferred from the plate cylinder to the blanket cylinder, which in turn "offsets" or prints the image onto the paper as it passes between the blanket cylinder and the impression cylinder (3).

Offset lithographic presses are available in a wide range of sizes from small office duplicators to huge *web-fed* (continuous sheet) *perfecting presses* (which print both sides simultaneously), capable of printing entire books in a single pass in a range from one to eight colors (4).

1

2

1 In the original lithographic process, the artist drew directly on the stone with a grease crayon. The stone was then chemically treated so that the image area would accept ink, and the non-image area would reject it.

2 A nineteenth-century lithograph by Henri de Toulouse-Lautrec.

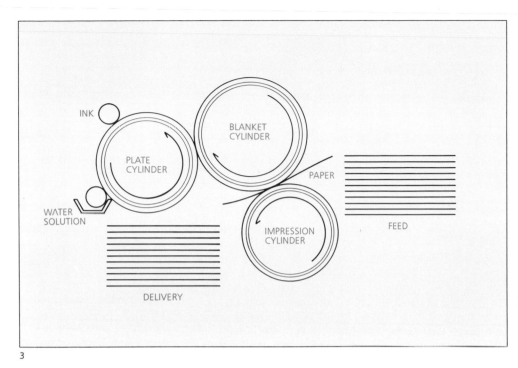

INK

BLANKET
CYLINDER

PLATE
CYLINDER

WATER
SOLUTION

PAPER

IMPRESSION
CYLINDER

FEED

DELIVERY

3

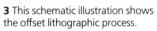

3 This schematic illustration shows the offset lithographic process.

4 Today, offset lithography is by far the most popular printing process. Shown here is a Heidelberg Speedmaster, capable of printing five colors in a single pass.

4

Color is one of the designer's most effective tools: it attracts attention, creates sales appeal, and clarifies complex designs.

Flat color, or *match color*, is any color specified by the designer that the printer must match. The colors chosen are usually part of a color system, such as the Pantone Matching System,® more commonly referred to as PMS® (1). A less utilized method is to ask the printer to match a piece of colored paper or detail from a sample piece.

The Pantone Matching System® is based on eleven Pantone colors (nine basic colors plus black and transparent white), which when mixed in varying amounts produce a total of 500 different colors. All the colors are numbered and arranged in a book. These "swatchbooks" are usually divided into two sections, one showing the colors printed on coated stock and the other on uncoated stock. (See Paper, page 117.)

When a color is selected, the designer attaches a small swatch of the color to the mechanical. The printer's swatchbook includes ink mixing instructions, allowing the color to be reproduced with reasonable accuracy.

Flat color printing is designated by the number of ink colors used: one-color, two-color, three-color, and so forth (or 1/C, 2/C, 3/C, etc.). Each color requires a separate printing plate; the more colors used, the more expensive the job. Most flat color jobs use from one to four colors, with two colors being the most common.

A one-color job means just that—one ink is used—whether black, red, blue, or green. If your budget limits you to one color, and you wish to create the appearance of a two-color job, you may wish to consider a colored stock. Remember, however, that most printing inks are not opaque, so any color in the stock will affect the color of the ink.

Printing more than one color offers great potential: the colors can be specified as solids, screened tints, or used in combination (2). Screened tints are available in a wide range of percentages, usually between 10% and 90%.

Other flat color techniques include *surprinting*, printing the image over a tint or halftone (3); *overprinting*, printing one color on top of another color (4); or *reversing*, dropping the type or the image out of the background (so the type takes on the color of the exposed paper) (5). When using any of the above techniques, care should be taken to make sure all type can be read.

Color can also be used to enhance halftones to create a *flat-tint halftone* or a *duotone*. The flat-tint halftone is a process where a halftone is printed over a flat background tint of another color (6).

The duotone is a more sophisticated two-color option. This is a special halftone in which the photograph is shot twice, once for the black plate and then for the color plate (7). The black plate is usually shot for contrast, and the color plate for the middle tones; when combined on press the effect is usually subtle and attractive.

PANTONE®
Warm Gray 7 C

1

1 This color chip was taken from the Pantone Matching System© swatchbook. Shown here is Pantone® Warm Gray 7C the second color used throughout this book.

2 Any color can be screened to produce a wide range of tints. Black is often screened to create shades of gray.

3 Surprinting is a technique of printing a color over itself. In this case, solid black type has been combined with a 20% screen.

4 Overprinting is printing one color over another. Here, solid black type has been printed over a block of Pantone® Warm Gray 7C.

5 Reversing is the technique of dropping out the type or image so that the paper shows through.

6 Flat-tint halftone is the technique by which a halftone is printed over a flat background tint of another color.

7 A duotone is a custom halftone in which the image is shot and printed twice, once for each color.

10% 20% 30% 40% 50%

60% 70% 80% 90% 100% (SOLID)

2

SURPRINTING OVERPRINTING REVERSING

3 4 5

6 7

Process Color Printing

Four-color process printing is the method used to reproduce full-color copy, such as transparencies, color prints, and paintings. The four colors used to print an image are yellow, red (magenta), blue (cyan), and black. They are referred to as the *process colors*.

The first step to printing high-quality, full-color images is to start with the best color transparencies possible. Look for balanced color, proper focus, and correct exposure. From these transparencies, color separations will be made, resulting in four pieces of film, one for each process color.

This is usually done on a laser scanner which electronically "reads" the colors and produces screened negatives from which the printing plates will be made (1). (Unscreened negatives or positives can also be created by a scanner if required by the printer.)

When printed, the screened dots combine in various sizes and patterns to approximate the full range of tones found in the original. If you study a full-color reproduction through a magnifying glass, you will note that the colors are created not by a physical mixing of inks, but by the optical mixing of the four original colors by the viewer's eye.

Process colors can also be used to create a wide range of custom colors. This is achieved by combining tints of two or more process colors. This technique can be used to reproduce black-and-white line copy in color or to approximate a PMS® color. Designers often take advantage of this option when a job prints in process colors.

1 Today, most color separations are produced by lasers. A schematic of a laser scanner illustrates how the original full-color image is broken down into four film negatives, one for each of the process colors: red, yellow, blue, and black. When printed these four colors combine to give the illusion of the original full-color image.

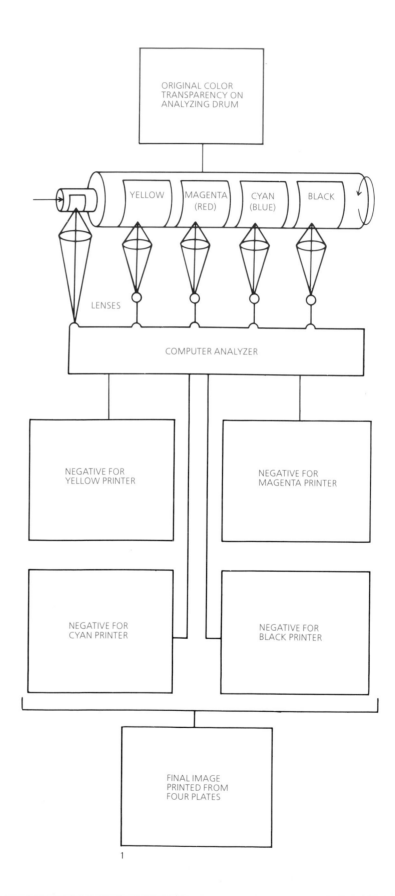

Before the job is printed, the designer, and often the client, will receive a sample of the printed piece, called a *proof*, to be checked for size and quality. The proof can be made from either the printing plates, called a *press proof*, or the screened separations, called a *pre-press proof*.

Press proofs are the most accurate because they are made from the printing plates and use the same paper and ink that will be used for the final job. They are also the most expensive.

Press proofs are usually accompanied by a set of *progressive proofs*, more commonly called *progs*. Progs consist of a number of sheets, each showing a process color by itself and in combination with others. Progressive proofs are invaluable to the printer when it comes time to make color corrections.

Pre-press proofs are much more common, because they are made from screened separations and are less expensive. No plates or printing is involved. The two most common methods are the *overlay system* (1), where four sheets of acetate representing the process colors are overlaid to make up the image (an example of this is the 3M Color Key™ Process), and the *transfer* system (2), where colored powders are burnished onto a pretreated carrier sheet. While both methods produce reliable proofs, the Chromolin® Process is generally considered superior.

Most proofs carry a *color bar* outside the image area showing the process colors, tints, numbers, and devices such as stars, targets, slur bars, and so forth. This is of little concern to either the designer or the client, but is invaluable to the printer. It indicates whether the colors are accurate, if the plates are in register, and countless other factors that control the quality of the job.

Color proofs should be checked not only for accuracy of color, but for such obvious things as size, spots, and scratches. Since the light source can affect how colors appear, proofs should be checked using the industry light standard of 5,000° Kelvin. This is the same light source used by the printer for inspecting color.

Although a number of people may be required to see the proofs, only one person should have the responsibility of recommending changes and final approval. All comments and alterations should state what is wrong with the proofed image and not try to suggest how to make corrections, which is the printer's responsibility. If the changes are extensive or corrections critical, it is advisable to request a corrected proof.

When comparing a transparency to the printed image, or proof, don't expect the image to match the brilliance of the transparency. Allowances must be made for the fact that the transparency is viewed by light passing through it, which gives the color a brilliance that could never be matched by ink on paper.

YEL
MAG
CYN
BLK

1

YEL MAG CYN BLK

2

1 A schematic of the overlay color proofing system in which four-color acetate sheets are combined to create a color proof.

2 A schematic illustrating the transfer system of color proofing using colored powders of the process colors.

The choice of paper plays a great role in how a printed piece is ultimately perceived. Choosing the right paper is a combination of personal preference and common sense.

The paper must satisfy the design requirements, the demands of the printing process, and the economic considerations. The finest art and design risk being compromised if printed on an inappropriate stock.

All papers are described and recognized by certain common characteristics: *size*, *weight*, *finish*, *color*, *bulk*, *opacity*, and *grain*. Each of these must be taken into consideration when selecting paper. A brief description of each characteristic is listed below.

Size. Each type of paper is available in a range of sizes with each paper category having one size that is considered standard. It is this standard size that is used to determine the weight of paper as well. Choosing the right size sheet is important to prevent wastage.

Weight. Also referred to as *basis weight*. This is the weight of 500 sheets of paper in its standard size. The number is given in pounds, for example, 80 lb. or 100 lb. This book is printed on 80 lb. book paper.

Finish. This refers to the way the surface of the paper has been treated. The two major finishes are coated and uncoated. The coated is preferable for the reproduction of both halftones and full-color images.

Color. Papers are produced in a wide range of colors and whites. Most jobs are printed on white paper and the color added by applying printing ink. This assures that highlights of the reproductions will be bright.

Bulk. Bulk describes the thickness of the sheet and ultimately the thickness of a book or printed piece. The most common method of measuring bulk is by pages-per-inch, or *PPI*. Designers will often choose a bulky paper to give a thin brochure or catalog a more substantial appearance.

1

1 Opacity gauges are used to determine the "show through" quality of a sheet of paper. By laying various sheets over the gauge, one can make the most appropriate choice.

2 Images reproduced on coated papers result in bright, accurate colors because the smooth surface reflects light uniformly. Uncoated papers, on the other hand, have uneven surfaces and tend to absorb ink, thus dulling the image.

Opacity. The quality of a paper to take ink on one side without having it show through on the other. If the paper you choose is not sufficiently opaque, the type will show through and not only distract the reader, but affect readability (1).

Grain. The grain of the paper is the direction in which the fibers line up when the sheet is produced. It is in this direction that the paper folds and tears most easily. Because all production paper possesses grain, the printer takes this into consideration when your job is planned.

Besides the above characteristics, printing papers can be broadly divided into four categories: *newsprint*, *writing papers*, *cover papers*, and *book papers*.

Newsprint. This is a low-grade paper used when permanence is unimportant. It lacks strength, has limited printing qualities, and tends to discolor. For these reasons its use is generally confined to newspapers and mass market paperbacks. Although newsprint leaves much to be desired, it can be used effectively for low-cost jobs.

Writing papers. These consist of *bond*, *ledger*, and *business papers*. They are available in a wide assortment of qualities and colors. The category of most interest to the designer is the bond, as it is the standard for stationery. The greater the rag content, the higher the quality: 25%, 50%, 75%, and 100% are the most common grades.

Writing papers are available in several weights, many colors, and two basic finishes: *laid* and *wove*. Laid has the traditional look of handmade paper, with a pattern of parallel lines running through the sheet. Wove has a uniform, slightly textured surface. It is not uncommon for writing papers to have watermarks.

Cover stock. This is a heavyweight paper and, as the name suggests, is used primarily for magazines, paperbacks, brochures, etc. It is available in a wide assortment of colors, weights, and finishes. Many cover stocks are designed to be compatible with book papers.

Book papers. Book papers encompass the widest range of printing papers and are, therefore, of particular interest to the designer. They can be used for practically every purpose. Book papers can be divided into two major categories: *coated* and *uncoated*.

Uncoated paper is the most basic, least sophisticated type of sheet. It is produced without any special coating. Coated papers have a special clay coating which gives the paper an extremely smooth finish. The finish of a coated paper may be dull, matte, or glossy. The higher the gloss, the more brilliant the reproduction of halftones or color images (2).

The purpose of this coating is to bury the fibers so that the ink rests on the surface, rather than being absorbed into the paper. This gives coated papers excellent ink *holdout*. The higher the ink holdout, the more brilliant the printed image will appear.

2

UNCOATED PAPER COATED PAPER

Envelopes

Envelopes are also an important part of a project and should be considered early in the design process. Make certain that the desired envelopes are available and that the piece to be enclosed will fit—allow at least 1/8" on all sides.

While custom envelopes can be created, you will find that the standard sizes are much more economical. If a design calls for a nonstandard format or an unusual color, check with your local post office for mailing restrictions or surcharges.

Paper manufacturers produce envelopes in a wide range of styles, colors, and sizes. The following are a few of the popular categories (1).

Commercial and official. This envelope style is probably the most widely used. It is available in a wide range of papers, sizes, and colors. The #10 is used for standard stationery.

Window. Window envelopes allow for the address to show through a glassine window. When using window envelopes, the designer should carefully position the address so that it will not be obscured.

Booklet. This style is generally used for brochures and direct mail pieces. Booklet envelopes have flaps running across the long side.

Catalog. This is a popular envelope for the mailing of heavier materials, such as catalogs, thick brochures, or magazines. These envelopes are usually made with heavier stock and have flaps running across the short side.

Announcement text. As the name suggests, this style envelope is primarily used for invitations and announcements. Designers often use this style when a reply envelope must be enclosed.

1 When planning a job involving envelopes, keep in mind there are standard sizes which will save you time and money.

BOOKLET

NO.	SIZE
2½	4½ x 5⅞
3	4¾ x 6½
4¼	5 x 7½
4½	5½ x 7½
5	5½ x 8½
6	5¾ x 8⅞
6½	6 x 9
6¾	6½ x 9½
7	6¼ x 9⅝
7¼	7 x 10
7½	7½ x 10½
8	8 x 11⅛
9	8¾ x 11½
9½	9 x 12
10	9½ x 12⅝
13	10 x 13

COMMERCIAL/OFFICIAL

***WINDOW**

NO.	SIZE
6	3⅜ x 6
* 6¼	3½ x 6
* 6¾	3⅝ x 6½
*7	3¾ x 6¾
7½	3¾ x 7⅝
*7¾	3⅞ x 7½
Data Card	3½ x 7⅝
*8⅝	3⅝ x 8⅝
*9	3⅞ x 8⅞
*10	4⅛ x 9½
10½	4½ x 9½
*11	4½ x 10⅜
*12	4¾ x 11
*14	5 x 11½

CATALOG

NO.	SIZE
1	6 x 9
1¾	6½ x 9½
2	6½ x 10
3	7 x 10
6	7½ x 10½
7	8 x 11
8	8¼ x 11¼
9½	8½ x 10½
9¾	8¾ x 11¼
10½	9 x 12
12½	9½ x 12½
13½	10 x 13
14¼	11¼ x 14¼
14½	11½ x 14½

ANNOUNCEMENT

NO.	SIZE
A-2	4⅜ x 5⅝
A-6	4¾ x 6½
A-7	5¼ x 7¼
A-8	5½ x 8⅛
A-10	6¼ x 9⅝
Slim	3⅞ x 8⅞

1

To ensure that your job is properly printed, you may wish to visit the printer and watch your job "going on press." Besides assuring yourself that the press sheets meet your requirements, visiting a printing plant is an excellent opportunity to increase your knowledge of the printing process. In most cases you will be accompanied by the designer.

Because there are any number of final details and preparatory requirements, allow ample time. Even a press check on a small job can require half a day. Large jobs may print over several days and perhaps on different presses; you will be called in at critical approval stages. But these approvals may take hours and last into the early morning. Bring something to read!

Regardless of the time it takes, a press check is exciting. Seeing ink on paper makes all the hours of preparation, revision, and anxiety suddenly seem worth it. The noise and smell of the pressroom lends an intensity that the average reader will never experience or appreciate.

Your task is to forget what is going on around you and examine the press sheet for apparent shortcomings. Did that rich blue color you specified find its way onto the press sheet? Are all the elements in register? Are the four-color images clean, crisp, and free of little spots and imperfections? Take a good hard look as the sample sheets come off the press. Are any changes or corrections necessary?

Some things are not difficult to change. Flat colors, for example, can be easily darkened without washing off the rollers and applying a new color. Minor deletions can often be burnished, or taken off the printing plate without delaying the job.

However, there is usually a charge by the hour for any delays that are not directly attributable to the printer's error. While minor changes are inexpensive, more complex alterations can become quite costly. For example, suppose you find a misspelled word at this stage. The press will have to be stopped, the mechanical quickly fixed (usually by "borrowing" type from another mechanical), a new film made, a new plate produced and put on press, and the job rerun.

This kind of time-consuming delay is particularly serious for another reason. If there is a job waiting to go on press following yours, you may lose your "press-hold" and have to reschedule.

At times you may find it wise to compromise; a printed piece rarely matches a comp precisely. For example, with flat color the paper used in the comps may have faded. Or perhaps the comp was viewed through an acetate overlay which distorted the color by making it appear glossy.

Four-color images present greater challenges, especially if multiple images are printed on the same sheet. If one image portrays a rich blue sky and the neighboring image has a dense red tomato, it may be impossible to print both colors accurately.

Work with the printer, explain the perceived shortcomings, and ask for suggestions. Most press operators take pride in their profession and strive for perfection. Don't be accusatory, and never explain how to correct a problem. Designers are aware of this and pose their questions as suggestions, saying things such as, "This green seems to be a bit weak, almost yellowish. Can we do something about that?"

To meet your standards, an experienced press operator can usually push the equipment to its quality limits and will do so if you can maintain patience, calmness, and perseverance. It is truly remarkable how much can be achieved on press.

By taking advantage of the opportunities to inspect the job while on press, you will gain experience and reduce the risk of unpleasant surprises. Knowing a few days ahead of time that the color is just right or the matte varnish was a good idea is reassuring.

Binding

The term *binding* generally refers to any trimming, folding, or assembly operation that takes place after a design has been printed. Although some printers have the capability to bind a project in-house, in most instances the binding process is handled by an independent specialty firm. Either way, the printer usually supervises and takes responsibility for the binding phase.

One of the printer's major concerns is *imposition*. This is the technique of arranging pages on a printed sheet in such a way that they will be in the correct order when the sheet is folded and trimmed. A full press sheet will normally print in units of 4, 8, 16, 32, or 64 pages. When folded these units are called *signatures* (1).

Although imposition is the printer's concern, understanding how a press sheet is laid out is advantageous even for simple jobs, such as brochures and flyers.

Producing a small brochure involves trimming and folding. The most common folding methods for a brochure are the *single-fold, accordion, gate-fold,* and *roll-over* styles. A single-fold style will yield a four-page brochure (2). Accordion brochures have the same size panels folded back-to-back (3). Gate-fold, as the name implies, have panels that fold in from one or both sides (4). With a roll-over fold, one panel usually opens to the left and the other panels "unroll" to the right (5).

When producing a brochure, the paper may often crack or fold poorly unless it is *scored*. (See Paper, Grain, page 117.) Scoring relieves the stress on the grain of the sheet and produces a clean, crisp fold. Although more expensive and time-consuming, with heavier papers scoring is a necessity.

The simplest method of binding is to staple the pages together through the fold. This procedure is called *saddle-wire stitching* because a support, called a *saddle,* is usually used to hold the sheets in position while they are being attached to one another. This is a common binding method for magazines and catalogs (6).

It is important to make the distinction between a *self-cover* and a *plus-cover* design. Self-cover pieces use the same paper for the cover as for the text, whereas a plus-cover design uses a different, usually heavier, stock for the cover. When numbering the pages, the cover of the self-cover is page one; in the case of plus-cover projects, page one begins with the first text page.

In those instances where a periodical is too thick for saddle-wire stitching, *side-wire stitching* may be employed. In this case the wires pass through the side of the book, close to the spine (7).

1

2 3

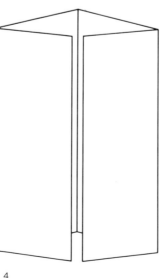

4 5

Another binding method for magazines or less expensive books is called *perfect binding*. In this case the pages are held together and fixed to the cover by means of a flexible adhesive (8). Perfect binding has several advantages over wire stitching. One is the ability to run type and information on the spine, another is the higher quality presentation. The major disadvantage, however, is that the binding may crack quite easily and pages can separate and fall free from the binding. To alleviate this problem, the pages may be sewn together before glue is applied. This strengthens a perfect bound book and holds the pages together.

Hard-bound, or *case-bound*, books usually combine sewing and gluing to create the most durable form of standard commercial binding. These high-quality publications involve the use of stiff boards to protect the text pages and to strengthen the binding (9).

A totally different method of binding is referred to as *spiral-binding*. In this style of binding, all the pages are punched through with a series of holes along the spine. A spiraling steel or plastic band is then inserted through the holes to hold the sheets together, in much the same manner as a three-ring binder (10). There are many forms and styles of spiral binding—some are simple and economical enough to be handled in-house for internal reports and other documentation.

Other operations usually handled by the bindery are *die-cutting, embossing,* and *stamping*. Die-cutting involves punching out a specified area of the sheet for a dramatic effect. Embossing produces a raised image on the surface of the sheet, while stamping often includes the addition of colored foil to enhance the type or image.

Regardless of the binding and finishing operations that a particular design calls for, there are two concerns which must always be addressed: the first involves accuracy and the second, time availability.

Most binding procedures do not involve extremely fine accuracy; for this reason design elements should never be placed exactly at the edge of a sheet, and items to be fitted into envelopes must allow at least 1/8" on every side. Check with your printer or binder before accepting a design that cannot be produced.

The binding process often requires more time than even the printing stage and cannot be rushed. Often a great deal of handwork is required. Keep this in mind during the planning stages and avoid procedures that might not be practical within your time (and cost) restraints.

1 Jobs with multiple pages must be carefully planned so that when press sheets are folded into signatures, the pages fall in the correct order.

2 Single-fold, four-page brochure.

3 Accordion, eight-page brochure.

4 Gate-fold, eight-page brochure.

5 Roll-over, eight-page brochure.

6 Saddle-wire stitched booklet.

7 Side-wire stitched booklet.

8 Perfect bound booklet.

9 Hard-bound, or case-bound book.

10 Spiral-bound book.

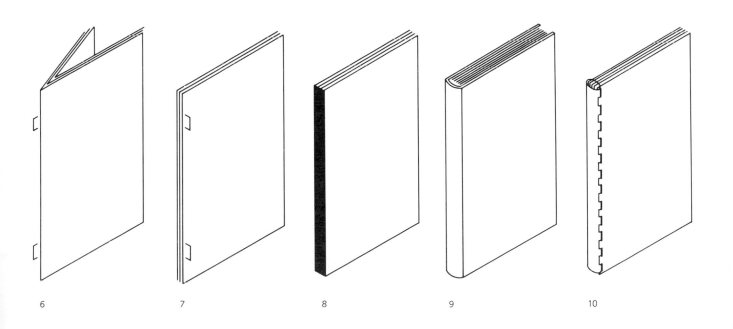

6 7 8 9 10

CREDIT CARDS

MAC WRITE
DESIGNER TEXT

ORIGINAL

Verbatim
DataLife
HD 2MB

Verbatim
DataLife
HD 2MB

Desktop Publishing

For years, the standard sequence of events in producing a typical design would entail the efforts of many individuals performing the following activities: typing a manuscript, developing a design, creating images, setting type, and preparing a mechanical. With desktop publishing, it is now possible for a single person to perform all these tasks while seated at a computer terminal.

The ability to manipulate design elements with unforeseen speed, ease, and economy is the strength of desktop publishing. It is possible to do in hours what once took days or weeks.

For these reasons desktop publishing has become a popular tool in the communications field and has made a significant impact on design and typography: from small design studios to the large public relations firms.

A Typical Desktop System

Desktop publishing systems can be broken down into two major components: *hardware* and *software*. Hardware, or the equipment, includes the *keyboard, monitor,* and *printer* (1). Software refers to the program and information stored on a tape or disk in digital form (2).

The keyboard, or input terminal, is used to type in the copy. Most keyboards have an accessory called a *wand, puck,* or *mouse* that both speeds up the design process and eliminates keystroke commands. By moving the mouse on a flat surface (or the wand across the screen), the operator is able to call up programs and commands, select typefaces, reduce or enlarge design elements, and position copy.

The monitor, or *display terminal,* contains the viewing screen, which permits the operator to observe the design as it develops. The quality of the image and the size of the screen will vary from system to system. Most screens are small, approximately 9 inches diagonally, because they are economical to produce and make the initial purchase market-competitive. However, designers prefer larger video screens so an entire page can be viewed at once.

The printer, or *output terminal,* produces hard copy. The quality of the output is determined by how the type and images are output. There are two basic methods in use today: *dot matrix* and *laser printing* (3).

The dot matrix is the least refined, printing type or images made up of from 40 to 100 lines of dots per inch. The dot matrix is often used for generating rough proofs, especially letters and office documents.

Laser printers, on the other hand, produce relatively high-quality images made up of between 300 to 600 lines per inch. This is more than adequate for internal company communications and newsletters.

For reproduction of the highest quality, disks can be sent to professional typographers who operate high-resolution printers which generate type at up to 2,450 lines per inch (6,002,500 dots per square inch).

An optional piece of hardware is the *laser* or *image scanner* which can "read" or record both line copy and, in some cases, continuous tone images; these are then converted into line copy. Once stored in digital form, the image can be manipulated to fit into a desired space or to create special effects.

Software is stored on a disk and refers to the information and programs that are used in conjunction with the equipment or hardware. Word processing programs such as Claris Macwrite or Microsoft Word are designed for keyboarding manuscripts. These word processing programs are often used in conjunction with design processing or page layout programs such as Aldus Pagemaker and QuarkXpress.

In addition to word processing and design processing programs there is software capable of creating art and illustrations. Two such programs are Apple MacDraw and Adobe Illustrator. Programs are continually updated for efficiency and versatility. At the same time new programs are being created. In many cases a single program has the capability for both word processing and design processing.

Some highly sophisticated programs can be integrated, or *interfaced,* with both desktop publishing equipment and sophisticated pre-press equipment. These programs, such as Crossfield Lightspeed and Scitex Visionary, are leading the way for state-of-the-art graphic communications.

2

3

1 A typical desktop publishing system is comprised of a monitor, keyboard, and laser printer.

2 Information is stored magnetically on floppy disks, diskettes, hard disks, magnetic tapes, and computer chips. Shown here is a 3½" diskette.

3 An enlargement of a single letterform showing the difference in the quality of output between a dot matrix printer and a laser printer.

MONITOR

KEYBOARD MOUSE

1 PRINTER

One of the major advantages of desktop publishing is the ability to "capture keystrokes." Typesetting is expensive, but a significant part of the cost involves retyping the manuscript. With today's technologies, it should not be necessary to have an entire job "rekeyed" after someone has already performed this task. Besides the added cost, rekeyboarding risks introducing errors.

If the designer has the same equipment that you are using, disks can be exchanged or the information can be sent by "modem," a device allowing computers to communicate over common phone lines (1)

If you do not have a desktop publishing setup, you may be able to borrow a terminal from the designer. In which case, you can then keyboard the manuscript and supply the designer with the disk.

Should you and the designer have different systems, such as Apple and IBM, there may be a problem with compatibility. There are, however, some options besides retyping the manuscript, such as converting the disk into a form suitable for use.

Some computer firms specialize in translating information from one form to another. The programmer will need to know the equipment and program used in order to make the conversion. For large amounts of copy, this will save considerable expense. If possible, have the designer or typographer handle this to prevent translation and coding problems.

Another option is to send the disk directly to a professional typographer. State-of-the-art typesetting equipment will accept information directly from personal computers. This approach provides high-quality results and minimizes cost by reducing the typographer's greatest labor expense—inputting the copy.

A third option is to have a manuscript, or other "hard copy," read by an *OCR* machine (2). OCR, which stands for Optical Character Recognition, is a system that deciphers typed letterforms and stores them on a disk compatible with the designer's equipment. Be aware that OCRs may present some problems since marks or slightly misshapen characters may be incorrectly read by the equipment.

Regardless of the method used to capture the keystrokes, they will have no specifications when "called up" on the computer screen; the designer must still specify typeface, size, and leading along with any other information.

1

1 A modem permits computer data to be transmitted over common phone lines, thus speeding up the communication process.

2 OCR, or Optical Character Recognition, machines are capable of reading hard copy and converting it into digital information, which is then stored on disks. Shown here is the DEST 211.

2

Once the operator has all the written copy on disk, it can be "called up" on the screen and the layout process can begin. For this task, the mouse or puck can be used instead of the keyboard.

Design processing offers a wide range of options which are pictured on the screen. By selecting from this menu (1), limitless design possibilities can be generated.

The operator develops a grid, chooses a typeface, arranges illustrations, and produces a final design (2). Although the results can be viewed on the screen in actual size and proportion, the operator usually prints out sample pages to assess the work in progress.

The speed by which the layout can be viewed and the ease by which it can be altered make it simple to view options that would otherwise never be tried. For example, a column of type can be changed in point size, linespacing, and pica measure in a matter of seconds to make it fit a desired layout.

Traditionally, page layout has been the domain of the designer. Desktop publishing has changed this by bringing design tools to the layman, but not necessarily the aesthetic. For this reason, many graphic designers believe that desktop publishing in the wrong hands can lead to poor design. You must determine when it is appropriate to handle a job yourself or turn it over to the designer.

1

2

1 To begin the design process, the operator selects options from the menu and creates a grid.

2 Next, the operator calls up the text copy and experiments with various typefaces and layouts.

Once the operator has produced the final design, the art can be reviewed in-house on a laser printer, usually of 300-line resolution or slightly better (1). Although this output is at times suitable for reproduction, quality work requires another important step.

For high-quality work, the final disk is sent to a typesetting facility where very high-resolution output is generated (2). Artwork with dense blacks, crisp whites, and sharply defined letterforms is returned on photo paper and ready for reproduction.

1

2

1 While developing designs, it is easy to generate proofs on an in-house laser printer. This example shows a 300-line proof.

2 Once a final design is approved, high quality proofs can be generated at a typesetting facility. In this case, the output was generated at 1,500 lines per inch.

Three Projects

The purpose of this section is to demonstrate how a job progresses from inception through completion. Three separate projects —a brochure, stationery, and a newsletter— serve as examples.

The first two projects were produced in the traditional manner, that is, with pencil and paper, whereas the newsletter was designed entirely with desktop publishing equipment.

By combining this specific information with the general information in the preceding sections, you should have a thorough overview of how the design process works.

Brochures are produced in endless variations and are used primarily for direct-mail advertising, promotion, and the general distribution of information. In most cases the format is dictated by standard mailing envelopes. (See Envelopes, page 118.)

The brochure demonstrated here was commissioned by Fordham University to celebrate the annual alumni reunion in addition to raising funds for the benefit of the school (1). The guidelines given the designer were to create something that would be eye-catching and appealing, and would capture the spirit of the occasion.

A moderate budget allowed for high-quality paper, multiple colors, and an uncommon size. In this case the designer was given no restrictions and asked to experiment.

Client: Fordham University

Project description: Eight-page (plus cover), alumni reunion brochure

Format: 7 1/4'' square with 7 1/2'' square envelope

Colors: Four flat colors

Paper: Text: Zaunders, 80 lb. T2000 text (translucent heavyweight paper). Cover: Warren Lustro Offset Enamel Dull, 80 lb. cover

Time was limited, and the designer had already established a working relationship with the client, so the decision was made, and agreed to by the client, to present thumbnail sketches before proceeding to tight comps. Three of the concepts were shown in this manner and discussed in the initial meeting.

The first sketch displayed the intention to use an accordion-fold brochure with large type running across all the panels. This was intended to form a poster effect and boldly present the name of the event (2). Underneath the display type the text would carry information concerning the event, time, place, and all pertinent facts.

The second concept attempted to exhibit a more festive impression. By using a confetti motif combined with some form of formal script lettering, it was felt that this goal could be achieved (3).

The third idea was a bit more ambitious from a production—and possibly budgetary—point of view. This concept involved the use of die-cuts (see page 121) on separate cards, each card carrying specific bits of information. The cut-out areas would allow design elements to appear from the cards below. The cards would be numbered so that in the event that they were shuffled, a possibility the design encouraged, they could be reassembled in the proper order (4).

When designers present multiple solutions, they usually favor one concept above the rest. This presentation was no exception; the designer preferred the third concept since the die-cut cards would provide an eye-catching and engrossing design.

1 Cover of Jubilee brochure for alumni reunion held annually by Fordham University.

2, 3, 4 Some of the early concepts for the Jubilee brochure were accordion folds and die-cuts. All were rejected for various reasons.

5 The final approved design employed translucent stock, Helvetica, hand lettering, and a confetti motif.

1

The client was concerned, however, that the final print cost would exceed the budget, and the information might thus become subservient to the design, become "overpowered," so to speak. The die-cut approach was therefore rejected. The client ultimately preferred the second idea using the confetti motif and script lettering.

Before the first presentation was concluded, other key members involved in the project were consulted, to make sure that the general direction was agreed upon. After additional input by the client and suggestions by the designer, some other points arose. The first was the desire to make the piece more "formal"; the second was to somehow create an interaction between the pages that the die-cut concept had offered.

Although it is often quite difficult to "mix" design elements from distinctive concepts, the designer prepared a full-size comp which achieved this goal. It involved the use of translucent paper, which allowed the images from the following pages to be read through the sheet being observed—like looking through panes of frosted glass.

In order to maintain readability on the translucent pages, the blocks of type were arranged so that no columns would be directly over another on two subsequent pages. The printed matter only appeared on the right-hand pages for the same reason.

Helvetica was used for the basic text because the simple and straightforward blocks of sans serif type were felt to complement the multi-colored confetti and the script lettering (5).

In order to suggest formality, the designer proposed the use of a black cover. The lettering was a hand-drawn script, prepared at a very small size and then blown up. This exaggerated the roughness of the forms and lent an interesting hand-addressed quality to the overall piece.

The client was quite satisfied with the final presentation, the only change being the request to add the university's name on the front cover. The envelope would follow the same format.

At this point the designer marked up the copy for the text type, which was then sent to the typesetter. Proofs were prepared for the designer and client, which could then be proofread (6). Final galleys were then prepared by the typesetter (7).

In addition to text type, the designer needed final art for all the display type. In most circumstances display type would also be prepared by the typographer, but in this instance it had to be hand drawn by the graphic designer. The final art was created by enlarging small calligraphic samples (8).

Following the approved comps, the designer prepared a set of mechanicals (9). These were thoroughly inspected by the client for any final typographical errors that may have escaped the first reviews. The final corrections were made, and the mechanicals were marked up for the printer on a tissue overlay (10). A mechanical was also prepared for the envelope. Both mechanicals were stamped with an approval checklist which each of the parties involved signed (11).

At this point the designer prepared a work order which addressed all the pertinent production facts; this sheet along with the mechanicals was submitted to the printer.

The final printed piece received a gloss varnish over the cover to enrich the black and to prevent fingerprinting. The "Jubilee" theme was very successful and was used on many collateral pieces, from stationery to postcards—establishing a look which was quickly recognized by the university alumni.

6, 7 Typewritten copy was carefully edited by the client, and then marked up by the designer for the typesetter. Typeset galleys were then proofread by both the client and the designer.

8 Display type was created by enlarging and retouching smaller, handwritten samples.

9

10

9 After the type and art was approved, the designer prepared the mechanicals. The text and display type were mounted directly on the mechanical board, while the confetti, which was printed in several colors, was carried on an overlay. Registration marks were required to ensure accurate printing.

10 A tissue overlay protected the mechanical and carried instructions to the printer.

11 The signed mechanical was authorization for both the designer and printer to proceed.

signature	MECHANICAL ARTIST
signature	ART DIRECTOR
signature	PROOFREADER
T. B	CLIENT SIGN OFF
T. B.	FINAL SIGN OFF

11

Today, many companies hire graphic designers to create programs to identify or promote their organization. These *identity programs* range in size and complexity, and usually include a logotype or logo, which is a symbol that represents the company, and type treatments for stationery, brochures, ads, etc. (1).

This project represents a simple identity program created for the New England Savings Bank—an institution that resulted from a merger of The Savings Bank of New London and other New England banks. With a new name, the bank wished to celebrate the merger by establishing a coherent identity program. Because some existing graphics were well established, old concepts had to be integrated with new ones.

The client also commissioned the designer to create a *Graphic Standards Manual* which could be used by local printers and in-house marketing staff as a guide for creating forms, brochures, and ads.

Client: New England Savings Bank

Project description: Identity program with logotype, stationery, and design manual

Format: Standard American sizes for letterhead, envelope, and business cards

Colors: Two

Restrictions: The designer had to integrate some elements from the institution's existing "look."

The first step in developing a new image was to analyze the existing stationery; this was done by both the designer and the client. Because the bank already had a recognized logo, a whale, it was decided to preserve it with significant modifications. The existing logo consisted of the bank's name set in outline type, which in turn was dropped out of a bright green whale (2).

After consultation it was agreed that the existing logo had many apparent weaknesses. The type was difficult to read due to its design and outline form; the overall image had to be reproduced rather large in order to be printed without filling in; the drawing itself was not well executed;

1

2

1 These four logos readily identify the companies they represent.

2 The old logo of a whale that required updating.

3, 4, 5, 6 Four different comps were submitted at the first presentation; they offered a wide range of possibilities.

and the bright green color seemed unappealing and inappropriate for a stately New England bank. The strength of the original logo was that the whale was a recognized symbol for the bank.

At the first meeting the designer met with all key personnel and decisions were made to attempt at least three things: improve the legibility and readability of the type; improve the design of the whale; and give the bank a more stately and classic aura.

Through a review of the design requirements and a series of rough sketches, several conclusions were reached. In brief, it was decided to completely abandon the illegible type, choose a deep blue to replace the green, and experiment with the whale image. Because several board members would be attending the first presentation, the designer chose to develop and submit tight comps in order to avoid misunderstandings.

Four comps were presented. The first employed a redrawn whale with sans serif type. This type when dropped out of a deep blue whale image was far more legible than the original. A one-point rule was also selected to unify the type and logo. For the support type (name, address, telephone number, etc.), a warm gray color was chosen to complement the color of the logo (3).

In the second comp an outline drawing of a large whale was placed across the top of the sheet, its eye aligned with the display type below. In this example the type and whale drawing would be in gray, with the rule and eye in blue (4).

In the third comp the whale was redrawn and placed at the base of the stationery. A logotype was created from the typeface *Trajanus* and four lines of type were arranged at the top left of the sheet. This typeface, designed by Warren Chappell in 1957, was selected because of its classic lineage and majestic appearance. Both the whale and the display type were in blue and the smaller type was in gray (5).

The fourth comp had no whale; instead, large sans serif letters were employed to boldly announce the new name while suggesting a more aggressive tone for the bank. Although one member felt strongly for its use, this example was the first to be eliminated (6).

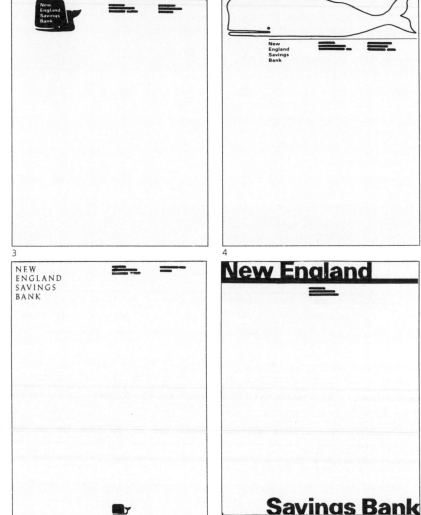

After a lengthy discussion concerning all the comps, the Trajanus type was unanimously preferred for the bank's name, because it captured the dignity and strength which the client wished to project. It was decided to use the whale as a small but prominent element. The color scheme of blue and gray was approved. Since no one design was chosen, another meeting was arranged in which a new comp was to be presented.

For this new comp the whale image was further refined, and the bank's name was presented slightly smaller. This introduced a new concern—one marketing professional felt that the type was too light for all foreseeable applications (7). The bold version, on the other hand, appeared too heavy and was inappropriate from the designer's point of view (8).

Because an in-between weight was not available from a type house, it had to be drawn by hand. Creating a new weight of a typeface is a relatively uncommon and expensive practice for a project of this nature. However, the resulting *Trajanus semi-bold* was to everyone's satisfaction and considered to be well worth the effort (9).

After much trial and error, a final comp of the stationery, showing all elements in position, was prepared (10). Using the same elements, sketches for the envelope and business card were drawn up, specifying exactly how the type should be set and the logos handled (11).

After the final designs were approved, type was set, final art created, and mechanicals prepared . Once the client approved the mechanicals, they were sent to the printer.

To finalize the project, a thirty-two page *Graphic Standards Manual* was prepared to illustrate how the new logo, support type, color, and basic layout should be handled (12).

The success and efficiency of this project was due to a number of factors: decisions were made early, key people were involved throughout, and clear objectives were established.

NEW ENGLAND
7

NEW ENGLAND
8

NEW ENGLAND
9

NEW
ENGLAND
SAVINGS
BANK

63 Eugene O'Neill Dr.
New London, CT 06320
203 442-0301

10

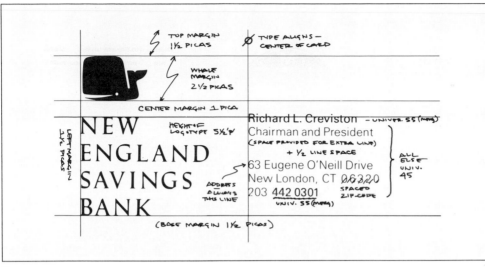

Handwritten annotations:
TOP MARGIN 1½ PICAS
TYPE ALIGNS — CENTER OF CARD
WHALE MARGIN 2½ PICAS
CENTER MARGIN 1 PICA
LEFT MARGIN 1½ PICAS
HEIGHT OF LOGOTYPE 5½'P
ADDRESS ALWAYS THIS LINE

NEW ENGLAND SAVINGS BANK

Richard L. Creviston — UNIVER. 55 (MFG)
Chairman and President
(SPACE PROVIDED FOR EXTRA LINE)
+ ½ LINE SPACE
63 Eugene O'Neill Drive
New London, CT 06320
203 442 0301
UNIV. 55 (MFG)
SPACED ZIP CODE
ALL ELSE UNIV. 45

(BASE MARGIN 1½ PICAS)

11

Basic Logotype

18

Numerous typefaces were presented and reviewed for the **New England Savings Bank** application. Trajanus, designed by Warren Chappell in 1957 for the D. Stempel AG Foundry in Frankfurt, Germany, was chosen for its classic lineage, majestic appearance, and rare usage. Trajanus Semi-Bold letterforms have been created exclusively for the new logotype, further contributing to its uniqueness and distinction.

The letterforms are well spaced and words are stacked with ample leading. Only the capitals are used. The logotype should be presented (executed) in the exact placement and proportion indicated below, except when the full name must appear on one line. The title should always appear either as four lines or one line, never as two or three. In most applications the logotype alone is ample symbol and stateliness for the **New England Savings Bank.**

NEW ENGLAND SAVINGS BANK

The Whale with Internal Type

19

The whale with internal (dropped out) type has a single application: advertising and temporary display where both the logotype and logo must appear with immediate impact and recognition. The deep blue color (pantone 288) is generally required. The special blue (pantone 285) is used where the deeper shade would be misprinted on newspaper stock.

The whale with dropped out type is used for special advertising purposes only – no elements (color or image) from this page are used under normal circumstances.

12

7 The typeface, Trajanus, was selected as the corporate typeface; however, it was felt that the regular weight was too light for all intended applications.

8 Trajanus Bold, on the other hand, was deemed to be too heavy.

9 A custom version of Trajanus was hand lettered and approved.

10 A final comp of the stationery with the new type and redrawn whale in position.

11 As this layout for the business card demonstrates, many design decisions had to be made before the designer was satisfied.

12 On large identity programs, a graphic standards manual is often created. This is to ensure that design consistency will be maintained on future projects. Shown here is a spread from the thirty-six page manual.

One of the most widely used methods of distributing information today is through the use of a newsletter, a printed sheet or brochure that is targeted for a specific group.

An effective and time-saving way to produce newsletters is through desktop publishing, since they usually need to be produced quickly, economically, in standard formats, and on a continuing basis. Once a design is finalized and stored on disk, it's easy to manipulate new text and design elements to generate new issues.

In this example a very simple newsletter is demonstrated (1). Entitled "Metropolis Perspectives," it was scheduled to be produced seasonally for *Metropolis* magazine. The purpose of the newsletter was to reach the audience of marketing and advertising agencies that advertise in *Metropolis* magazine.

Client: Horton-Berman Communications/ Metropolis magazine

Project description: Two-page newsletter (one sheet, both sides)

Format: 8 1/2" x 11"

Colors: Two

Paper: 90 lb. uncoated white

Restrictions: The newsletter was to be produced at minimal cost, and had to be efficiently designed so quarterly issues would be quickly generated. In addition, the spirit of the magazine, aimed at the sophisticated architecture and design community, was to be maintained.

The client agreed on the need for a newsletter to encourage the personnel from various agencies to buy more advertising space in their magazine. After representatives of the magazine met with the public relations consultants, the designer was brought in on the project, copy was written and a working title, "Metropolis Perspectives," was created by the public relations group.

1

2

METROPOLIS

1 A newsletter, entitled "Metropolis Perspectives," aimed at advertising and marketing agencies who buy space in *Metropolis* magazine.

2 It was decided to retain the logo from the monthly magazine, *Metropolis,* for purposes of easy recognition.

3 The designer developed a number of rough pencil sketches before beginning work on the computer.

4 Several options developed on the computer for the display type, Perspectives.

The client suggested the use of the Metropolis logo that appears on the monthly magazine (2). The copy was produced on an Apple Macintosh SE, using the Microsoft Word program. Since the designer used similar equipment, the copywriter simply submitted a disk with the information contained thereon. In addition to the stored information, a sheet of "hard copy" was provided for the designer to review.

The design parameters stressed economy and ease of updating and distributing the newsletter. For these reasons, 8 1/2" by 11" white medium bond paper made the most sense. Another factor discussed was the desire for a quick, contemporary reading piece.

Although the project would be computer-generated the designer chose to present some very rough sketches prepared in the conventional manner. The computer is a powerful design tool, but for initial conceptualizing most graphic designers still feel more comfortable with pencil and paper in the early stages (3).

The client approved of the general direction, and the designer began to develop the concepts on the computer. The first requirement was to create a masthead which incorporated the existing Metropolis logo with a new design for the word Perspectives.

In order to create an interesting type treatment for the name Perspectives, the Adobe Illustrator program was selected. This program permitted type to be manipulated in endless ways. Numerous options were tried until one was found to be acceptable to the designer. Compared to traditional methods of hand lettering, the program saved many hours (4).

Since the Metropolis logo already existed, it could be "scanned" and then called up on the screen. This was accomplished using a line scanner which "read" the image and stored it on a disk.

At this point the designer had the following elements stored on a disk: the copy, the Perspectives art, and the Metropolis logo. With these elements the newsletter could be assembled.

3

4

The designer then used the Aldus Pagemaker program to lay out the newsletter. First a basic two-column grid was designed (5). The Perspectives logo, previously created on another program, was then brought into Pagemaker. Copy was then called up and *placed* into position on the grid. In this case 11/13 Times Roman was selected (6). If desired, other typefaces could have easily been substituted, an advantage of design processing.

To check results and get a feel for how the piece was progressing, the designer was able to output hard copy at any time on the laser printer. As the process neared completion, several refinements were introduced using the aforementioned programs. These included display initials, condensed type for the issue number and date (7), and slightly distorted type for a call-out paragraph (8).

When the computer-generated newsletter was output, it was then submitted to the client for approval. Minor alterations were quickly modified and stored on the disk.

In order to obtain high-quality results, the final disk was sent to a professional typesetter who had the capability to run high-resolution repro proofs. In this case a linotron 300 was used to generate the copy at 2,450 lines per inch. This provided much higher resolution than would otherwise be obtained by an in-house laser printer.

Although most of the layout work was complete, simple mechanicals were prepared by mounting the final repro to a board and indicating trim marks. In addition an overlay was needed to indicate how the word Perspectives was to be positioned. The artwork was then approved by both the public relations group and the client.

The job was then sent to the printer. The following issue was even easier to produce since many of the elements had already been created and stored onto the disk.

5

6

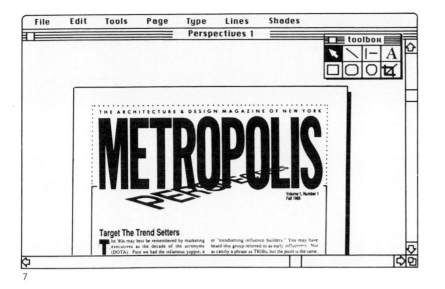

File Edit Tools Page Type Lines Shades

Perspectives 1

toolbox

THE ARCHITECTURE & DESIGN MAGAZINE OF NEW YORK

METROPOLIS

Volume 1, Number 1
Fall 1988

Target The Trend Setters

The '80s may best be remembered by marketing executives as the decade of the acronyms (DOTA). First we had the infamous yuppie, a | or "trendsetting influence builders." You may have heard this group referred to as early influencers. Not as catchy a phrase as TRIBs, but the point is the same.

7

File Edit Tools Page Type Lines Shades

Perspectives 1

toolbox

cross between preppie and the acronym for young urban professional that has transcended marketing jargon to become a pejorative for an entire generation. When yuppie became part of the popular lexicon, demographers quickly gave us such derivatives as dinks (dual income, no kids) and sinks (single income, no kids).

The acronyms proved to be shorthand for a significant marketing development: segmenting audiences along ever narrowing demographic lines. With the evolution of data base technology, marketers have placed a premium on defining their potential customers as acutely as possible, carefully gathering information about them, and spending advertising and marketing dollars where they will most effectively reach that audience.

I'd like to join the marketers and demographers who are carving up the population into yuppies, dinks and sinks. I think a critical group has been overlooked: TRIBs.

This is the inaugural issue of Metropolis Perspectives. Since 1981, Metropolis has built a strong relationship with its close to 80,000 affluent readers. We have also developed a unique perspective on how to effectively reach them with new products and ideas. Metropolis Perspectives is our forum for sharing this information with other influential audiences: our advertising and marketing partners.

These people are vitally important in any marketing effort. They are trendsetters, characterized not so much by lifestyle as by what they know, who each await any new product or service in a given field, whose opinion can make the difference between a hit and a miss; after all, there is no better sales pitch than a friend or professional colleague recommending a product or service.

Every industry has its TRIBs. Perhaps the most organized and easily accessible TRIBs are found in the world of personal computers. Computer TRIBs form their own clubs and create networks through electronic bulletin boards. Information and opinions are shared eagerly and easily. By tapping into these clubs, marketers get reliable feedback quickly and relatively inexpensively. A recent example comes from software manufacturer Lotus Development Corporation. Faced with a new software

8

5 The Aldus Pagemaker program was used to assist the designer in developing a workable two-column grid.

6 Copy was called up and within seconds the selected type was positioned within the grid.

7 Through the use of the computer, it was a simple matter to experiment with the size, style, and position of the display types.

8 To call attention to a specific paragraph, the designer used the computer to modify the type.

Appendix

Graphic designers can be found working in all fields concerned with visual communication; their tasks range from simple brochures to complex manuals, slide shows to mixed-media presentations, and line illustrations to computer-generated images. To understand the diversity of the industry, here are some of the basic fields in which graphic designers practice their professions.

1

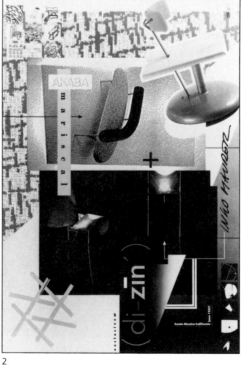

2

1 Full-color ad for BMW automobiles was art directed by Jeff Vogt for Ammirati & Puris, Inc.

2 Poster created by April Greiman is an excellent example of computer aided design.

Advertising. The advertising business can be divided into two major categories: *print* and *broadcast.* Print involves magazine ads, posters, and point-of-purchase displays, while broadcast deals with radio and television commercials.

Specialization in the advertising field is quite common — with one designer responsible for the concept and others responsible for type, mechanicals, and production. Besides the efforts of staff designers, most ads require the services of outside designers, such as photographers and illustrators. Graphic designers work closely with copywriters, account executives and, at times, clients.

Advertising is a high-budget industry due to the expense of ad placement, the exacting demands imposed by agencies, tight deadlines, and an ad approval process that involves dozens of people.

Audiovisual presentation. Audiovisual presentations, or AV's, is a professional version of the home slide show often involving multiple projectors, narration, music, and sound effects all controlled by computer. Audiovisual presentations are utilized primarily for seminars, sales conferences, exhibitions, and major industrial presentations.

Audiovisuals draw upon the designer's skills in photography, typography, and design. The designer is usually responsible for the sequencing and pacing of a presentation and should have the proper equipment and technical ability to satisfy your needs.

The creation of a successful audiovisual presentation can require significant planning. For example, a script is usually prepared by the client or in cooperation with the designer. Then, art has to be selected, type set, slides prepared and put in their proper sequence. Afterwards, narration, music, and special effects are added. Finally, the entire production is then programmed for computer playback.

Computer graphics. Computer-assisted design (CAD) became a major force during the 1980s. In the design field the computer was combined with the video monitor to create everything from simple charts to animation and complex visual images.

Systems range in size, cost, and capabilities; today they are used by many designers to assist in the creative process. Because of speed and flexibility, they permit the designer to study a wide range of options and to choose the one that best solves the problem.

While some systems and their associated software are within the financial means of the average designer, there are other systems that are so sophisticated and expensive that they are used exclusively by studios specializing in computer graphics for the film, TV, print, and advertising industries.

Corporate design. Corporations require the services of graphic designers to satisfy the demand for vast numbers of visual material, such as logos with stationery, catalogs, newsletters, sign systems, manuals, annual reports, and identity programs.

Many of these projects are handled by staff designers while the more complex — and often more glamorous — jobs are given to outside studios that specialize in identity programs and annual reports.

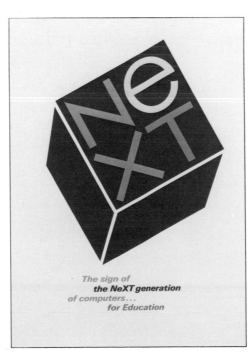

1 Poster designed by Paul Rand introducing NeXT computers.

1

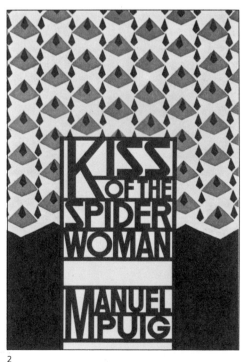

2

1 An exhibition celebrating the American space program, designed by Rudolph DeHarak & Associates, Inc. for Expo '70 in Osaka, Japan.

2 Book jacket designed by Lidia Ferrara for Alfred A. Knopf, Inc.

Editorial design. This industry can be divided into three major fields: *book, magazine,* and *newspaper.* Publishing is the largest employer of graphic designers. There are over 50,000 books published every year, as well as over 60,000 magazines and periodicals, and daily newspapers for every major city and community.

Graphic designers that are attracted to the publishing industry are generally strong in typography and organizational and layout skills. While most of the design is performed by staff designers, outside services of illustrators and photographers are often used for book jackets and illustrations.

Environmental design. Most think of environmental design as landscape architecture; however, outdoor information is also a very important part of any industrial, commercial, or public environment. Signs are the responsibility of the graphic designer. It is absolutely imperative that anyone involved in the design of signs have a strong typographic background.

Signs take many forms, dictated by their use and location: storefronts, highways, airports, and so on. They can be fabricated from metal, plastic, wood, stone, neon etc.

Exhibition design. Until quite recently the field of exhibition design was dominated by architects, industrial designers, and display manufacturers. Today, exhibition design has become another area of specialization for the graphic designer. Projects range from simple display booths, as used in trade shows, to international expositions.

Designers specializing in exhibitions often have architectural or industrial design abilities and are, therefore, skilled in working three dimensionally. They also draw heavily upon their experience in typography, audiovisual, video, and film.

Film and video graphics. Two disciplines where designers are active is in the creation of film and video productions. Filmmaking is used mainly for projected images such as movies, documentaries, animated presentations, and industrials. Video, on the other hand, is the medium of choice for the television industry. Today, however, videotapes are also popular as educational tools, whether they're for personal use or part of a corporate presentation.

Illustration. This is a particularly diverse field in which the artists are usually self-employed. Most illustrators eventually become specialists in one or two areas, such as advertising, book and jacket illustration, posters, and storyboards. Some areas require more than just drawing skills; for example, medical illustrators usually have a background in both medicine and anatomy.

All illustrators should be knowledgeable about typography, since the images are usually combined with a title or some message.

Package design. The package design profession can be divided into three major categories: *industrial, consumer,* and *promotional.* A well-designed package is not only a protective container, but a powerful advertising tool. Successful package designers are skilled at working three-dimensionally with a range of materials, including paper, plastic, and metal. They must combine this ability with a knowledge of photography, typography, and reproduction methods.

Photography. The majority of images reproduced in books, magazines, and newspapers are created by photographers. As with illustrators, most photographers are self-employed and specialize in a specific field or discipline, such as advertising, fashion, photojournalism, public relations, industrial, or architecture. Photographers charge by the day or half-day, plus materials and expenses.

Public relations. Most public relations firms have graphic designers on staff who are responsible for a range of in-house services including visual presentations, brochures, special interest magazines, point-of-purchase displays, and audiovisual presentations. As with advertising, clients generally work through an account executive rather than directly with the designer. Other related industries that often employ the services of designers are market researching, marketing, and media buying.

1

2

1 A promotional poster sponsored by Mobil and designed by Arnold Saks for the Museum of Contemporary Crafts.

2 Consumer packaging for 3M adhesive tape products. The client and designer have taken care to ensure that the brand name and logo are prominently displayed.

Glossary

A

AA. Abbreviation of "Author's Alteration." It is used to identify any alteration which is not a PE (Printer's Error).

Access. In desktop publishing, to call up information from storage or auxiliary disks.

Accordion fold. Series of parallel folds in paper in which each fold opens in the opposite direction from the previous fold—like an accordion.

Account executive. Person responsible for speaking with clients, getting new accounts, and coordinating work between agency and client.

Acetate. Transparent plastic sheet placed over a mechanical for overlays.

Against the grain. Folding paper at right angles to the grain.

Airbrush. Small pressure gun, shaped like a fountain pen, that makes tonal images by spraying paint or ink by compressed air.

Alignment. Arrangement of lines of type that makes the ends of the lines appear even on the page, that is, flush left, flush right, or both.

Antique finish. Soft, bulky paper with a relatively rough surface, similar to the old handmade papers.

Art. All original copy, whether prepared by an artist, camera, or other mechanical means. Loosely, any copy to be reproduced.

Art director. Supervisor of all aspects of creative production in an advertising agency or design studio.

Ascender. That part of the lowercase letter that rises above the body of the letter, as in *b, d, f, h, k, l,* and *t.*

Asymmetrical type. Lines of type set with no predictable pattern in terms of placement. Also called *random.*

Author's corrections. See AA.

B

Bad copy. Any manuscript that is illegible, improperly edited, or otherwise unsatisfactory to the typesetter. Most typographers charge extra for setting type from bad copy.

Baseline. Imaginary horizontal line upon which all the characters in a given line stand.

Basis weight. Weight in pounds of 500 sheets (a ream) of paper cut to a given standard size (this size is called the *basis size* and varies depending on the grade of paper).

Bible paper. A thin, opaque, high tensile-strength book paper used when low bulk is essential: for bibles, insurance rate books, encyclopedias, etc.

Bindery. An establishment that binds books, pamphlets, etc.

Binding. The fastening together of printed sheets in the form of signatures into books, booklets, magazines, etc. Also, the covers and backing of a book.

Bleed. Area of plate or print that extends ("bleeds off") beyond the edge of the trimmed sheet.

Blow-up. Enlargement of copy: photograph, artwork, or type.

Blue line. Blue nonreproducible line image printed on paper showing the layout. Used for a stripping guide or for mechanicals.

Blueprints. Also called *blues, diazo prints, dzalid prints,* or *blue lines.* Blue contact photoprints made on paper, usually used as a preliminary proof for checking purposes.

Blurb. Summary of contents of a book presented as jacket copy. Also, a short commentary, such as a caption or the text in comic strip balloons.

Body size. Depth of the body of a piece of metal type measured in points.

Boldface. Heavier version of a regular typeface, used for emphasis. Indicated *BF.*

Book paper. A category or group of printing papers that have certain physical characteristics in common which make them suitable for the graphic arts. Used for books, magazines, and just about everything we read, with the exception of newspapers and pulp novels.

Bulk. Thickness of printing papers, measured by pages per inch (PPI).

Bullet. Large dot used as an ornamental device.

C

C. & s.c. Stands for *caps* and *small caps.*

Caliper. The thickness of a sheet measured under specific conditions. The paper is measured with a micrometer and is usually expressed in thousandths-of-an-inch (mils or points).

Calligraphy. Elegant handwriting, or the art of producing such handwriting.

Camera-ready art. Copy assembled and suitable for photographing by a process camera.

Capitals. Also known as *caps* or *uppercase.* Capital letters of the alphabet.

Caps and small caps. Two sizes of capital letters on one typeface, the small caps being the same size as the body of the lowercase letter. Indicated as *c. & sc.* Looks Like This.

Caption. Explanatory text accompanying illustrations.

Casting. A typesetting process in which molten metal is forced into type molds (matrices). Type can be cast as single characters or as complete lines.

Casting-off. Calculating the length of manuscript copy in order to determine the amount of space it will occupy when set in a given typeface and measure.

Centered type. Lines of type set centered on the line measure.

Character count. Total number of characters in a line, paragraph, or piece of copy to be set in type.

Character generation. In digital typesetting, the projection or formation of typographic images.

Characters. Individual letters, figures, punctuation marks, etc., of the alphabet.

Characters-per-pica (CPP). System of *copyfitting* that utilizes the average number of characters per pica as a means of determining the length of the copy when set in type.

ACCORDION FOLD

BULLETS

Cicero. European 12-point unit of type. Equivalent to the pica.

Client. Customer or patron; the person who pays the bills.

Coated paper. Paper with a surface treated with clay or some other pigment and adhesive material to improve the finish in terms of printing quality. A coated finish can vary from dull to very glossy and provides an excellent printing surface that is especially suited to fine halftones.

Collate. To arrange sheets or signatures (*which see*) in proper sequence so the pages will be in the correct order before sewing and binding.

Collotype. Also known as *photogelatin*. A photomechanical method of printing, similar to lithography, that utilizes an unscreened gelatin-coated plate rather than a halftone screen to print continuous-tone copy. Collotype is the only feasible form of halftone reproduction that does not require a halftone screen. Produces extremely true reproductions but is suitable for short runs only.

Color bars. Carried on all four-color process proofs to show the printer the four colors that were used to print the image. Color bars show the amount of ink used, the trapping, and the relative densities across the press sheet. Used mainly as a guide for the platemaker and printer.

Color correction. Changing the color values in a set of separations to correct or compensate for errors in photographing, separation, etc. Also, the act of indicating on a set of color proofs what color corrections are to be made by the printer.

Color-matching system. Method of specifying flat color by means of numbered color samples available in swatchbooks, such as Pantone's PMS® system.

Color print. Photographic print in color, such as Anscochrome, Cibachrome, dye transfer, Kodacolor, and Kodak Type C.

Color process. Term used to describe multicolor printing from process-separated materials, as opposed to multicolor printing in nonprocess colors.

Color proof. Printed color image which enables the printer to see what is on the film and the client to make sure the color is accurate and in register. Ideally, the proof should be printed on the same press and paper that will be used for the finished job.

Color scanner. *See* Electronic scanner.

Color separation. The operation of separating artwork into the four process colors by means of filters in a process camera or by electronic scanners. The result is four continuous-tone films (negatives or positives), which when screened are used to make printing plates.

Color terminology. In the printing industry, color is described in terms of *hue* (chroma), *strength* (saturation), and *gray* (value). Hue is the pure color; strength refers to the color's strength, or saturation; and gray refers to how "clean" the color is. These are not terms used by the artist; they have been suggested by the printing industry to help communication among designer, client, and printer.

Color transparency. Also called a *chrome*. A full-color photographic positive on transparent film: Agfa Color, Cibachrome, Ektachrome, Kodachrome, etc.

Comp. *See* Comprehensive.

Composition. *See* Typesetting.

Compositor. A typesetter or typographer.

Comprehensive. More commonly referred to as a *comp*. An accurate layout showing type and illustration in position.

Condensed type. Narrow version of a regular type.

Contact print. Photographic print made by direct contact as opposed to enlargements or reductions made by projection where there is no direct contact.

Continuous-tone copy. Any image that has a complete range of tones from black to white, such as photographs and drawings.

Contrast. Wide range of tonal gradations between highlights and shadows.

Copy. In design and typesetting, typewritten copy. In printing, all artwork to be printed: type, photographs, illustrations.

Copyfitting. Determining the area required for a given amount of copy in a specified typeface.

Copywriter. Person on a creative team who is responsible for the written portion of the message.

Corporate design. Usually refers to graphic design activity within a corporation. Often the primary task of a corporate designer is to monitor the corporate design image and maintain consistent standards.

Counter. Space enclosed by the strokes of a letter, such as the bowl of the *a*, *d*, etc.

Cover paper. Term applied to a variety of heavy papers used for the outside covers of brochures, booklets, and catalogs.

Crop. To eliminate part of a photograph or illustration.

Crop marks. In design, the lines drawn on an overlay or in the margins of a photograph to indicate to the printer where the image should be trimmed.

Cursives. Typefaces that resemble handwriting, but in which the letters are disconnected.

Cursor. Blinking indicator on computer screen denoting current work site.

CROP MARKS

D

Deadline. Time beyond which copy cannot be accepted.

Deckle edge. Irregular, ragged edge on handmade papers, or the outside edges of machine-made paper produced on the paper-making machine.

Definition. Degree of sharpness in a negative or print.

Delete. Proofreader's mark meaning "take out." Looks like this: ℓ

Descenders. That part of a lowercase letter that falls below the body of the letter, such as in *g, j, p, q,* and *y.*

Diazo. *See* Blueprint.

Didot. Typographic system of measurement used in the non-English-speaking world. Comparable to our point system.

Die cut. Paper or cardboard cut into shapes other than rectangular by means of die cutting.

Disk. Computer storage device available in several formats and styles. Floppy disks and diskettes are most common, with hard disks utilized for extensive storage.

Display initial. The first letter of a body of copy, set in display type for decoration or emphasis. Often used to begin a chapter of a book.

Display type. Type that is used to attract attention, usually 15 point or larger.

Drop-out type. *See* Reverse type.

Dummy. Preliminary layout of a printed piece showing how the various elements will be arranged. It may be either rough or elaborate, according to the client's needs.

Duotone. A two-color halftone made from a regular black-and-white photograph. One plate is made for the black, picking up the highlight and shadow areas; a second plate is made for the second color, picking up the middle tones.

Duplex paper. Paper or board with a different color or finish on each side.

Dye transfer. A full-color print used for retouching or as short-run quantity displays.

E

Editing. Checking copy for fact, spelling, grammar, punctuation, and consistency of style before releasing it to the typesetter.

Elite. Smallest size of typewriter type: 12 characters per inch as compared with 10 per inch on the pica typewriter.

Embossing. Producing a raised image on a printed surface.

Emulsion. In photographic processes, the photosensitive coating that reacts to light on a substrate.

End-of-line decisions. Generally concerned with hyphenation and justification (H/J). Decisions can be made either by the keyboard operator or by the computer.

End papers. The sheets at the front and back of a case bound book that attach the pages of the book to the cover, or case.

Estimating. Determining the cost of a job before it is undertaken.

Exposure. In photography, the time and intensity of illumination acting upon the light-sensitive coating (emulsion) of film or plate.

Extended. Also called *expanded.* A wide version of a regular typeface.

F

Family of type. All the type sizes and type styles of a particular typeface (roman, italic, bold, condensed, expanded, etc.).

Finish. The surface properties of paper.

First proofs. Proofs submitted for checking by proofreaders, editors, etc.

Fit. Space relationship between two or more letters. The fit can be modified into a "tight fit" or a "loose fit."

Flat. An assemblage of various film negatives or positives attached, in register, to a piece of film, goldenrod, or suitable masking material ready to be exposed to a plate.

Flexography. A relief printing process using wrap-around rubber or soft plastic plates and volatile, fast-drying ink. Widely used in the packaging industry.

Flop. To turn over an image so that it faces the opposite direction.

Flush left (or right). Type that lines up vertically on the left (or right).

Flyer. Advertising handbill or circular.

Foil. Sized metallic or pigment leaf used in stamping letter or designs on a surface. Used primarily for stamping book covers.

Folio. Page number. Also refers to a sheet of paper when folded once.

Font. Complete assembly of all the characters (upper- and lowercase letters, numerals, punctuation marks, points, reference marks, etc.) of one size of one typeface: for example, 10-point Garamond roman.

Format. General term for style, size, and overall appearance of a publication.

Four-color process. Method of reproducing full-color copy by separating the color image into its three primary colors—magenta, yellow, and cyan—plus black.

Freelancer. Designer who sells his or her creative services directly to others without a middleman or organizational ties.

French fold. A double fold: the sheet is printed on one side only, then folded twice, once vertically and once horizontally, resulting in an economical, attractive four-page folder. Used for formal invitations, etc.

Full out. Type set flush having no indentations.

G

Galley proof. Also called a *rough proof.* A first proof of type that allows the typographer or client to see if it has been properly set.

Ghosting. A condition in which the printed image appears faint where not intended.

Glossy. Photoprint made on glossy paper. As opposed to matte.

GRID

DROP-OUT TYPE

Grain. Direction of the fibers in a sheet of paper.

Gravure. Printing method based on intaglio printing, in which the image area is etched below the surface of the printing plate.

Gray scale. Series of density values, ranging progressively from white through shades of gray to solid black. Used in film processing to check the degree of development.

Grid. Means of layout and organization of the printed page. Plan of the grid is based on the specific size and style of type, and combinations of these type units.

H

Hairline. Fine line or rule; the finest line that can be reproduced in printing.

Hanging punctuation. In justified type, punctuation that falls at the end of a line is set just outside the measure in order to achieve optical alignment.

Hard copy. Typewritten copy as opposed to electronically stored copy.

Hardware. In typesetting and the word processing field, a term referring to the actual computer equipment.

Heading. Bold or display type to emphasize copy.

Headline. The most important line of type in a piece of printing, enticing the reader to read further or summarizing at a glance the content of the copy which follows.

Hickey. A defect, or spot, appearing in the printed piece.

Holding lines. Lines drawn by the designer on the mechanical to indicate the exact area that is to be occupied by a halftone, color, tint, etc.

Hyphenation. Determining where a word should break at the end of a line. In typesetting, computers are programmed to determine hyphenation.

I

Identity manual. Guidebook that shows standards of a graphic identification program for an organization or corporation.

Illustration. General term for any form of drawing, diagram, halftone, or color image that serves to enhance a printed piece.

Imposition. In printing, the arrangement of pages in a press form so they will appear in correct order when the printed sheet is folded and trimmed. Also, the plan for such an arrangement.

Indent. Placing a line (or lines) of type in from the margin to indicate the start of a new paragraph.

Indicia. Information printed by special permit on cards or envelopes that takes the place of a stamp.

Input. In computer composition, the data to be processed.

Italic. Letterform that slants to the right: *looks like this.*

J

Jacket. Also called a *dust cover.* The paper dust jacket or over-cover of a case bound book.

Justified type. Lines of type that align on both the left and the right of the full measure.

K

Kerned letters. Type characters in which a part of the letter extends, or projects, beyond the adjacent character.

Keyline. *See* Mechanical.

Kicker. Also called a *teaser.* A short line above the main line of a head, printed in smaller, or accent, type.

Kill. To delete unwanted copy.

Kromecote. A brand name for a coated paper with a very glossy finish.

L

Laid paper. Paper having a laid pattern: a series of parallel lines simulating the look of old handmade papers.

Laminating. Applying a thin plastic film (acetate or polyester) to a printed sheet for protection and/or appearance. A laminated surface has a hard, high gloss and is impervious to stains. Lamination may be applied in liquid form or in sheets.

Laser Printing. State-of-the-art printing method, employing the use of a laser beam.

Layout. Plan showing the basic elements of a design in their proper positions.

L.C. Lowercase, or small letters of a font.

Lead-in. First few words in a block of copy set in a different, contrasting typeface.

Leading. (Pronounced *ledding.)* The space between lines of type: also called *linespacing.*

Ledger paper. A tough, smooth, nonreceptive paper generally used for keeping business records, such as ledgers.

Legibility. That quality in type and its spacing and composition that affects the speed of perception: the faster, easier, and more accurate the perception, the more legible the type.

Letterfit. The quality of the space between the individual characters. Letterfit should be uniform and allow for good legibility.

Letterpress. The printing method originally used to print woodblocks or type. It is based on relief printing, which means that the image area is raised.

Letterspacing. Adding space between the individual letters in order to fill out a line of type to a given measure or to improve appearance.

Ligature. Two or three characters joined, such as *ff, ffi, ffl,* Ta, *Wa,* Ya, etc.

Lightface. Lighter version of a regular typeface.

Lineale. *See* Sans serif.

Line copy. Any copy that is solid black, with no gradation of tones: line work, type, dots, rules, etc.

Line drawing. Any artwork created by solid black lines. A drawing free from wash or diluted tones.

Linespacing. In typesetting, a popular term for *leading.*

KERNED LETTERS

Literal. A small type error induced in keyboarding affecting one or two letters.

Lithography. In fine art, a planographic printing process in which the image area is separated from the nonimage area by means of chemical repulsion. The commercial form of lithography is *offset lithography.*

Logotype. Commonly referred to as a *logo.* A symbol or type characters used as a trademark or a company signature.

Lowercase. Small letters, or minuscules, as opposed to caps.

M
Manuscript. Copy to be set in type. Usually abbreviated to MS. (sing.) and MSS. (pl.).

Margins. Areas that are left around type and/or illustrative matter on a page: the top, bottom, and sides.

Markup. In typesetting, to mark the type specifications on layout and copy for the typesetter. Generally consists of the typeface, size, line length, leading, etc.

Masthead. Any design or logotype used as identification by a newspaper or publication.

Match color. *See* Flat color.

Matte finish. A paper with an uncalendered, lightly finished surface. Also, in photography, a textured, finely grained finish on a photograph or photostat, as opposed to glossy.

Mean line. The line that marks the top of lowercase letters without ascenders.

Measure. Length of a line of type, normally expressed in picas.

Mechanical. Preparation of copy to make it camera-ready with all type and design elements pasted on art board.

Menu. In desktop publishing, a list of options displayed on the screen. Each computer program has specific menus relating to the type of work it produces.

Metric system. Decimal system of measures and weights with the meter and the gram as the bases. Here are some of the more common measures and their equivalents:

kilometer	00.6214 mile
meter	39.37 inches
centimeter	00.3937 inch
millimeter	00.0394 inch
kilogram	02.2046 lb.
gram	15.432 gr. (av.)
inch	02.54 cm.
foot	00.3048 meter
yard	00.9144 meter
pound	00.4536 kilogram

Mezzotint. In fine art, a form of etching in which the entire surface is "burred." Also, a line conversion of a photograph which imitates the mezzotint effect.

Minus linespacing. Also called *minus leading.* The reduction of space between lines of type so that the baseline-to-baseline measurement is less than the point size of the type.

Modem. Device allowing computers to transmit data via telephone lines.

Moiré pattern. (Pronounced *moh-ray.)* Undesirable patterns that occur when reproductions are made from halftone proofs.

Monitor. Computer screen and main terminal. Large independent screen monitors are also available.

Mouse. A hand held device used to supplement the keyboard when working with computers. When moved across a flat surface its motion is simulated on the screen by a cursor. Also called a *puck.*

N
Negative. Reverse photographic image on film or paper: white becomes black and black becomes white.

Newsprint. A low grade of paper used for printing newspapers and low-cost flyers or broadsides.

O
Oblique. Roman characters that slant to the right.

OCR. Device which deciphers manuscript pages, converting them into a format required for typesetting. OCR refers to Optical Character Recognition.

Offset lithography. Also called *photolithography* and, most commonly, *offset.* The commercial form of lithographic printing.

Opacity. That quality in a sheet of paper that prevents the type or image printed on one side from showing through to the other side.

Outline. Typeface with only the outline defined.

Overrun. Printing a quantity in excess of what is ordered. Buyers of printing should be aware of the extra charges that nonregulated overruns may add to the bill.

Ozalid. *See* Blueprint.

P
Page proofs. Impression or proof pulled of page before the print run for checking purposes.

Pagination. To number pages in consecutive order.

Pamphlet. Generally used interchangeably with the *booklet.* Also used to designate a minor booklet of a few pages.

Pantone Matching System. Brand name for a widely used color-matching system *(which see).*

Paste up. *See* Mechanical.

PE. Abbreviation of "Printer's Error," or mistake made by the typesetter or printer, as opposed to AA.

Perfect binding. A relatively inexpensive method of binding in which the pages are held together and fixed to the cover by means of flexible adhesive. Widely used for paperbacks, manuals, textbooks, and telephone books.

LOGOTYPE

Perfecting press. A printing press that prints both sides of a sheet or a web in a single pass through the press.

Perforating. The punching of a line of minute holes in a sheet so that a part may be easily torn away in the manner of postage stamps.

Photocopy. Duplicate image made from the original. Also, the correct generic term for Xerox, which is a trade name.

Photostat. Trade name for a photoprint, more commonly referred to as a *stat*.

Phototypesetting. Also known as *photocomposition* and errone- ously as *cold type*. The preparation of manuscript for printing by projection of images of type char- acters onto photosensitive film or paper.

Pi characters. Special characters not usually included in a type font.

Pica. Typographic unit of measurement: 12 points v 1 pica and 6 picas v 1 inch. Also used to designate typewriter type: 10 characters per inch (as opposed to elite typewriter type, which has 12 characters per inch).

Plate finish. A finish that gives paper a smooth, hard surface.

PMS. *See* Pantone Matching System.

Point. Smallest typographical unit of measurement: 12 points v 1 pica. Type is measured in terms of points, the standard sizes being 6, 7, 8, 9, 10, 11, 12, 14, 18, 24, 30, 36, 42, 48, 60, and 72.

Portfolio. Collection of art and design pieces which document a student's class performance or a professional's work experience.

Positive. Photographic reproduction on paper, film, or glass that corresponds exactly with the original, as opposed to a negative, in which the tonal values are reversed.

Preparation. Also called *prep work*. In printing, all the work necessary in getting a job ready for platemaking: preparing art, mechanicals, camera, stripping, proofing.

Pre-press proof. A proof made directly from film before the printing plate has been made.

Press proof. A proof pulled on the actual production press (as opposed to a proofing press) to show exactly how the form will look when printed. Press proofs are expensive.

Printer's error. *See* PE.

Printing plate. A surface, usually made of metal, that has been treated to carry an image. The plate is inked and the ink is transferred to the paper or other surface by a printing press.

Process camera. Also called a *copy camera* or a *graphic arts camera*. A camera specially designed for process work such as halftone-making, color separation, copying, etc.

Proofreader. Person who reads the type that has been set against the original copy to make sure it is correct, and who also may read for style, consistency, and fact.

Proofreader's marks. Shorthand symbols employed by copyeditors and proofreaders to signify alter- ations and corrections in the copy.

Proofs. Trial print or sheet of printed material that is checked against the original manuscript and upon which corrections are made.

Puck. *See* Mouse.

Q
Quad. Letterpress spacing material used to fill out lines of type.

Quad left, right, or center. To set lines flush left, flush right, or center.

R
Ragged. *See* Unjustified type.

RAM. Random access memory. Temporary memory available to assist operator and speed up computer functions.

Range. *See* Alignment.

Recto. The right-hand page of an open book, magazine, etc. Page 1 is always on a recto, and rectos always bear the odd-numbered folios. Opposite of verso.

Reflection copy. Also called *reflective copy*. Any copy that is viewed by light reflected from its surface: photographs, paintings, drawings, prints, etc. As opposed to transparent copy.

Register marks. Devices, usually a cross in a circle, applied to original copy for positioning negatives in perfect register. Also used for preparing mechanicals.

Reproduction proof. Also called a *repro*. A final, corrected proof to be pasted into mechanicals.

Retouching. The correcting of imperfections in or the altering of a photograph or dye transfer print before it is reproduced. Retouching can be done by airbrushing or by using pencil, pen, brush, or dyes.

Reverse type. Type that drops out of the background and assumes the color of the paper.

Revise. Change in instruction that will alter copy in any stage of composition.

Rough. Sketch or thumbnail, usually done on tracing paper, giving a general idea of the size and position of the various elements of the design.

Rule. Black line used for a variety of typographic effects, including borders and boxes.

Run-around. Type in the text that runs around a display letter or illustration.

Running head. A title repeated at the top of each page.

MOIRÉ PATTERN

REGISTRATION MARKS

S

Saddle-wire stitching. A common, inexpensive way of binding pamphlets and booklets if they are not too thick (usually less than ⅛"). The pages are bound together by wire staples inserted through the backbone.

Sans serif. Typeface design without serifs.

Scaling. Process of calculating the percentage of enlargement or reduction of the size of artwork to be enlarged or reduced for reproduction.

Scanner. Electronic equipment for scanning full-color copy by reading the relative densities of the copy to make color separations. The scanner is capable of producing negative or positive film either screened or unscreened. The scanner can only separate copy that is thin enough to be wrapped around a drum, therefore limiting copy to transparencies and photographic prints. Scanners are also used for screening black-and-white prints.

Scoring. Creasing paper mechanically so it will fold more easily.

Screen. In printing, the finely cross-ruled screen placed in contact with the film to break up continuous-tone copy into dots for reproduction.

Screen printing. Formerly called silk screen printing, this process refers to forcing ink through an open area in a piece of silk stretched on a frame. Excellent for printing bright, flat colors in limited editions.

Script. A typeface based on handwritten letterforms. Scripts come in formal and informal styles and in a variety of weights.

Self-cover. A cover of the same stock (paper) as used in the rest of the book. Used for booklets or pamphlets when the cover stock does not have to be particularly strong, or to save the cost of the extra materials and operations required to produce and bind a cover.

Self-mailer. A printed piece designed to be mailed without an envelope.

Serifs. Short cross-strokes in the letterforms of some typefaces.

Show-through. Phenomenon in which printed matter on one side of a sheet shows through on the other side.

Side-wire stitching. Also called *side stitching*. A method of binding books, catalogs, and magazines in which wires in the form of staples are inserted near the binding edge.

Software. Computer programs-procedures, etc., as contrasted with the computer itself, which is referred to as *hardware*.

Solid. In composition, refers to type set with no linespacing between the lines.

Spacing. Separation of letters and words in type, or the separation of lines of type by insertion of space.

Spec. To specify type or other materials in the graphic arts.

Spiral binding. A binding in which a continuous wire or plastic spiral is threaded through pre-punched holes along the binding sides of the paper.

Square halftone. A rectangular —not necessarily square—halftone, i.e., one with all four sides straight and perpendicular to one another.

S.S. Also indicated as *S/S*. Abbreviation for "same size."

Stamping. A printing method in which type or designs, in the form of a relief die, are impressed with heat and pressure through metal foil onto the surface to be printed.

Stat. *See* Photostat.

Stet. Proofreader's mark that indicates copy marked for correction should stand as it was before the correction was made.

Stock. Also called *substrate*. Any material used to receive a printed image: paper, board, foil, etc.

Storage. In computer terminology, a device (a memory tape, disk, or drum) into which data can be entered, in which it can be held, and from which it can be retrieved at a later time.

Storyboard. Rough presentation of scenes to be filmed for a TV commercial. Usually done with markers.

Stripping. Assembling photo-graphic negatives or positives and securing them in correct position.

T

Text. Body copy in a book or on a page, as opposed to the headings.

Text type. Main body type, usually smaller in size than 14 point.

Thermography. An inexpensive finishing process that simulates the effect of steel-die engraving, pro-ducing raised letters.

Thumbnails. Small, rough sketches.

Tint. In printing, a photo-mechanical reduction of a solid color by screening. Color obtained by adding white to solid color.

Tip-in. The process of pasting a leaf onto a printed page before or after binding. This is common in art books.

Transfer type. Type carried on sheets that can be transferred to the working surface.

Transparency. A positive colored photograph on transparent film, such as Kodachrome and Ektachrome films.

Trim. To cut off and square the edges of a printed piece or of a stock before or after printing.

Trim size. Final size of a printed piece, after it has been trimmed.

T-square. Mechanical drawing tool used with a drawing board and other aids to make certain the type and image is straight or "square."

SCREEN

Type family. *See* Family of type.

Type gauge. Commonly called a *line gauge*. A rule with calibrated picas and inches. These are used to gauge the number of lines set in a given type size; they are also useful for copyfitting.

Typesetting. Refers to type set by hand, machine (cast), typewriter (strike-on), phototypesetting (projected), and digital (generated).

Type style. Variations within a typeface: roman, italic, bold, condensed, expanded, etc.

Typographer. Person who sets type.

Typographic errors. Commonly called *typos*. Errors made in copy while typing, either at a conventional typewriter, or by the compositor at the keyboarding stage of typesetting.

Typography. The art and process of working with and printing from type.

U

U. & L.C. Also written *u/lc*. Commonly used abbreviation for upper- and lowercase.

Uncoated paper. The basic paper produced on the papermaking machine with no coating operations.

Unjustified type. Lines of type set at different lengths which align on one side (left or right) and are ragged on the other.

Uppercase. Capital letters of a type font: A, B, C, etc.

V

Value. The degree of lightness or darkness of a color or of a tone of gray, based on a scale of graduated tonal values running from pure white through all the gradations of gray to black.

Varnish. A thin, protective, and/or decorative coating applied to the printed piece like ink on the printing press. Can be matte or glossy.

Verso. The left-hand side of a spread.

W

Web printing. Printing method in which paper is fed into the press from continuous rolls (webs), as opposed to flat sheets as in sheet-fed printing.

Weight. In composition, the variation of a letterform: light, regular, bold. In paper measurement, the weight of 500 sheets (a ream) of paper of standard size.

Widow. End of a paragraph or of a column of reading matter that is undesirably short: a single, short word; or the end of a hyphenated word, such as "ing."

Word space. Space between words.

Wove paper. An uncoated paper that has a uniform surface with no discernable marks.

X

x-height. Height of the body of lowercase letters, exclusive of ascenders and descenders.

Bibliography

Annuals

American Illustration Showcase. American Showcase. New York.

American Photography Showcase. American Showcase. New York.

Art Directors' Annual. The Art Directors Club of New York, New York.

The Art Directors' Club of Toronto Show Annual. Wilcord Publications, Ltd. Toronto, Ontario.

Art Directors' Index to Photographers. Roto Vision S.A. Mies, Switzerland.

Creative Source Canada. Wilcord Publications, Ltd. Toronto, Ontario.

Graphic Design USA. The Annual of the American Institute of Graphic Arts. New York.

Graphis Annual. Zurich, Switzerland.

Graphis Packaging. Zurich, Switzerland.

Graphis Photo. Zurich, Switzerland.

Graphis Poster. Zurich, Switzerland.

Illustrators' Annual. The Society of Illustrators. New York.

One Show. Roto Vision S.A. in association with The One Club for Art and Copy. New York.

Penrose Annual. International Revue of the Graphic Arts. New York: Hastings House.

The Society of Illustrators. Madison Square Press. New York.

The Society of Publication Designers. Madison Square Press. New York.

Typography. The Annual of the Type Directors Club. New York.

The Workbook Portfolio. Scott & Daughters Publishing. Los Angeles.

Graphic Design

The Art of Advertising: George Lois on Mass Communication. George Lois. New York: Harry N. Abrams, Inc.

The Bauhaus. Hans Wingler. Cambridge: The MIT Press.

A Designer's Art. Paul Rand. New Haven: Yale University Press.

By Design: A Graphics Sourcebook of Materials, Equipment, & Services. New York: Quick Fox.

Forget all the Rules You Ever Learned About Graphic Design. Bob Gill. New York: Watson-Guptill.

Graphic Design Manual. Armin Hofmann. New York: Van Nostrand Reinhold.

The Grid. Allen Hurlburt. New York: Van Nostrand Reinhold.

Layout. Allen Hurlburt. New York: Watson-Guptill.

Living by Design. Pentagram. New York: Watson-Guptill.

Magazine Design. Ruari McLean. New York: Oxford University Press.

Milton Glaser. New York: J.M. Folon.

Publication Design. Allen Hurlburt. New York: Van Nostrand Reinhold.

Thirty Centuries of Graphic Design. James Craig and Bruce Barton. New York: Watson-Guptill.

Thoughts on Design. Paul Rand. New York: Van Nostrand Reinhold.

Type Sign Symbol. Adrien Frutiger. Zurich: ABC Edition.

Periodicals

Advertising Age
Crain Communications, Inc.
740 Rush Street
Chicago, IL 60077

Communication Arts
410 Sherman Avenue
Palo Alto, CA 94303

Design Quarterly
Walker Art Center
Vineland Place
Minneapolis, MN 55403

Graphis
CH 8008
Zurich, Switzerland

Print
355 Lexington Avenue
New York, NY 10017

U & lc
216 East 45 Street
New York, NY 10017

Printing and Production

Advertising Agency and Studio Skills. Tom
Cardamone. New York: Watson-Guptill.

Graphic Designer's Production Handbook.
Norman Sanders. New York: Hastings House.

Pasteups & Mechanicals. J. Demoney and
S. Meyer. New York: Watson-Guptill.

Photographing for Publication. Norman
Sanders, New York: R.R. Bowker.

Pocket Pal. International Paper Company.
New York.

Production for the Graphic Designer.
James Craig. New York: Watson-Guptill.

Reference Books

The Creative Black Book
Friendly Publications, Inc.
401 Park Avenue South
New York, NY 10016

Literary Market Place
R.R. Bowker Company
1180 Avenue of the Americas
New York, NY 10036

Magazine Industry Market Place
R.R. Bowker Company
1180 Avenue of the Americas
New York, NY 10036

National Association of Schools of Arts
11250 Roger Bacon Drive #5
Reston, VA 22090

Standard Directory of Advertising Agencies
National Register Company
866 Third Avenue
New York, NY 10022

Standard Rate & Data Service
McGraw-Hill Publications Company
1221 Avenue of the Americas
New York, NY 10020

U.S. Book Publishing Yearbook Directory
Knowledge Industry Publications, Inc.
701 Westchester Avenue
White Plains, NY 10604

Typography

Asymmetric Typography. Jan Tschichold. New
York: Reinhold.

Calligraphic Lettering. Ralph Douglass.
New York: Watson-Guptill.

Designing with Type. James Craig. New York:
Watson-Guptill.

Phototypesetting: A Design Manual.
James Craig. New York: Watson-Guptill.

Pioneers of Modern Typography. Herbert
Spencer. London: Lund Humphreys.

Printing Types: Their History, Forms, and Use.
2 Vols. Cambridge, Mass.: The Belknap Press
of Harvard University.

Type and Typography. Ben Rosen. New York:
Van Nostrand Reinhold.

Index

3100 N. CENTE CCLD
CLIF
1-815-694-2000

James Craig, a well-known author, was born in Montreal, Canada. He studied fine arts in Montreal and Paris before coming to the United States. Craig received his B.F.A. from The Cooper Union and his M.F.A. from Yale University. He is design director for Watson-Guptill Publications and a member of the New York Art Directors Club. Craig teaches graphic design at The Cooper Union and lectures widely.

William Bevington received his B.F.A. at The Cooper Union. He worked for Rudolph de Harak & Associates and was Assistant Designer at Peter Schmidt Studios in Hamburg. Currently, an instructor of typography at The Cooper Union, he has also lectured at SUNY, Purchase and Baruch College. Bevington illustrated *Graphic Designer's Production Handbook* authored by Norman Sanders. He is President of Wm. Bevington Design, Inc., New York.

3100 N. CENTRAL SCHOOL RD.
CCLD
CLIFTON, IL 60927
1-815-694-2800
WITHDRAWN

Editor: Lanie Lee

Designers: James Craig and William Bevington

Production Manager: Ellen Greene

Typesetting: Type by Battipaglia, Inc.

 JCH Graphics, Inc.

Text Type: 9½ point Frutiger 45